Music and Painting

By the same author

DEBUSSY: HIS LIFE AND MIND
(2 vols.)

Music and Painting

A Study in Comparative Ideas from Turner to Schoenberg

Edward Lockspeiser

Icon Editions

Harper & Row, Publishers

New York, Evanston, San Francisco, London

FIRST U.S. EDITION

STANDARD BOOK NUMBER: 06-430040-4 (paper)

STANDARD BOOK NUMBER: 06-435325-7 (cloth)

LIBRARY OF CONGRESS CATALOG CARD NUMBER: 73-7979

Contents

Illustrations

That which is neither a sensation nor a
perception, that which is neither individual . . .
nor general . . . which neither refers to outward
facts, nor yet is abstracted from the forms of
perception . . . to which there neither is nor can
be an adequate correspondent in the world of the
senses;—this and this alone—is an Idea.

Coleridge, *The Statesman's Manual*

Introduction

My acknowledgements, in investigating this field of research, which has turned out to be more illuminating than I had imagined, go in the first place to the Leverhulme Trust Fund which generously offered me a part-time Visiting Lectureship in the Faculty of Music at King's College, London. This enabled me to devote my time to an approach to the artistic turmoils of our time. My aim in the first place was an interpretation of the interaction of ideas in music and painting in the nineteenth century. Acting on the principle that ideas, however developed they may have become, must have some germinal beginning, I felt that some additional illumination of our musical problems might be found in an adjacent realm of the imaginative mind.

I do not know whether my students at King's College learnt as much from me as I learnt from them. I was the observer of the musical scene, they were the young musicians on whom our future depends. One of my theories, often contested, was this: since there can be no understanding of earlier musical periods except through the contemporary mind, authenticity, as an ideal or an illusion, must eventually lead to mummification. Consequently, if I have arrived at some understanding of the concrete, the electronic and the aleatoric spheres of music it is due to the youthful guidance I received from the forward-looking King's College students.

Obscurities persisted, however, also perplexities. Several writers on the contemporary scene had floundered in one way or another, and for obvious reasons. A civilization has the critics it deserves, and who was I, less methodical than my predecessors, to perceive what had already passed them by? I am grateful to Sir Anthony Blunt who at about this time invited me to lecture on the relationship between music and painting at the Courtauld Institute. It was there that I became fascinated

by a discovery, long associated with Sir Anthony Blunt, that Poussin had based the technique of certain of his pictures on the character of the Renaissance modes. The trouble was that art historians knew hardly more about the modes than music historians knew about Poussin. However, I was privileged to lead discussions on this subject at the French Musicological Society and at the Collège de France where Professor René Huyghe honoured me with a Visiting Professorship.

Such an approach must sound forbiddingly academic. But in the light of present-day developments it is not at all academic. Though I had no intention of extending my investigations to remote periods, it was here, in certain pictures of Poussin, as Blunt shows, that we may see the beginnings of abstract art. I mention this point in passing since abstract art, and the schools associated with it, lean not towards the pictorial but towards the musical spheres. These unsuspected musical influences in Poussin promoted the sequence of ideas I was trying to build up.

My explorations were not to extend beyond Schoenberg and the Expressionist painters. As we know, the connections between their ideas and those of earlier schools are nowadays becoming more apparent. Later developments belong to another study. Yet here again the beginnings of some of the wilder notions of the present day are evident in the revolutionary nineteenth century. Several eminent scholars have kindly assisted me. Professor Josef Rufer provided me with documents allowing me to form an independent assessment of Schoenberg's relationship with the painters of his time. John Warrack offered me the benefits of his research on Weber, and I am similarly indebted to Geoffrey Skelton for facilitating my explorations into the literary works of Wagner. I was greatly inspired by my conversations, during his last days at Alfriston, with Sir Gavin de Beer, the foremost authority on Darwin, whose theories were reflected in the evolutionary ideas of artistic thought. On another level, I wish I had been able to discuss the matter of mathematics and music with the late Professor Thurston Dart, head of my Faculty at King's College, and himself a mathematician. But I fear there would have been a temptation to branch out into many fascinating by-ways beyond the limits I had imposed.

Monsieur André Meyer placed the manuscript of Debussy's unpublished play *Frères en Art* at my disposal, and I have drawn abundantly on the remarkable studies of André Schaeffner and Jean Seznec. It was, however, after my absorbing discussions with René Huyghe that the form of my book was ultimately determined. Many other names

should be included in these acknowledgements for I have not hesitated to draw upon the advice and wisdom of many good friends. (Among them Miss Anne Carter of Cassell's and Miss Pamela Morris of the *Encyclopaedia Britannica* have been unfailingly kind and patient in their editorial assistance.) My hope is that they will take some satisfaction in seeing that the conclusions we agreed upon have not been too drastically distorted in the course of my contribution.

Translations, when the name of the translator is not indicated, are my own. This is not because I hope to improve upon earlier translators; on the contrary, I look back on their work with envious admiration, notably the translation of Delacroix's *Journal* by Lucy Norton, who kindly allowed me to use her telling version of a sentence of Delacroix at the head of Chapter 4. It is simply that confronted by figures of a certain complexity, among them Baudelaire and Valéry, an historian must convey his personal response.

Several studies incorporated in my book, sometimes in a curtailed or an expanded form, have appeared in professional journals. They are: 'The Renoir Portraits of Wagner', *Music and Letters*, January 1937; 'Poussin et les Modes', *La Revue de Musicologie*, Vol. 53, 1967, No. 1; 'The Mind of Alban Berg', *The Listener*, 16 March 1967; 'The Berlioz–Strauss Treatise on Instrumentation', *Music and Letters*, January 1969; 'Baudelaire and Music', *The Yale Review*, Summer 1970; 'Frères en Art: Pièce de théâtre inédite de Debussy', *La Revue de Musicologie*, Vol. 56, 1970, No. 2.

Permission to use extracts from published articles or books has been granted by the Hogarth Press Ltd. and Mrs Katherine Jones for an extract from Volume III of *Sigmund Freud: Life and Work* by Ernest Jones; and for extracts from the *Duino Elegies* by Rainer Maria Rilke, translated by J. B. Leishman and Stephen Spender; by Messrs Hermann, Paris, for a passage from *Nicolas Poussin: Lettres et propos sur l'art* edited by Sir Anthony Blunt; by *La Revue des Deux Mondes* for an extract from the study *L'Amitié de George Sand et d'Eugène Delacroix* by André Joubin; by the Librairie Droz, Geneva, for an extract from the study of Jean Autret, *L'Influence de Ruskin*; by George Allen & Unwin Ltd. for extracts from *History of Western Philosophy* and *Why I am not a Christian* by Bertrand Russell; by Thames and Hudson Ltd. for extracts from *The Complete Letters of Vincent van Gogh* translated by J. van Gogh-Bonger and C. de Dood; by Routledge and Kegan Paul Ltd. for extracts from Vols. I and II of the *Collected Works of Paul Valéry*; by *La Nouvelle Revue Française* and Madame Olivieri Ramuz for an

extract from the article 'Le Cirque' by C. F. Ramuz; by the executors of Dame Edith Sitwell for an extract from *The Russian Ballet Gift Book* (1922); by The Bodley Head for an extract from *A History of Painting* by R. Muther, translated by G. Kriehn; by Pantheon Books of Random House Inc, for an extract from Camille Pissarro, *Letters to his Son Lucien*; by Faber & Faber for an extract from Goethe, *Faust*, Parts I and II, translated by Louis MacNeice, and for an extract from T. S. Eliot's 'The Love Song of J. Alfred Prufrock'; by Éditions Gallimard for extracts from Valéry's works *Mélange* and *Pièces Diverses*; and by Phaidon Press for an extract from *Nicolas Poussin* by Sir Anthony Blunt.

Pictorial illustrations have deliberately been kept to a minimum. Key pictures alone, illustrating particular theories, are represented, the reason being that a pursuit of ideas is likely to be retarded by the sight of a vast number of illustrations. References are invariably given to relevant pictures or reproductions of them, which I believe to be a more rewarding plan. Musical quotations from well-known works are omitted for a similar reason. The widening diffusion of music frequently makes this admirable practice superfluous. In earlier years the Strauss revision of the Berlioz treatise on instrumentation, with its abundant full-score reproductions of Gluck, Berlioz and Wagner, itself amounted to a tome at least twenty times the size of the present book. I have been content to deal with an assessment of this subject in a few pages, with the knowledge that any interested person can easily consult the Strauss version if, in fact, he is not at this time of day perfectly well acquainted with the works themselves. In the same spirit I have replaced the bibliography by source references indicated in a more practical fashion in the text or in footnotes. Appendices are reserved for further explorations and side-lights.

A book should speak for itself and does not necessarily need an introduction. A few words on the structure, however, may be helpful. The unification of the artistic experience was, as is well known, a nineteenth-century ideal. But it was only partly realized and only over a short period. Discussions of the pictorial basis in certain works of Mendelssohn, Beethoven, Weber and Berlioz open the argument, though musicians nowadays are inclined to dismiss these pictorial elements. This is only natural for it was a musical ideal that was breaking through, an abstract ideal, invading the minds of painters, disturbing their vision and intensifying their sense of colour. It was desirable therefore to define the first signs of this abstract art, which we have

inherited today, leading to musical impulses in Delacroix and Turner and the criticisms of Baudelaire.

Musical readers, alive to harmonic, orchestral and vocal colour will relish the colour criticisms of Ruskin, Baudelaire and Van Gogh. In the history of music, regrettably, we have had no writers of this stature. Impressionism, as the painters maintain, aspires to a fluid musical state realized, as we now see, in the Prelude to *Lohengrin*, the *Flying Dutchman*, the Fire Music in *Die Walküre*, in *Parsifal*, even more than in *La Mer* or the Fishermen's chorus in *Butterfly*. There is no discussion, therefore, on the specific movement of Impressionism which quickly became an umbrella term embracing works from the Renaissance onwards.

The second part opens with another aspect of Baudelaire, who was surely the Shakespeare of the great nineteenth-century upheavals. Without Baudelaire there would have been no Freud, no Debussy, no Berg and perhaps no Picasso, or at any rate not the Picasso of the Harlequin pictures. Present-day musical history is largely based on the ideal of technical analysis. This is not surprising since we live in a technological age. The humanistic approach seems to be overshadowed. Yet the discovery and the pursuit of an underlying purpose or an idea, displayed by Baudelaire and before him by Coleridge, was a root principle of the early historians. It is said that art histories are concerned either with the 'how' (the technical approach) of their subjects or with the 'why' (the humanistic approach). However this may be, a humanistic revival may still illuminate much of the past and perhaps something of the future.

Part One

Towards Baudelaire

'It is not so much in the dream state but
in a mood of ecstasy before sleep that I am
aware of a region where colours, sounds
and perfumes coalesce.'
E. T. A. HOFFMANN, *Kreisleriana*

I

Evocation and Colour

'Indistinctness is my forte'
TURNER

'It is not that musical thought is too nebulous for verbal expression; on the contrary, by its nature it is too precise', observed Mendelssohn in 1842. The composer of *Fingal's Cave* Overture, of the *Midsummer Night's Dream* music and other such evocative works establishes in these words the no-man's-land between musical and literary symbolism. Beethoven and Weber belong to the same persuasion. Thirty years later Mallarmé similarly retreated from any definition of poetic symbolism. 'Sonnets are written not with ideas but with words', he told Degas. Commenting on such fanciful interpretations as 'The Twilight' or 'The Dawn' as the subject of one of his more obscure sonnets, Mallarmé retorted that no such idea was ever in his mind. His poem sprang from the contemplation of a prosaic chest of drawers. The same order of ideas prompted Debussy, reflecting on the bassoon solo in the Second Movement of the Pastoral Symphony, to declare that at last we knew which were the animals making their way to the brook. They were cows. Obviously there is a comic element in musical symbolism. At a pictorial representation of this same Beethoven symphony (not an uncommon event in the nineteenth century) the intrusion of a hollow bassoon solo in the Scherzo of the merry-makers was quaintly impersonated not by farmyard animals but by a bigoted village pastor.

All these delightful puerilities are of course brushed aside in the great Impressionist movement that swept through the nineteenth century, leaving us, however, with certain germinating ideas that were quite naturally expressed in adjacent realms of the imaginative mind, often in a comparable fashion, and that were calculated, on this deeper level, to draw music and painting closer together.

When Mendelssohn and his friend Klingemann visited the Highlands in 1829 they set down in wonderfully vivid letters to Mendelssohn's

family their accounts of the Scottish heathlands. Musicians have seldom left us with literary descriptions of this order. 'Long before you arrive at a place you hear it talked of; the rest is heath with red or brown heather, withered fir branches and white stones between, or black moors where they shoot grouse. Now and then you find beautiful but empty parks, broad lakes, but without boats, and the roads are deserted. And over all this the brilliance of the rich sunshine which changes the heath into a thousand colours, all so divinely gay and warmly lighted; and the cloud shadows chasing hither and thither. It is no wonder that the Highlands have been called melancholy.'

Though Mendelssohn was a cherished figure of urban society, he happened also to have been a talented draughtsman and water-colourist, and his privately printed sketchbook *Reisebilder aus der Schweiz* (Basle, 1954) shows a manner similar to that of the contemporary Nazarenes, notably J. A. Koch, or even that of the Pre-Raphaelites, a rather surprising manner in fact to have been produced by the composer of the Scottish and Italian symphonies. In the desolate Scottish landscape—'no church, no street, no garden, the rooms are pitch-dark in broad daylight, children and fowls lie in the same straw, many huts are without roofs altogether, many are unfinished, with crumbling walls, or just ruins of burnt houses, and even such inhabited spots are but sparingly scattered over the country'—in this bleak landscape Mendelssohn was inspired by natural phenomena far indeed from the Pre-Raphaelite manner—by dramatic cloud effects and changing heathland colours. At Tobermory on the Isle of Mull he seems to have been overcome by the far-reaching seascape. 'In order to make you understand how extraordinarily The Hebrides affected me', he writes, 'the following came into my mind there.'* And he writes out, in its original form, the opening bars of what was eventually called *Fingal's Cave* Overture.

Not surprisingly, this early romantic seascape, part realistic but which also represents one of the first examples of musical Impressionism, went through several stages before reaching its present-day form. In the course of these transformations Mendelssohn told his sister that he wished to convey in this Hebridean Overture not so much a sense of counterpoint but the 'smell of blubber and codfish'. He was looking to the future. Not for nothing did Wagner declare *The Hebrides* to be a masterpiece of a landscape painter. It was a precursor of *The Flying*

* See Mendelssohn, *Letters* edited by G. Selden-Goth (London, 1946).

Dutchman Overture of which Mendelssohn was to hear the first performance fourteen years later.

Mendelssohn's manner of conveying impressions in *Fingal's Cave* Overture was reflected in the work of another artist of this period. By a coincidence, Mendelssohn's Isles of Fingal Overture, as it was then called, and the oil-painting *Staffa, Fingal's Cave* by Turner, one of the first works of Turner's maturity (see Plate 1), were brought before the public in the same year. This was more than a coincidence for the works have a certain aesthetic affinity. Mendelssohn and Turner had followed an almost identical itinerary in the Highlands. Turner, who visited Abbotsford in the year before Sir Walter Scott's death, is ironically referred to in Scott's *Journal* (Edinburgh, 1831) as 'the man of art'. Two years earlier Mendelssohn at Abbotsford saw the towering Scottish romantic as a reincarnation of Thor. Scott's *Journal* does not cover this period; and indeed the writer who brought the ancient history of Scotland into the heart of nineteenth-century music, inspiring, among others, Donizetti, Berlioz, Schubert and Bizet, professed to be wholly unmusical. This is not entirely true. Of the nature of romantic music he paradoxically declared: 'You feel where it is not, yet you cannot describe what it is you want.' At a concert of the London Philharmonic Society in 1832, Thomas Attwood, Mozart's favourite pupil, conducted the first performance of the overture of Mendelssohn; Turner's canvas bearing a similar title was first exhibited at the Royal Academy, London, in the same year. Scott's description of Fingal's Cave in *The Lord of the Isles* was printed in the Royal Academy catalogue as a comment on the picture of Turner, and might equally be applied to the cavernous echoes and raging tempests in the score of Mendelssohn:

> Nor of a theme less solemn tells
> That mighty surge that ebbs and swells
> And still, between each awful pause
> From the high vault an answer draws.

These are powerful lines representing a picturesque affinity. The art of Turner, on the other hand, opens up a less tangible world. Though present-day criticism would not normally associate Mendelssohn, the darling of Victorian England and admired for his stylistic elegance, with the visionary genius of Turner, looking forward to Impressionism and the abstract styles of a later period, these contemporary Hebridean works do momentarily reflect a certain equivocal manner, common to

the composer and the painter, taking the form of a certain vagueness or lack of precision deliberately cultivated for its own sake. This is illustrated in the famous reply given by Turner to the original owner of his picture *Fingal's Cave*. The dissatisfied purchaser had complained that the picture was 'indistinct'. He was referring, presumably, to the ill-defined nature of its forms and colour schemes. 'You should tell him', Turner confidently retorted, 'that indistinctness is my forte.'

This was a far-sighted statement. Most of the nineteenth-century art historians from Ruskin onwards have maintained that images are not perceived with precision either on the physical or the imaginative plane. We never see objects clearly. Hence such terms as 'blurred' or 'coalesced' used to describe effects in Turner's pictures of this period. *Fingal's Cave* is a painting in which the 'tossed-up spray of the waves tends to coalesce . . . foreshadowing the blurring of distinctions between natural forms'. It also shows a 'growing tendency towards the dissolution of the outlines separating one form from another'*— observations suggesting the beginnings not so much of an Impressionist but of an abstract aesthetic.

Strange as it may seem, similar observations were made of Mendelssohn's *Fingal's Cave* Overture at the time of its first performance. Nowadays we consider the harmonic and instrumental effects in this well-turned, elegant work to be a model of clarity. But this was not at all the impression made at its first performance. Writing of the original impression in *Mendelssohn and his Times* (London, 1963), H. E. Jacob states with much perspicacity: 'There is something indirect about Mendelssohn's use of the trumpets, something veiled about them which has nothing to do with their dynamics, with their forte or piano.' Effects were produced by 'underwater trumpets'; or the trumpets sound as if they were played 'through a curtain of water'. 'Veiled', 'underwater', 'through a curtain of water' or alternatively effects that are 'blurred' or 'coalesced'—these are terms identifiable certainly in the musical or pictorial techniques of these particular works and that indicate an approach to those unfathomable depths of the mind described by Verlaine as the region where 'l'indécis au précis se joint'.

Vagueness of this kind was assuredly not understood by Beethoven, and indeed one would not readily associate Beethoven with the birth of musical Impressionism. Nevertheless his volcanic work offers occasional signs of the new spirit that was breaking through in the Impressionist

* John Rothenstein and Martin Butlin, *Turner* (London, 1964).

sphere, notably the whole of the transition, so curiously static in effect, from the Scherzo to the Finale of the Fifth Symphony and a certain vocal effect ('über Sternen muss er wohnen') in the Finale of the Ninth Symphony anticipating the ecstatic, other-worldly aspirations of the post-Impressionist Messiaen.

Musicians are aware of the vast profusion of fashions in Beethoven criticism over the past hundred years, and they are also resigned to the present-day tendency to concentrate on his technical mastery—we live in a technical age. As for the nourishing of Beethoven's imagination by the symbolism of painting, this has been relegated to a secondary plane —an odd approach decidedly to any understanding of this all-embracing nineteenth-century figure.

Perhaps the controversies, academic for the most part, arising from Beethoven's description of the Pastoral Symphony as a work presenting 'rather an expression of feeling than of painting' have in the end restricted a broader view of Beethoven's great nature work. Pictorial elements in Beethoven are treated almost with contempt. Goethe, who greatly fertilized Beethoven's mind, could never have admitted this isolated view. In admiration of Nature's profusion the soulful Werther declares: 'I couldn't draw now, not a stroke, and yet I have never been a greater painter than at these moments.' Nor do the poetry or pictorial appeal of the Pastoral Symphony seem to have been observed by Berlioz who, as he freely admits, responded to the visual arts in limited fashion. Grandiloquently he writes, 'This amazing landscape seems to have been composed by Poussin and designed by Michelangelo'— inappropriate comparisons to be sure and in no way designed to disclose the contemplative poetry of the Pastoral. Elsewhere Berlioz calls on the spirit of the Greek and Latin Pastoral poets, Theocritus and Virgil, whose bucolic manner is similarly remote from Beethoven's ideas, and exclaims: 'Voilez-vous la face, pauvres grands poètes anciens . . . vous êtes de glorieux vaincus, mais des vaincus.'

One wonders how much harm has been done to Beethoven's cause by histrionics of this kind. The musical symbols of the Pastoral Symphony are twofold. There are those of realistic associations, such as the lightning and thunder motives in the storm scene; and there are those of atmospheric associations evident in the idyllic First Movement and the scene by the brook. Realism in musical symbolism is frequent. However, the fragmented streaks of rain characteristic of a shower are brilliantly represented, according to Maurice Griveau, by the single downward-moving notes of an F major chord. Elsewhere this

perspicacious critic introduces an illuminating symbolical interpretation. Referring to the lightning motive in the Fourth Movement, he writes:

> Why should lightning, you may ask, be recorded by an upward-moving figure? Is that not contrary to Nature? When a thunderbolt strikes or lightning pierces the clouds the streak runs downwards from above; the opposite movement is extremely rare. I will ask you in turn why this upward-moving musical figure does in fact faithfully present an image of lightning. By sheer instinct, you will observe, every composer must translate a flash of lightning in the form of an ascending figure . . . This reinforces the theory of a subjective, psychical element in the art of composition. For what impresses the mind (not the eyes) in a flash of lightning, is the abruptness of the impression . . . The first flash of lightning in a storm induces a rising of the diaphragm and of the chest, and at the same time a heightening of the features of the face. The eyelids after a flicker lift up and so do the eyebrows. The head stands erect, often the arms are raised up.*

In the Second Movement the murmur of the running water heard throughout the movement in a veiled lugubrious manner on the lower strings derives from a sketch-book representation of this theme which leads one to suppose that methods of catching sensations on the spur of the moment in the sketch-books of musicians and painters are not dissimilar. Finally, Beethoven provides an anticipation of some of the true Impressionist methods. In his analysis of the Pastoral Symphony published in 1896, that is to say when style was still discussed in terms of poetic imagery, Sir George Grove made the point that the spring-like out-of-doors feeling of the First Movement derives not from any dramatic contrast of ideas but from deliberate repetitions, almost throughout the whole movement, of versions of the opening germinating theme. This, he paradoxically declares, 'causes a monotony—which however is never monotonous—and which, though no imitation, is akin to the constant sounds of Nature—the monotony of rustling leaves and swaying trees, and running brooks and blowing wind, the call of the birds and the hum of insects'. A work of accumulated impressions, in fact, not far removed from the boldly Impressionistic works, pieced together in this same repetitive manner in the work of painters of a much later period.

Impressionism, then, in the broader sense, not merely in the sense associated with the Impressionist movement founded by Degas, Monet

* Maurice Griveau, 'Analyse de l'orage de la Symphonie Pastorale', *Rivista Musicale Italiana* (Turin, 1895).

and others in 1874, consists of a certain vagueness or lack of precision in conveying sensations; or it may consist, as in the divisionist technique of Pissarro or Seurat, of the accumulated repetition of a sensation. The repetitive manner in the First and Second Movements of the Pastoral Symphony suggests a musical anticipation of this technique. Beethoven, if we endorse Grove's interpretation, foreshadows these later Impressionist ideas.

Impressionism has many obscure manifestations, the repetitive effect, the blurred evocative effect, as we have seen, and above all the subtle, indefinable and elusive appeal of colour. One can never hope to define the infinite variety of colour theories in painting as in music. Yet the late nineteenth-century composers, among them Mahler, Debussy and Stravinsky, who were ultimately overwhelmed by the irresistible colour appeal, all look back to the inspiration of Weber. It is true that Weber, who in his youth was a painter in oils, a miniaturist and an engraver, described himself as a *Tonkünstler* as opposed to Beethoven, who preferred to be known as a *Tondichter*;* also that there are many outstanding examples of scenic painting in his operas, among them the Wolf's Glen scene and the portrait of Caspar in *Freischütz* and the Mermaid's Song in Act 2 of *Oberon*. The wonderful horn solo at the opening of the *Oberon* Overture and the dramatic tremolo writing in the *Freischütz* Overture are the first great examples of awe and wonder in orchestral colour. It is also true that Weber's orchestra in 'primary colours', so to speak, provides classic examples of instrumental timbre suggesting atmosphere or character. Nevertheless Weber's value is principally seen in his impact on later composers, particularly Wagner and Debussy. His use of timbres in his operatic works may nowadays strike us as rudimentary, yet it was precisely these rudimentary notions of instrumental colour that opened the way to the opulent instrumental orchestra of the Impressionists. Here Weber plays a part comparable to that in painting of Delacroix, who similarly stands at the head of the Impressionist movement.

More than this, Weber was one of the principal artists to establish the theory of the *Correspondances* or the *art intégral*, an ideal which originated in Germany and was later developed in France. No wonder that with E. T. A. Hoffmann he was so greatly admired by Baudelaire.

* The use of the alien term *Komponist* in German dates from the sixteenth century, yet *Komposition* is also a term of painting used in the eighteenth century. In English and French the term 'composition' is used of both music and painting. One is also a 'composer' of verse.

Poets were dramatists, painters were moralists and composers were
associated with the symbolical worlds of poetry, painting and philo-
sophy. A curious work illustrating this spirit at the beginning of the
nineteenth century was *Die Ruinen am Rhein,* edited by Nicolas Vogt.*
Portraying the struggle between paganism and Christianity, this
theatrical chronicle, half-spectacle, half-pageant, draws upon the legends
of Don Juan and Faust. Pictures of Raphael, Guercino and Teniers are
seen on the stage and the music heard includes Mozart's *Requiem, Il
Seraglio* and *Don Giovanni.* The work closes with a performance of
Haydn's *Creation.*

Though eclipsed by the composers who drew from him their con-
ceptions of colour and character, Weber's influence was greater than his
work. He was able, for instance, to convey the psychological character
of one of his heroines by the contrasting timbres of the oboe and the
cello. He was able to create the character of certain wind instruments,
such as the clarinet in *Freischütz* which Berlioz was never able to forget
('l'écho de l'écho, le son crépusculaire'). His terrifying tremolo on the
strings in *Freischütz* marks the introduction in music of the romantic
sense of horror. Elsewhere he perceives the melancholy nature of the
unaccompanied flute and was the first to produce from the cavernous
sound of the bassoon a sense of mystery. The three opening notes on the
horn in *Oberon* carry us to the beyond. In all these effects Weber uses
the orchestral equivalent of primary colours. The flecked or dappled
orchestration of the *Fire Music, Till Eulenspiegel* or *La Mer* was of
course a much later development. But it is obvious that the Impression-
ist orchestra is based on the orchestra of Weber in exactly the same way
as the Impressionist palette derives from the colour schemes of Dela-
croix: the rational and irrational nature of colour was taken a stage
further.

In his *Tonkünstlerleben* Weber states that the impression he receives of
a mountain or a tree is able immediately to suggest in his mind a
musical form, a sonata or a pastorale. This is obviously not to be taken
too literally. Weber was indulging in the typical literary fantasies of his
time. Nevertheless, there was an element of truth in these fantasies.
Elsewhere (in the *Gespräche mit Weber,* published by Hans Dünnebeil)
Weber states that he was seeking certain combinations of timbre that
should correspond to the colour effects used by painters to convey the

* This rarely found work was published by J. E. B. Mohr at Frankfurt-am-Main in
1809. It consists of two plays, *Die Brüder* and *Faust* (also referred to as *Der Färberhof oder
die Buchdruckerei in Maynz*).

light transitions between dawn, morning, afternoon and evening. It would seem that Weber was looking forward to the scientific techniques of Claude Monet: haystacks and cathedrals do present these changing light schemes in Monet's well-known series. In fact the series of pictures by Philipp Otto Runge entitled *Tageszeiten* which inspired Weber's comparison are not concerned with the play of light upon form but with contrasts of symbolical conceptions illustrated by angels, arabesques and foliage.

All these evocative or pictorial associations of Weber's instrumental music were remarkably defined by Debussy in his analysis of Weber's technique given in conversation to his friend Robert Godet in 1902 after the dress rehearsal of *Pelléas et Mélisande*.★ This remarkable survey of Weber's work goes beyond the analytical framework. Though the reader may not wish to refer to specific passages mentioned by Debussy in the works of Weber,† he will surely be aware of methods common to composers and painters. His observation, for instance, that 'tone colours superimposed without mingling . . . enhance rather than abolish their individuality' would be immediately intelligible to Gauguin or Van Gogh, colourists who were principally concerned with contrast. Debussy provides a curious surrealist image and proceeds to follow the inner workings of Weber's mind.

> Supposing a visitor from Mars were to come this evening to pay us a musical call—all the stars having fallen, as you know.‡ I willingly leave to you the controversial subjects: theory of sound, scales, chords, form, the whole group. But let us take note of the word 'timbre' which just escaped me. I would take charge of the chapter 'orchestra' and it would hardly give me any trouble: Weber alone would undertake the whole. Barring one or two postscripts, his work is the best of instrumental treatises. What is a clarinet? I would not know how to instruct the Martian better than by referring him to Agatha to learn the virginity, not of that young girl, but of the instrument which would reveal to him in the *Konzertstück* one of the most beautiful secrets of its deep register. The flute? There I should be embarrassed in my choice, but there is a duo which would reveal to the Martian one of its latest possibilities,—notwithstanding the period,—the thirds accompanying

★ Robert Godet, 'Weber and Debussy', in *The Chesterian* (London, June 1926).

† These are indicated in my *Debussy: His Life and Mind*, Vol. 2, p. 64, containing also an abridged version of Debussy's analysis. Robert Godet and Georges Jean-Aubry were united in their friendship for Debussy and presumably Godet wrote his study on Debussy and Weber for *The Chesterian*, edited by Jean-Aubry, in English. The emendations to his text which I made in my work on Debussy have here been revised.

‡ The reference is to the line of *Pelléas*, Act 2, Scene iii, 'Oh, oh! Toutes les étoiles tombent.'

the 'casting of the bullets' or those not less nocturnal but so different in
shade, which are introduced in the adorable air of the said Agatha in the
second act of *Freischütz*; and in this same act he would hear in the 'hunting
scene' the piccolos which have lost nothing of their fierceness. He would
hear in addition, a quartet of horns which remains a model of wildness,
whilst that of the overture has not been surpassed for sylvan charm and
bird-like sweetness. As foreshadowing our modern brass, I could find
nothing better, off-hand, than the song of the trumpet to the sunrise in
Oberon, and those breathless exclamations of the trombones in the overture
of *Freischütz*. Now if the Martian had not had enough of the wind instru-
ments, well! we would have to abandon all hope of going to bed early. . . .
Who has made better use of the strings than Weber, of associating them,
contrasting them, choosing amongst them the most expressive, entrusting
an E string with a cantilena, making the most of the bowing, varying the
attack and the style of the tremolo? He has resplendency, he has delicacy,
and I think he is without a rival in the art of subduing—that is to say, notably
in the use of the mutes: think of those with which he tempers the violins in
the prelude of *Oberon* in order better to illuminate the answer of the violas
and cellos; think of the ethereality of the different violins in the air already
mentioned of Agatha, and in the octet of *Euryanthe* so mysteriously darkened
for the appearance of the ghost. . . . It is not sufficient to say that the instru-
mental resources are familiar to him to a rare degree: it would be necessary
to say that he scrutinizes the soul of each instrument and exposes it with a
gentle hand. This being so, the instruments yield more than he appears to
demand of them. Also, the most daring combinations of his orchestra, when
he makes himself most deliberately symphonic, have in particular the tone
colour preserved in its original quality: such as colours superimposed without
mingling their mutual reactions and which enhance rather than abolish their
individuality. A predilection for the voluminous, if not corrected by aversion
to neutral tone, is fatal. Weber, when he gathers together his forces, knows
well how to be formidable, but as a colourist, he has too great a sense of
values and as a musician too much taste, for quantity ever to matter more
with him than quality. Only one example more, of the woodwind, not the
strings, a quite minute example but a very delectable one, and then good-
night, (already the Martian has vanished). Re-read the four or five introduc-
tory bars to Max's air in G, after the waltz in *Freischütz*, and listen intently
for the hammering of the clarinet which insinuates itself into the frail
sonorous edifice between the tone colours of the flutes which crown it and
the tones of the oboe which support it. Then you will tell me what you think
of it . . . but not on the evening of a dress rehearsal!

The vast influence of Weber's sense of orchestral colour extending to
Stravinsky was absorbed not only by Debussy and his contemporaries
but before him by Wagner, whose essay on the *Freischütz* Overture set

the standard for an understanding of Weber's orchestral ideas, and by Baudelaire who was among the first of the followers of Weber in France. It is at this point that the colour principles of Weber are reflected, through Baudelaire's poetic interpretations, in the colour principles of Delacroix. We must reserve an investigation of this theory of the *Correspondances* for later chapters. In the meantime, however, Debussy himself, an artist born from this theory of the *Correspondances*, eventually saw Weber through the eyes of Baudelaire. Not only does his literary fantasy of Weber in *M. Croche* imitate a certain manner of Baudelaire;* it is designed to bring Weber into the poet's newly discovered dream worlds where poetry, painting and music find themselves merged or equated.

* Weber in London consists, according to Debussy, of 'un corps usé par une lumière aiguë, le front au rayonnement spécial à ceux derrière lesquels il s'est passé de belles choses.' See A. Schaeffner, 'Impressionismo' in *La Musica*, Vol. II (Turin, 1968).

2

Berlioz and John Martin

'What I want to see are the birth of new
peoples and towns that have sprung up out
of the earth'
BERLIOZ

With his remarkable sense of artistic affinities, Kenneth Clark in *The Gothic Revival* was able to see the spirit of the legendary neo-Gothic masterpiece Fonthill Abbey reflected in the music of Berlioz. Berlioz thus becomes the principal composer of the movement that produced not only Beckford's Fonthill Abbey, with its huge tower dramatically piercing storm-laden clouds—that is the phantasmagoric conception conveyed in the engraving by John Martin—but, among existing landmarks, the neo-Gothic monuments of St Pancras Station in London or the panorama of the Houses of Parliament. Such more commonplace architectural evocations are not meant to detract from the stature of Berlioz but to indicate certain neglected aspects of his many-sided achievement. It is not difficult to discover in the critical writings and correspondence of Berlioz proof of Lord Clark's theory of these neo-Gothic elements or at any rate clear evidence of an idealistic kinship.

Let us first of all look at Berlioz's work in a wide framework. No great effort is needed to bring the work of Berlioz to the frontiers of the visual arts. In his tale *La Fanfarlo* Baudelaire states: 'Ceux-là seuls peuvent me comprendre à qui la musique donne des idées de peinture', obviously a motto for the entire Berliozian gallery. Wild landscapes, desperate love-scenes and opium dreams nourished the imagination of this commanding figure. He was greatly attracted to processions, the winding procession of priests in the 'March of the Pilgrims' from *Harold in Italy*, the monotonous tramping of soldiers in the 'March of Night' from the *Childhood of Christ* and, though not exactly a procession, the diabolical 'Ride to Hell' from the *Damnation of Faust* reminiscent of the Faust lithographs of Delacroix. Apart from the closing pages of the

'Scene in the Fields' in the Fantastic Symphony and the septet in *The Trojans*, Berlioz was not given to static effects or to scenes of reverie. He overwhelms us, on the other hand, with a sense of tempestuous movement, as in the frantic saltarello of the *Roman Carnival* Overture. Elsewhere, in the Amen fugue from the *Damnation of Faust*, Berlioz introduces a grim sardonic manner reflecting, as some believe, the spirit of Daumier; or he unaccountably develops the lightness and dappled texture of an Impressionist orchestra, as in the 'Queen Mab' Scherzo, a counterpart, surely, of the aerial *Queen Mab's Cave* by Turner in the Tate Gallery.

The musical panorama of Berlioz was thus inspired in the traditional French manner by a variety of visual associations. Two scholars, Jean Seznec and Léon Guichard★ have recently shown the origin of some of the more extravagant elements in Berlioz's imagination which, they maintain, reflect the ideas of the English painter John Martin. Before assessing their research, however, I think it desirable to consider certain extravagant features of this kind in Berlioz's own nature, his biographers having often left the man curiously estranged from his work. Perhaps this is due to a certain play-acting element in Berlioz's character and to his compulsion, common to men of genius, to create out of his life a legend. Such artists, unlike their biographers, see themselves with surprising clarity. There is a merciless analysis of this mechanism in the character of Samuel Cramer, Baudelaire's self-portrait in *La Fanfarlo*:

> A gentleman by birth, taking on the airs of a scoundrel—by temperament he was an actor—he played behind closed doors unbelievable tragedies, or rather tragi-comedies. If possessed by a gentle spirit of mirth, he must nevertheless clearly establish this fact and proceed to train himself to explode in peals of laughter. A moist eye might reflect an awakened memory, whereupon he would watch himself in the mirror pouring forth floods of tears. Responding to the childish jealousy of a girl scratching him with a needle or a penknife, Samuel must glorify this episode by stabbing himself; or if he owed the wretched sum of twenty thousand francs, he would joyously proclaim 'What a sad lot is that of a genius plagued by the debt of a million francs!'

Where have we read scenes of this kind before? Again and again, of course, in Berlioz's irresistible *Memoirs*, in the pointless quarrel with

★ Jean Seznec, *John Martin en France* (London, 1964). Léon Guichard, 'Berlioz et Heine', *La Revue de Littérature Comparée* (January–March 1967).

Habaneck, for instance, conductor of the Requiem, or the suicidal despair when encouraged to develop his excellent literary gifts. These cults of pleasure and adventure were shared with Baudelaire, also an indulgence in unfathomable boredom, our old friend the romantic *ennui*. Baudelaire's ideals were the vices of poison, rape and arson. Berlioz, a fraternal diabolist, proclaims himself 'an Attila ravaging the musical world, a revolutionary to be guillotined'. Disillusionment ultimately engulfs their worlds in a vast yawn, and the famous sardonic line that Baudelaire implants in the mind of the reader of the *Fleurs du Mal* may similarly light up the enigmatic genius of Berlioz himself:* 'Hypocrite lecteur,—mon semblable,—mon frère!'

Amazingly, Berlioz seems never to have cared for the paintings of his contemporaries. 'Instrumentation is, in music, the exact equivalent of colour in painting', he declares in *A Travers Chants*. Yet this supreme colourist among the early romantic figures never refers to the many elusive colour problems that preoccupied painters and composers— the theories of Goethe, for instance, which had greatly influenced Turner or even the colour principles of Delacroix which look forward to Impressionism. It is true that Berlioz was inspired by the instrumental ideas of colour in Gluck and Weber and that Berlioz's *Treatise on Instrumentation*, revised by Richard Strauss in 1908, allows us to follow the evolution of instrumental colour throughout the nineteenth century.† But it is curious that the correspondence and memoirs of Berlioz, remarkably well documented as they are, ignore these contemporary discussions on colour. He never seems to have entered a museum or an art gallery. We have no evidence that he even visited the Louvre or the art galleries in London or Munich. In Paris he certainly did not frequent the Salons. Though he was a composer inspired by Nature there is no mention in his writings of Constable, for instance, who enjoyed an immense reputation in France and whose influence on Delacroix at the time of the exhibition of his *Hay Wain* at the Paris Salon in 1824 was decisive.

Moreover, when Berlioz mentions Delacroix, among the greatest of his contemporaries, it is not in reference to the character or style of his painting but to suggest that Harriet Smithson, his wife, appears to have been Delacroix's model. Ingres appears in an even stranger guise. He is

* Berlioz had in fact outlined this penetrating analysis in a letter to his father of 19 February 1830: 'L'habitude que j'ai prise de m'observer ne m'échappe et la reflexion la rend double, je me vois dans un miroir.'

† See Appendix A, 'The Berlioz–Strauss Treatise on Instrumentation.'

mentioned in the context of a discussion on Rossini. Raphael receives only a passing acknowledgement while Poussin's classical landscapes, as we have seen, are inappropriately compared to the early romantic landscapes evoked in Beethoven's Pastoral Symphony. One has the impression that all these painters were mere names for Berlioz. It is true that Berlioz believed that 'music is the sum of all the other arts', yet Michelangelo's *Last Judgement* produced 'a feeling of acute disappointment', prompting him to confess, 'I know nothing about painting.'

On one occasion only, recalling his impressions of the Charity Children at St Paul's Cathedral in London, Berlioz gives us a detailed description of the work of a contemporary artist. This was the engraving of John Martin, *Satan presiding at the Infernal Council* (see Plate 2), the sight of which was revived by Berlioz in his *Soirées de l'orchestre* in the form of an hallucination or even a nightmare. Martin's engraving was an illustration for Milton's *Paradise Lost*. Berlioz's dramatic account, to be presented on page 28, surely leads a way into the secrets of his inspiration. One perceives, perhaps for the first time, the sources of certain diabolical and grandiose elements in Berlioz's musical imagination and we may therefore dwell for a moment on the significance of Martin for a whole generation of artists, particularly in France, and the reflection of this vogue in the formation of Berlioz's musical mind.

In the first half of the nineteenth century the English artist best known in French literary circles, as opposed to the world of painting, was not Turner or Constable but John Martin (1789–1854). This illustrator of Milton and the Bible, who was Berlioz's almost exact contemporary, was an artist in a class by himself. Indulging in grandiose architectural or scenic panoramas and catastrophic visions designed, in the traditional manner of cataclysmic prophets, to make one's flesh creep, Martin, as in his engraving *The Flood* (see Plate 3), can hardly be said to derive from any style hitherto cultivated in painting. He was an isolated figure rather in the manner of Berlioz himself. Yet he looks forward to Gustave Doré and the later developments of the present day. Martin's world was revived in the twentieth century, according to M. Seznec, in the work of an early school of film producers: 'We know that Hollywood has a way of its own of using biblical curses. We have seen the pillars of the temple collapsing on the Philistines and Pharaoh's armies submerged by the waves. The sluice gates of heaven have been opened and thunder clouds are set aflame by lightning. Effective cinema methods allow swarms of people to move about against the Hollywood

architectural background. One is not unfair to Martin in noting this twentieth-century development. A precursor of Cecil B. de Mille, he is also the heir of Milton, a degenerate heir, but who nevertheless lived in the shadow of greatness and who was able to keep alive a reflection of genius.'

It may seem absurd to associate the composer whose mind was fertilized by Virgil, Shakespeare, Goethe and Byron with spectacular visions of this seemingly meretricious order. Yet, as we learn from M. Seznec's study, Martin was a kind of Beckford for the French artists of his time and his floods, storms and scenes of terror created an imaginary Fonthill Abbey, disturbing and indeed overwhelming their more modest critical standards. Hugo, Sainte-Beuve, Gautier and Michelet were among his admirers and he also influenced the fantastic descriptions of Gérard de Nerval. Berlioz clearly belongs to this dream world. 'It is not that I wish to imitate Byron', he writes to his sister, 'that would be pitiful; what I want to see is America, the islands of the Southern seas, the great scenes of catastrophe in Nature, the birth of new peoples and towns that have sprung up out of the earth.' There speaks the typical Martin disciple.

Addicted to a family weakness for pamphlets and autobiography, Martin was something more than a painter, engraver and amateur writer. He produced some excellent plans for a purer London water supply, for improved coastal lights as well as methods for preventing coal-mine explosions. Martin's work is often garish—'Martin's panto-mime', said Constable—but what amazes us today is his capacity for surrealist evocation. Sometimes his empty distances and long colon-nades foreshadow Chirico. In his immediate empire he suggests the imaginative worlds of Doré and also of Blake and Fuseli.

In 1830 Martin dedicated his *Fall of Nineveh* to Charles X, unfortu-nately as it turned out, since this was the year which also marked the fall of the Bourbons. Thereafter Martin's reputation bridged the literary and social worlds. He was favoured by Louis Philippe and also by Louis Napoléon, who expressed the desire that Martin be elected to the French Institute. In the meantime his oriental and catastrophic visions were acclaimed by Théophile Gautier and Alfred de Vigny. Martinn, Martynn or Martyns—the spelling of the artist's name was frequently gallicized, suggesting a desire to incorporate his work within the nation-al tradition. But he remains an exotic. 'Babylonian' seemed to be the favourite epithet used by French critics of Martin's work. This was also the term used of Satan's abode in *Paradise Lost*, and it was the term used

by Berlioz himself to describe the monumental character of his later sacred works.

Together with these surrealist or primitive associations contemporary critics observed a reflection of Martin's style in the architecture of John Nash. Martin himself was an architect and it is clear from the evidence of certain megalomaniac figures among contemporary colleagues that Martin's spirit prevailed in Nash's Regency buildings originally extending from Regent's Park to Piccadilly. According to Gérard de Nerval the name given by Londoners to this monumental Regency style was 'Babylonian'. Architectural evocations of this kind may be discovered in Berlioz's correspondence. 'I should die of boredom in this Babylon', he writes from London in 1847. In 1855 the 'Tibi omnes' and the 'Judex' from the *Te Deum* 'are pieces in a Babylonian, Ninevite manner'. In his *Treatise on Instrumentation* much attention is paid to concert hall architecture and to problems of reverberation. His mammoth orchestra presents the impression of a Martinian cataclysm:

> In the thousand instrumental combinations offered by the orchestra may be found a richness and a variety of harmony and colour together with a wealth of contrasts unequalled in any form of artistic expression. . . . In repose the orchestra suggests the slumber of the ocean; in a state of agitation it recalls a tropical tempest. The orchestra sometimes explodes and it is then a volcano. Buried in the depths of the orchestra are the murmurs and the mysterious sounds of the primeval forest. At other times one hears the passionate outbursts of people rejoicing in triumph or overcome by grief. Silence inspires fear, and the most rebellious of men will shudder at the overpowering crescendo of the orchestra roaring ever more fiercely and devouring everything in an all-embracing fire.

To see the music of Berlioz reflected in Beckford's Fonthill Abbey or the 'Babylonian' nature of John Nash's Regency architecture may require a stretch of the imagination by people today. But I think we may be helped in this direction by the shrewd but affectionate caricatures of Berlioz in the correspondence of Heine. Diabolical elements in Berlioz's work were constantly sought out by this master ironist, notably in the 'Witches Sabbath' from the *Fantastic Symphony*: 'The mass is said by the Devil and sacred music is parodied in a spirit of outrageous clownery. This is a farce in which all the vipers buried in our hearts rise up in some kind of joyful hissing.'[*] This grotesque

[*] 'Lettres confidentielles' in *La Gazette Musicale* (21 January and 4 February 1838). Quoted in 'Berlioz and Heine' by Léon Guichard, *op. cit.* p. 10.

approach, unjustified today, was nevertheless in keeping with Heine's comparison of Berlioz and John Martin. 'Honour to whom honour is due', he proclaims in his letter to the *Gazette d'Augsburg* of 25 April 1844.

We shall begin today with Berlioz whose first concert served to inaugurate the musical season.★ Works not exactly new brought a fair reward of praise and even ordinary apathetic people were carried away by an overpowering genius revealed in every creation of this great master. One is aware of a beating of the wings in this music which is not that of an ordinary singing bird; Berlioz is a colossal nightingale, a skylark of the size of an eagle such as existed in a primitive antediluvian world and which recalls creatures now extinct, mammoths for instance. His music will also evoke the gruesome scenes of violence in ancient civilizations and other such harrowing visions. His magical moments bring before us Babylon, the hanging gardens of Semiramide, the marvels of Nineveh, the bold architecture of Mizraim such as we see in the pictures of the Englishman Martin. Indeed if one looks for an analogy in painting there is in fact a precise resemblance, an elective affinity between Berlioz and the eccentric Englishman; the same bold conception of all that is stupendous and excessive and the same conceptions of infinity [*l'immensité matérielle*]. In the one, striking effects of light and shade, in the other, a fiery sense of orchestration. A poor sense of melody on the one hand, a poor sense of colour on the other. In both an occasional absence of beauty and no feeling at all for simplicity. The works are neither old-fashioned nor romantic; they recall neither pagan Greece nor the Catholic Middle Ages. In fact they plunge back to a more remote age, to the architectural period in the Assyrian, Babylonian and Egyptian styles, to those poems in stone inspired by the great drama of human passion, by the eternal mystery of the world.

Berlioz saw this article not in 1844 but ten years later at the time of the production of the *Childhood of Christ* in 1854. In his *Memoirs* Berlioz comments:

Three weeks after the book [i.e. *Lutèce* reprinting the article on Berlioz and Martin] was published the first performance of *L'Enfance du Christ* took place. Next day I received a letter from Heine in which he apologized profusely for having misjudged me. 'I hear from everyone', he wrote from his sick bed, 'that you have plucked a nosegay of the most exquisite blooms of melody, and that altogether your Oratorio is a masterpiece of simplicity. I can never forgive myself for having been so unfair to a friend.' As he began to accuse himself I said: 'But why do you behave like a commonplace

★ The 'Sanctus' from the *Requiem* and the *Roman Carnival* Overture were the works of Berlioz heard at this time.

critic and express a categorical opinion on an artist whose entire work is by no means known to you? You are always thinking of the 'Witches Sabbath' from my *Symphonie Fantastique* and the 'Dies Irae' and 'Lacrymosa' from my *Requiem*. I believe, however, that I have done and am able to do things of quite another character.' ★

One can hardly imagine that the *Fantastic Symphony* and the *Requiem* were works that were in any way untypical of Berlioz. On the contrary, they represented to Berlioz himself, as they do to us today, the true nature of his genius. That this essential aspect of his work was reflected in the works of Martin was not only the opinion of Heine; it was the opinion of Berlioz himself.† In 1851 Berlioz was sent by the French Government to London to serve as a member of the World Exhibition Jury. At St Paul's Cathedral at the annual service of the Charity Schoolchildren he heard a service sung by a choir of 6500 children. Not only was he impressed by the vast space of Wren's cathedral, 'the greatest in the world after St Peter's in Rome', the size of which was 'not to be compared with Notre Dame', but, alive to every kind of visual stimulus, he was overwhelmed by the sight of the mass of children converging on the centre of the cathedral from the perimeter. The following night, in what was certainly a revealing hallucination, if it was not actually a nightmare, he presents this whole ceremony in

★ An affinity with Turner may be perceived in Berlioz as noted on p. 21. Henri Lavoix in his *Histoire de l'Orchestration* (1878) was the first to observe the birth of the Pre-Raphaelite spirit in music in the *Childhood of Christ* (1854), six years after the foundation of the Pre-Raphaelite brotherhood. This later development of Berlioz is seen in his slender, picturesque orchestration and his undulating melodic lines.

† Closely united to Heine—both were atheists and followers of Voltaire—Berlioz published his final opinion of Heine's musical ideas in the *Journal des Débats* on 19 October 1855, a few months before Heine's death:

Heine when speaking about music does not offer us more nonsense, in fact very much less nonsense, than the majority of poets. He has obviously a feeling for the grandeur of music though perhaps not for its subtleties; he sees the qualities required for the establishment of a musical style. Molehills are not mistaken for Alpine ranges, nor do we find him kneeling before the little popular manufactured idols. He adores the whole of Mozart though he admits, unfortunate poet, that there are works of Beethoven that are beyond him. Though he published a caricature of Spontini he believes in the beauty of his big dramatic works. He has a shrewd understanding of the value of certain works of Mendelssohn and Stephen Heller and also of the talents of many virtuosi [. . .]. I am greatly indebted to him for having transformed an acquaintance of mine [i.e. Berlioz himself] into a sort of Cyclops deprived, almost by the nature of things, of human feelings whilst forgetting that Polyphemus was wildly in love with Galatea. However, when he takes it upon himself to tell us—oh, thrice-anointed poet! You see what I am getting at—I could easily be off in an utterly different direction. Let me finally recall the parting words of the conspirators of the Marais [the old aristocratic third arrondissement]: 'Discretion, silence, wait and see!'

terms of Martin's picture (known to us in the form of an engraving), *Satan presiding at the Infernal Council.*

The picture illustrates the closing lines of Book I of Milton's *Paradise Lost* and the opening of Book II where the devils build a Pandemonium for Satan's headquarters. Satan thereupon considers his policy in the war against God:

> Satan exalted sat, by merit rais'd
> To that bad eminence . . .

A colossal sphere arises from the centre of a circus of limitless proportions from the highest point of which the Satanic Emperor commands his myriad peoples.* In the *Soirées de l'Orchestre* we read:

> When I returned to Chelsea . . . I had hoped to sleep; but nights following days such as this are not intended for sleep. Ceaselessly going round in my head were the harmonious storms of *All people that on earth do dwell* [to the music of Berlioz's compatriot Goudimel]. I saw St Paul's Cathedral whirling around and I was once again within. By some strange transformation the Church was changed into the abode of Satan. The setting was that of the celebrated picture of Martin. Instead of the Archbishop on his throne Satan was enthroned. Instead of the thousands of the faithful and the children grouped around him, hosts of demons and souls in torment shot forth their fiery glances from the depths of the visible darkness, and the whole iron structure of the amphitheatre on which these millions were seated vibrated in a terrifying manner, filling the air with hideous harmonies.

There we have it—Berlioz himself shows us the connection between his mammoth-sized works and the vast romantic panoramas (or cosmoramas or nausoramas) prompted by Martin.† Fonthill Abbey, the

* In *La Peinture au 19ᵉ siècle* (Paris, 1927) Henri Focillon suggests a connection between Martin's picture and the fantasy visions of Edgar Allan Poe:

Aloft on an enormous sphere placed in the centre of a circus the extent of which cannot be embraced by the human sight and beneath flaming lustres lost in the depths of a nocturnal infinity, the Emperor of the demons presides over his myriad peoples. . . . This marvellous sight is animated by a dizzy sense of logic, in the manner of the terrors of Edgar Allan Poe.

† In his introduction to the John Martin Exhibition held in Newcastle upon Tyne in 1970, William A. Feaver writes:

The most crushing criticism to level at Martin was to the effect that his work belonged among the phantasmagoric shows so popular in his age. Only Mme Tussaud's with its modern planetarium exists today as a reminder of these devices: *Cosmoramas, Europe-amas, Typoramas, Dioramas, Panoramas, Nausoramas*, which ranged from peepshows carried on the back to revolving auditoria providing a full repertoire of breakneck journeys from Niagara to the Hellespont, trips down volcanoes, battles at sea (Turner

'Babylonian' architecture of John Nash and the Milton illustrations of Martin—all belong to the same family of stupendous, overheated conceptions—opium-inspired as Alethea Hayter in her book *Opium and the Romantic Imagination* (London, 1968) suggests, even though these wild conceptions of the age had been assimilated by both addicts and non-addicts of the opium drug.

Finally we must include one more illustration in this Berliozian gallery, an unexpected illustration, were it not for a coincidence of dates—the Eiffel Tower. In his collection of art criticisms *Certains*, published in 1889, Huysmans scathingly condemns this highest man-made steel structure as puny and slender. 'What can we say', he said, 'of this demijohn encased in painted straw, its campanile deadened by a cork with a dropping-tube by comparison with the powerful constructions of Piranesi or even the monuments invented by the Englishman Martin?' Martin might well have conceived something more stupendous than the Eiffel Tower. And indeed if we look further into this assessment, Huysmans' irony was directed against this towering landmark not merely on architectural grounds. The Eiffel Tower was erected to commemorate the centenary of the French Revolution. The breakthrough of Martin and Berlioz, representing a similar revolutionary break-through in the spiritual mind, was likewise receding into history.

Or was it not merely the illusion of a break-through? Martin inflamed the literary minds of the romantic movement and his reputation diminished with the eclipse of this many-sided movement. Sometimes the French claims made for Martin were matched by the extravagances of English critics. Bulwer Lytton claimed that Martin was 'the greatest, the most lofty, the most permanent, the most original genius of his age'. His fame was meteor-like, as we have seen. William Feaver tells us that in 1855 three of Martin's masterpieces were valued at 8000 guineas. In 1935 these same works 'were knocked down for the price of old lino; one was turned into a fire-screen'. The reputation of Berlioz has not rocketed to this extent, but among the composers of his time he remains to this day, along with the creations of Beckford and Nash, the historic Eiffel Tower immeasurably elevated over the romantic scene.

designed the Battle of the Nile for the *Naumachia* in 1799), and ghostly visitations. They all exploited light and movement, attempting by using darkened halls and sound effects to hustle the audience into a state of rapturous shock.

3

Abstraction and Mathematics

'Music is the arithmetic of sounds as optics
is the geometry of light.'
DEBUSSY

The visual or evocative associations in the works of early romantic
composers were not an isolated manifestation. They were part of an
all-embracing scheme in which, according to some strange law evident
at certain periods in artistic evolution, there was a constant interchange
or cross-fertilization of values. Berlioz, when his works were beginning
to be seen in perspective, was said to be 'not a musician at all—he uses
the methods of painting'—a deliberate overstatement, of course, which
nevertheless illustrates this particular point. Also, there were certainly
painters, nearer our own time, whose methods were almost entirely
drawn from musical procedures. These developments need not con-
cern us for the moment; they merely indicate the wider modern terri-
tories to be explored. The contemporaries of Mendelssohn, Weber and
Berlioz were painters who clearly aspired to a musical ideal. These
figures were principally Delacroix and Turner—Delacroix who in his
representational works cultivated what he called 'the music of the
picture', that is to say a realistic scene which, upon reflection, recedes
into an underlying, almost indefinable mood; and Turner, the painter
of fire, water, light and air, the elemental painter, in fact, whose work
was a counterpart of the great musical evocations of Wagner.

How did this particular cross-fertilization arise? What prompted this
rapprochement? What caused this widening of the artistic horizon,
this invading of adjacent territories of the imaginative mind? This is a
phenomenon reaching back to remote periods. Sir Anthony Blunt, the
authority on Nicolas Poussin, established that certain landscapes and
mythological scenes in the work of this classical artist of the seventeenth
century had been inspired by the particular character of the Renaissance

modes, that is to say by the sequence of notes in a scale upon which modal music was based and which ultimately led to the major and minor modes of the diatonic system. 'I hope by the end of the year', Poussin wrote in 1647, 'to have painted a subject in the Phrygian mode, that is to say a mode which is violent and furious, very severe, and calculated to produce amazement.'* The severe, tragic or exuberant character believed to be associated with one mode or another determined, according to this theory, the style or nature of certain of Poussin's compositions. 'The whole space formed by the architecture', writes Anthony Blunt, 'is filled with a mass of struggling groups brought into harmony by a careful balancing of movements.' (See Plate 4.) 'The idea of applying the principle of the modes to painting is highly original because, according to the earlier writers on the arts, the means of conveying a mood by an emotion had been by gesture, whereas Poussin maintains that it can be done by the actual style of the painting, that is to say *by almost abstract means* [my italics]. Delacroix was to put forward much the same idea in the nineteenth century and since that time it has become a commonplace.'†

Obviously this theory has a distinct bearing on the interaction of musical and pictorial problems throughout the nineteenth century. There are many works of a nebulous character in nineteenth-century painting, notably the works of Delacroix and Turner, and it was this 'musical' idea to which Poussin likewise aspired. Art historians have sometimes questioned the degree to which, despite Sir Anthony Blunt's evidence, Poussin consciously reproduced the character of the modes in his painting. But I do not think there can be any doubt about the validity of this claim. The character and the methods of Poussin's works may not be immediately recognizable as counterparts of one musical mode or another, but, as we shall see from Poussin's correspondence referred to in Appendix B, many of his works were certainly inspired by a musical ideal. Other problems arising from Sir Anthony Blunt's research include the interpretations, rational and irrational, of the theory of numbers in music—the rational theories of mathematics and the irrational theories of numerology. These we shall return to in a moment, dealt with by Bertrand Russell and Freud; also to the fact that the nature of the musical modes themselves, as they were evaluated by contemporary Renaissance composers, never seems to have been

* See Appendix B, 'Poussin and the Modes.'

† Anthony Blunt, *Nicolas Poussin* (2 vols.). The A. W. Mellon Lectures in the Fine Arts, London, 1967.

taken into account by the art historians who have assessed this problem. Art and musical historians have failed to join forces on this issue. In the meantime, however, I think we may perceive Poussin's ideas more clearly in the light of Sir Anthony Blunt's conclusions illustrating the use of modal technique in Poussin's landscapes and mythological scenes.

'No artist before Poussin', he writes, 'seems to have applied the idea of the modes to painting with the same remarkable results.' We must pause for a moment here to consider certain works of Poussin illustrating this theory. Admirable reproductions of these works will be found in Anthony Blunt's work on Poussin.* Blunt introduces the subject by suggesting that 'the jagged movements of the figures in the two versions of *Moses Trampling on Pharaoh's Crown* convey the right sense of alarm, while the motionless calm and emphatic horizontals and verticals give grandeur to *The Holy Family on the Steps*. Colour also plays an important part, and the Dublin *Lamentation* [see Plate 5] owes much of its drama to its almost strident harmonies, whereas the tones of the Louvre *Rebecca* are all sweetness.' *The Rape of the Sabine Women* in the Louvre presents 'the most elaborate example of displaying emotion by gesture' (see Plate 4). Elsewhere in the same volume more precise indications are given:

> It is in his landscapes that Poussin gives most evidence of his doctrine of the Modes. *The Ashes of Phocion* can properly be called Dorian. The story which it enshrines is grave and severe, and the treatment corresponds exactly to these categories. The same can be said of the pair to it, which shows Phocion's body being carried out of Athens after his execution. The colours are less sombre but the atmosphere is as severe and the structure as rigid as in the other painting. The *Pyramus and Thisbe* is in a different Mode, perhaps Lydian; it is tragic rather than heroic, and the mood is of greater violence. A softer Mode, perhaps the Hypolydian, is used in the *Orpheus and Eurydice*, one of Poussin's calmest and most harmonious landscapes, which sets forth in visible terms the sweetness of Orpheus's music. The titles of the *Storm* and the *Calm* [presumably the landscape with travellers resting] define their moods, though it would not be easy to assign them to a specific Mode. Finally, there are the two paintings which embody an almost philosophical theme, the *St Francis* and the *Diogenes* in which the mood is not merely calm, but contemplative.

'Dorian, Lydian, Hypolydian'—the technical terms associated with the Renaissance modes conveyed in the paintings of Poussin 'by almost

* A. Blunt, *op. cit.*, Vol. II.

abstract means'—here was obviously the beginning of a rapproche-
ment between music and painting in modern times, a fertilization of
ideas persisting in many different forms far beyond the classical era of
Poussin.

The doctrine of the modes, based on a sequence of intervals, raises, as
we have suggested, the significance of numbers in music and this is the
place to quote the amazing analysis of this numerical theory by Baude-
laire. 'Musical notes are numbers',* he declares. Before pursuing this
Baudelairean argument I think we may summarize some of the earlier
mathematical theories of music. Numbers in music are not merely
concerned with the order of notes in the modes, nor with the complex
machinery of counterpoint, nor with degrees of confusion and order in
harmony, nor even with modulation, a shifting perspective which is
surely the ultimate musical marvel. Numbers reflect the ideas of
Pythagoras: they are a musical counterpart of arithmetic or mathe-
matics. Helmholtz, Chevreuil and David Sutter showed that there was
a comparable approach to the conception of light in painting.† These
were the scientists of painting. In all these complexities I think we are
best guided by the principle of Jean Cocteau, 'Art is Science in the flesh',
a principle calculated to unite many contrasting theories.

Writing of the drugged state induced by hashish, Baudelaire states:

> A more remote sensitive region is opened up, and the mind is ordered by a
> heightened response of the senses. The senses of smell, sight, hearing and
> touch are each affected. One peers into infinity and out of a tumult normally
> unregistered sounds are perceived. One is possessed by hallucinations.
> Familiar objects assume new forms and a confusion arises of double visions.
> Sounds assume a colour and colours contain music. All this is natural and
> any healthy poetic mind easily conceives these analogies. There is nothing
> unnatural in intoxication by hashish; it is simply that the corresponding
> responses of the senses are intensified or sharpened. Each response despotic-
> ally penetrates the mind. Musical notes are numbers, and to the mathe-
> matically inclined, melodies or harmonies, sensuous in themselves, are

* See Baudelaire, *Le Poème du Haschich* (III, *Le Théâtre de Séraphin*).

† David Sutter declared: 'The laws of the aesthetic harmony of colours are learned as
one learns the rules of musical harmony. The knowledge of harmony in music makes one
understand immediately the laws of unity and aesthetic harmony of colours.' This would
be valid only if 'the rules of musical harmony' went unchallenged. The scientific theories
of light are analysed in W. I. Homer, *Seurat and the Science of Painting* (Cambridge,
Mass., 1964); in Paul Signac, *D'Eugène Delacroix au néo-Impressionisme*, ed. Françoise
Cachin (Paris, 1964), and in the letters of Pissarro to his son Lucien. We are not very far
in this scientific approach to the art of painting from the dodecaphonic theories of
Schoenberg and his school associated with the *Blaue Reiter*.

transformed into a vast arithmetical machine where numbers give birth to other numbers, the phases of which may be followed with extraordinary ease or with the agility of a performer.*

Here again we must pause to relate the ideas of Baudelaire to modern psychology. There are so many instinctive concepts of Baudelaire that prefigure the theories of Freud that I think we are justified in contrasting the functions of numbers as they are used in the work of these two explorers of the unconscious mind. Freud's work itself is outside the scope of our enquiry, but not that of his contemporaries, Schoenberg, Berg and Webern, the artists of the *Blaue Reiter* and *Die Brücke*. Many of the artists of this generation, as well as the artist-psychologists, were obsessed not so much with numbers as with numerology and occultism.

Of course one would applaud the discovery of the line of research that would illuminate, within the unconscious, the mechanism of magical and other occult practices. But this is not the problem with which we are concerned. In his biography of Freud, Ernest Jones emphasizes that Freud did not always look upon these occult regions from a strictly scientific viewpoint. He was suspicious of the number seventeen and had faith, under the influence of the spurious numerologist Wilhelm Fliess (1858–1928), in the mystical numbers twenty-eight and twenty-three. These disclosures might cause alarm to students of Freud's rational research. Why this belief in magic and other wholly unscientific functions? Ernest Jones rightly associates these indulgent activities of Freud, the atheist, with the occultism of other figures of his time, notably Sir Arthur Conan Doyle, Sir Oliver Lodge and the Italian psychologist Cesare Lombroso, to whom Berg was also attracted. Jones writes:

> In the years before the great war I had several talks with Freud on occultism and kindred topics. He was fond, especially after midnight, of regaling me with strange or uncanny experiences with patients, characteristically about misfortunes or deaths supervening many years after a wish or prediction. He had a particular relish for such stories and was evidently impressed by their more mysterious aspects. When I would protest at some of the taller stories Freud was wont to reply with his favourite quotation: 'There are more things in heaven and earth than are dreamt of in your philosophy.' Some of the incidents sounded like the obscure workings of unconscious motives. When they were concerned with clairvoyant visions of episodes at a distance, or visitations from departed spirits, I ventured to reprove him for his inclination to accept occult beliefs on flimsy evidence. His reply was: 'I don't like

* See Baudelaire, *op. cit.*

it at all myself [*Ich mag das alles nicht*] but there is some truth in it,' both sides of his nature coming to expression in a short sentence. I then asked him where such beliefs could halt: if one could believe in mental processes floating in the air, one could go on to a belief in angels. He closed the discussion at this point (about three in the morning!) with the remark: 'Quite so, even *der liebe Gott*.' This was said in a jocular tone as if agreeing with my *reductio ad absurdum* and with a quizzical look as if he were pleased at shocking me. But there was something searching also in the glance, and I went away not entirely happy lest there be some more serious undertone as well.*

Freud's friendship with Fliess was fading at the beginning of the century but Fliess's numerological influence persisted throughout Freud's life. By a coincidence, in 1915, Alban Berg wrote a letter to Schoenberg in which the mystique of Fliess was seriously put forward as a philosophical basis for intellectual and musical thought though, as later critics were obliged to admit, this number mystique of Fliess clearly belonged to the most bigoted products of the end of the Middle Ages. Berg writes: 'You are quite right, Herr Schoenberg, when you refuse to accept that a certain number (the number twenty-three) should necessarily be a number portending ill luck. In fact I know that this number has been connected with good luck . . . This number has always played a major part in my life . . . That it may be a lucky number occurred to me in connection with the *Gurrelieder* . . . The performance took place on 23 February 1913 . . . My call-up for military service was also connected with the number twenty-three. Your advice to free myself from a suspicious obsession with numbers is certainly acceptable.' †

Unfortunately this advice was offered to a composer himself addicted to the superstitions of numbers. According to the article in *Grove*, 'Schoenberg shared the common superstition about the "unlucky" number thirteen, and during his last illness he is reported to have said that if he survived the thirteenth day of July, he would recover: but he died on Friday, 13 July 1951, thirteen minutes before midnight.' Debussy's early associations with Jules Bois and the Pre-Raphaelites

* Ernest Jones, *Sigmund Freud: Life and work*, Vol. III (London, 1957), p. 408.

† The text of this unpublished letter from Berg to Schoenberg was kindly communicated to me by Dr Mosco Carner. Some of the theories supporting the attributes of the numbers twenty-eight and twenty-three, put forward by Freud's friend Wilhelm Fliess, are discussed in *The Origins of Psychoanalysis: Letters to Wilhelm Fliess* by Sigmund Freud (London, 1954), and are likely to arouse further suspicions as to the nature of the scientific methods of Freud. Berg, though drawn to Fliess in his youth, later distrusted the psychoanalytic theories of Freud, and presumably Fliess's influence on Freud. This matter is discussed in Appendix C, 'The Mind of Alban Berg.'

similarly shows a preoccupation with occultism, though he later invoked the theory of Pythagoras: 'Music is the arithmetic of sounds.' All this may seem to throw a suspicious light on the number or modal theory used in the seventeenth century by Poussin. If occultism and the practices of numerology flourished at the end of the nineteenth century why was there no trace of this wholly irrational approach in the classical works of Poussin? The answer, surely, is that Reason had prevailed, or at any rate a faith in the concept of Reason, however widely this concept may be questioned today. An early treatise on harmony owed its success, it was said, to the fact that 'Reason became music'. Musical ideas, moreover, were determined by the mathematical concepts of modality and tonality. Other rather more forbidding concepts naturally replaced their decline.

Let us return now to the original theory propounded by Sir Anthony Blunt, that the character of the Renaissance musical modes reproduced and defined in 'abstract terms' in the paintings of Poussin opened the way to a reflection of musical methods in the paintings of Delacroix and the later Impressionists. It must seem that many far-reaching excursions have been made in the realms of numerology and psychology merely to support this simple conclusion. But the fact is that once the functions of numbers are approached in the limited spheres of sound or light waves, a vast complexity of theories is likely to be uncovered. We see this clearly enough in the writings of Bertrand Russell. ('Pythagoras, as everyone knows, said that "all things are numbers". This statement, interpreted in a modern way, is logically nonsense, but what he meant was not exactly nonsense. He discovered the importance of numbers in music.') Some of these theories, particularly those of Wilhelm Fliess, had to be drawn into the argument to indicate the labyrinthine nature of the present-day artistic imagination. As we shall see in the following chapter, Delacroix and his relationship with music presents the problem in a more crystallized form. Delacroix obviously did acquire his 'musical' approach from a knowledge of the modes reflected in the paintings of Poussin and it is certain that Delacroix opened up a vital new world. He enunciated a famous principle which guided him throughout his work. It is *L'art du coloriste tient évidemment par certains côtés aux mathématiques et à la musique*. Mathematics and music—that is what we have been talking about, an interplay that will uncover fresh problems for each succeeding generation.

4

'The Music of a Picture'

'What moves men of genius, or rather what
inspires their work, is not new ideas, but
their obsession with the idea that what
has already been said is not enough.'
DELACROIX, *Journal*, 15 May 1824

Art historians have long held that the work of Delacroix contains the wonderfully fertile seeds of Impressionism. 'We are all in Delacroix', said Cézanne, an allegiance shared among others by Van Gogh and Renoir. Broadly speaking, music developed in a similar manner.

In her book *Impressionism* (London, 1967) Phoebe Pool asks how it came about that certain aesthetic beliefs were shared by painters of the Impressionist school who were often of different temperaments and experience. Some of her questions, slightly amended, may be applied to corresponding developments in the musical style. 'Why did [the Impressionists] consider light and the exchange of coloured reflections as the unifying elements of a picture', Miss Pool asks, 'instead of relying on the traditional methods of construction based on drawing, outline or sharp contrasts of light and shade?' In the history of musical style we may similarly ask: Why did many of the composers of the post-Wagnerian school rely on combinations or juxtapositions of instrumental timbres instead of on the formal developments of the sonata form with contrasted principal and subsidiary subjects and a scheme of modulations designed to throw the musical argument into perspective? Developing her approach, Miss Pool asks: 'Why do [the Impressionist] canvases often display visible, choppy strokes of paint applied with a hog's-hair brush, rather than the smoother surface achieved by Delacroix and Corot, whose work they admired?' Here again musicians may ask: Why do Wagner and his followers employ a dappled or a flecked form of orchestration and a form of ambiguous harmony in which allegiances to tonality are undermined and where the borderlands between consonance and dissonance become increasingly blurred?

I think we may find keys to some of these answers in an analysis of Delacroix's use of colour in *Delacroix* by Dr Lee Johnson (London, 1963) and of the influence which his theories had over late nineteenth-century painters. Colour was associated in Delacroix's mind in the first place with mood, as in the leaden tones and olive shadows of the *Barque de Don Juan*, copied by Manet, Degas, Cézanne, Gauguin and others, and in the similar colour schemes of *Hamlet and Horatio in the Churchyard*. Alternatively, colour, according to Delacroix, may have 'a purely abstract or a "musical" quality that exists independently of the subject depicted'. The famous *Femmes d'Alger* (see Plate 6), almost a counterpart of *Carmen*, is indicated here. Touches of colour are used not for representational purposes but to 'enhance the chromatic harmony as a thing apart'. This was obviously a new principle which one does not discern in the theoretical principles of earlier painters, despite their impressionistic tendencies, and which for the first time was designed to bring painting to the borderlands of music.

Technical investigations have a fascination of their own. Dr Johnson reveals the manner in which one may discover the pigmentation of objects of a seemingly neutral appearance. Basing his argument on an analysis of such insignificant details in the pictures of Delacroix as a slave's foot in *Sardanapalus* with its amazing complexity of colour, or the monochrome drops of water in the foreground of the *Barque de Dante* where again, on close inspection, an almost rainbow variety of colour is disclosed, Dr Johnson shows the origin of a system which each of the Impressionists was to develop in an individual manner. Another illuminating point is the influence of Constable's *Hay Wain* on Delacroix's *Massacre at Chios*—something of a polemical chestnut in art history, since the nature of this influence has never been conclusively established. Nevertheless, Constable's influence reinforced the Impressionist approach. We are shown, too, the fertilization by Delacroix of the style of Van Gogh, drawn also to the 'intimacy' of the Wagnerian orchestra. And finally, a survey of Delacroix's theories leading not only to Van Gogh and Gauguin but beyond them to the painters of the present day.

These painters, writes Dr Johnson, 'went a step further than Delacroix in freeing colour from a naturalistic function: Van Gogh towards a subjective, expressionistic use of colour, Gauguin towards purely decorative abstraction. In the first decade of the twentieth century Matisse and the other Fauves almost completed the divorce of colour from nature, to produce a riotous feast for the eye. Shortly before the first World War, Kandinsky released colour from every representational

purpose, allowing it only an abstract and spiritual value; and thus the revolution in colour that Delacroix had set in motion ended.' It was also a revolution in colour based on synaesthesia, on the *Correspondances* of Baudelaire, and for this reason Delacroix was fully understood only through Baudelaire's interpretations.

Now the significance of this argument is that the very same conclusion—the release of colour and the cross-fertilization of the senses in an all-embracing empire of the arts—is approached in a musical study, namely the relationship between Delacroix and Chopin. Investigating the seminal nature of the chromatic harmony of Chopin, Juliusz Starzynski similarly shows how musical and pictorial ideals were eventually interwoven in the work of Kandinsky. (Baudelaire and of course Kandinsky's great contemporaries, Debussy, Schoenberg and Messiaen, are embraced in this survey.) Dr Starzynski's study may sometimes be overbold, yet it is an invaluable piece of original research: it shows us for the first time the genesis of an alliance.* Comment on the main points in this study will be made in due course but in the first place the purely musical character of Delacroix should be assessed.

No painter of the Romantic era possessed such a wide knowledge of music as Delacroix—he was himself a gifted amateur pianist and violinist; and no other artist of this period was so keenly aware of the principles of colour common to both painting and music—at least so it would seem if we may believe some of the notions of musical and pictorial colour attributed to Delacroix by George Sand. He was principally attached to Cimarosa and the Italian composers of the early nineteenth century, and later to Mozart, but not, as we might imagine, to his romantic contemporaries Berlioz and Weber. As late as 1847 he writes, 'My head is full of the chords of Cimarosa. What variety in his genius and how pliable and elegant. Decidedly, he is more dramatic than Mozart . . . *Il Matrimonio Segreto* is perfection itself.' Together with Stendhal he establishes the cult of Rossini. The chorus of the shades in Rossini's *Moïse* suggests a picture that he unfortunately failed to pursue. He subscribes to the belief, still held today, that *L'Italiana in Algieri* represents the perfection of the *buffo* style. *Semiramide*, with reservations, is similarly impressive though he is aware in this work of an excessive preoccupation with musical decoration, a disintegrating element likely

* Juliusz Starzynski, *Delacroix et Chopin* (Paris, 1962). Kandinsky's treatise *Über das Geistige in der Kunst* (Munich, 1912) is held to proclaim, well after Baudelaire, an affinity of the arts 'qui nous semble émaner des séances musique-peinture qui réunissaient Delacroix, Chopin et George Sand'.

to undermine the style of Rossini's followers. *La Gazza Ladra* suffers quite understandably by comparison with Mozart's *Don Giovanni* and the painter of *Sardanapalus* and the *Massacre at Chios* soon senses Rossini's limitations. 'By a peculiarity not often met with in men of genius, he is lazy, he follows the well-worn paths, uses patchwork effects, individual enough in themselves, but which do not make a genuine impact.' Oddly, he does not seem to have written of the *Barber of Seville*. Nevertheless the Italian contralto Marietta Alboni in *Cenerentola* fills him with delight. 'Je jouissais de tout.' He concedes that Rossini introduced into music certain 'romantic' qualities.

Bellini's *I Puritani* and *Norma* are praised in moderation, and in the operas of Donizetti his preference goes to *Lucrezia Borgia*. *Lucia di Lammermoor*, apart from the sextet, leaves him bored. It is 'slender' music hardly appropriate to 'heroic times'. The famous Mad Scene is not even mentioned. His enthusiastic accounts of the operas of Mozart, that is to say *Figaro*, *The Magic Flute* and *Don Giovanni*, the principal works known in Paris at the beginning of the nineteenth century, throw an interesting light on Delacroix's musical tastes. By comparison with Rossini, Mozart introduces an expression of 'melancholy', the very Romantic character which, as we shall see, Baudelaire attributed to the pictures of Delacroix himself. The characterization of *Don Giovanni*, he says, would have met with the approval of E. T. A. Hoffmann. He must have been one of the first critics to observe in *Don Giovanni* the 'romanticism' of Mozart.

In the manner of most French amateurs of music of his time, Delacroix was principally attracted to opera. It is amazing to read from one of the great artists of pictorial composition that the repetition or transformation of themes belongs to the 'pedantic aspects of composition'. After Rossini and Mozart, the overture to Gluck's *Iphigénie en Aulide* 'reminds a nineteenth-century listener of plain chant'. Nevertheless, thematic elements of the opera itself, as we are now clearly aware, are presented in this overture in the manner of the overtures of Weber and Wagner. 'I imagined that the overture', Delacroix states with foresight, 'should establish the subject and character of the opera in the listener's mind.'

Beethoven, the composer one would be tempted to associate with Delacroix's revolutionary tendencies, sets up a maze of contradictory impressions. One of the *Leonora* overtures is 'often confused'. Other Beethoven overtures are the product of a 'strange, uncultivated inspiration'. Yet he is undoubtedly 'the man of our time . . . of dark violent

outbursts, a romantic of the highest degree'. In his study of Delacroix's musical ideas Raoul Duhamel★ suggests grounds for an artistic kinship:

> Delacroix, as a poet of colour, could not have been unaware that in introducing new instruments to the orchestra of Mozart, Beethoven had enriched the orchestral palette with new sonorities, notably the trombones, piccolo and double bassoon in the C minor Symphony. He endowed the horn with an unsuspected colour and expression, particularly in the trios of the Seventh Symphony and the Eroica and the Adagio of the Ninth. Moreover, Beethoven was the first to emphasize the expressive power of the timpani.

Perhaps these novel orchestral effects did not leave Delacroix indifferent, though curiously enough orchestral colour as such is never mentioned in his writings. Berlioz's orchestra repelled him, and he is silent on the wonderful orchestration of *Freischütz* and *Oberon*, which remains a model for Weber's successors, among them Debussy, Strauss and Stravinsky.

Here is an almost insoluble problem in any consideration of Delacroix's sense of pictorial or musical colour. How do we account for those many unexpected or contradictory opinions? Brought up during a revolutionary period, he was probably at loggerheads with himself. A disciple of Rubens, Veronese and Rembrandt, he was powerfully attached to the past, but he was also, as we have seen, a precursor of many later principles of painting. It is in these innovating regions that he is most interesting. As an explorer he identifies the procedures of music with those of painting in the manner of artists of a much later date. Painting, he says, anticipating the abstract forms, 'does not need a subject'. Similarly, realism in the conventional sense is 'wholly opposed to art'. What, then, can realism mean? It is illusion, 'the illusions created in painting'. In the same vein we read that 'man has innate sentiments which do not respond to any kind of concrete object'. Obviously not. Limitation, therefore, is pointless. 'What can the supreme art of music imitate?' All this reveals an awareness of the chaotic forces of the unconscious. Colour, not form, is the essential virtue of a picture, he believed, and his favourite theme, as we have seen, is that the forms and colours of a picture 'seen from a distance reach the most intimate regions of the soul and convey what one may call the music of a picture'. When he recommends the suppression of detail and the necessity to paint objects 'unified in the atmosphere in

★ Raoul Duhamel, *Eugène Delacroix et la Musique* (Milan, 1939).

which they are bathed'* one might almost be reading the letters of Monet or Pissarro.

Delacroix's musical opinions, as we have outlined them, change in the course of years. Even so, it is difficult to imagine how the painter of *Sardanapalus* and the *Femmes d'Alger*, advocating a 'musical' ideal in painting, could ever have misjudged certain of his musical contemporaries in the way that he did. Berlioz is a 'terrifying mess' (*un héroïque gâchis*). Mozart's G minor Symphony is 'rather boring', apart from the opening, Delacroix specifies, thereby admitting that he was averse to the principles of musical argument. Beethoven, on the evidence of the Archduke Trio heard in 1847 and the Eroica two years later, is 'terribly unequal'. Weber, however, like Beethoven, brought to music qualities of 'a sudden novelty' (*l'abrupte nouveauté*). He seems always to have been constitutionally incapable of grasping Beethoven's formal ideas, however. Musical logic was beyond the range of his experience, yet he accepts the statement of Chopin, the least contrapuntal of composers, that 'fugue represents the logic of music'. Paradoxes and contradictions abound. In a letter to George Sand he suggests that 'Merdi' should be the name of the composer of Verdi's *Jérusalem* (the French version of *I Lombardi*). Of the Eroica in 1854 he writes: 'I was thinking of the way in which musicians seek to achieve unity in their works. Normally, a return of the principal theme is held to be the most effective means; but it is also a means which particularly lends itself to the small mind. If a thematic return sometimes offers much satisfaction to the mind and the ear, when abused it becomes a subordinate or rather a wholly artificial device. Is memory so elusive that connections can only be made between different sections of a piece of music by means of an insatiable repetition of the principal theme?' Painting which 'does not catch you at the throat' like music 'does not present this disadvantage. A painting is seen as a whole and one becomes accustomed to distinguishing and relishing its finer effects.'

Obviously from all these accounts Delacroix's musical judgements, spontaneous and often provocative as they are, present, to our way of thinking, a mass of conflicting impressions. Had he assimilated the works he had heard, was he unreasonably prejudiced, had he in mind, perhaps, a spontaneous, rhetorical type of music, or was there some

* Delacroix, *Journal* III, Paris, 25 January 1857 ('Notes pour un Dictionnaire des Beaux-Arts'): 'Quand nous jetons les yeux sur les objets qui nous entourent, que ce soit un paysage ou un intérieur, nous remarquons entre les objets qui s'offrent à nos regards une sorte de liaison produite par l'atmosphère qui les enveloppe et par les reflets de toutes sortes qui font en quelque sorte participer chaque objet à une sorte d'harmonie générale.'

personal element that determined his critical approach? André Joubin, an early authority on Delacroix, puts forward a theory that eliminates many of these contradictions and that goes some way to drawing the whole picture of Delacroix's musical judgements together. Writing of Delacroix's meeting with Chopin and their relationship, which lasted from 1835 to 1849, Joubin states:

This was, we may say, a thunderbolt, love at first sight [un coup de foudre] no doubt unique in the life of Delacroix. This man who, apart from his child-hood acquaintances, Pierret, the Guillemardets and Leblond,* had no friends, neither among artists nor among the writers, this great solitary figure, reserved, remote and secretive, was from the first and without any reserva-tions, conquered by Chopin. Here was an inexplicable phenomenon, like all such attractions of a purely sentimental nature. Rarely could two artists, of different orders, it is true, have been more dissimilar. Chopin understood nothing of painting, and in any case loathed the paintings of Delacroix. Delacroix who loved music but who had no well-defined outlook became enamoured of the music of Chopin, and henceforth loved only that to which Chopin himself was attracted, that is to say Mozart above all and the Italians from Cimarosa to Rossini. Hence it came about that he detested Berlioz, who should have filled him with enthusiasm, and he later failed to understand not only Liszt and Wagner but also Beethoven. On the other hand, the man [Chopin] delighted him. Was it his dandyism, his refinement and elegance? Or was it the sympathy which the sick man inspired in Delacroix, afflicted with the same illness? All these reasons contributed to the fact that Delacroix adored Chopin *mon cher petit Chopin*, as he called him [he was thirteen years Delacroix's junior], an adoration transferred to George Sand in the first place and later to her whole entourage.†

It is unfortunate that the whole of this passage, of obvious psycho-logical importance, is omitted from Dr Starzynski's study. Though Chopin is frequently mentioned in Delacroix's *Journal*, his works are referred to by title on one occasion only. This is on 1 July 1847 when Delacroix mentions the early and hardly characteristic Trio, Op. 8. Nor does Delacroix comment upon Chopin's wholly original style of piano

* J. B. Pierret and his wife, both portrayed by Delacroix (the former in Turkish cos-tume), were friends concerned with the problems of Delacroix's bachelor housekeeping. Félix Guillemardet was the son of Ferdinand Guillemardet, the French Ambassador to Spain of whom there is a famous portrait by Goya. It was through Guillemardet that Delacroix became acquainted with the works of Goya. Frédéric Leblond was a schoolboy friend known to us through Delacroix's portraits of him progressively going through the stages of a sneeze.

† A. Joubin, 'L'amitié de George Sand et d'Eugène Delacroix' in La Revue des deux mondes (15 June 1934).

writing. This fact alone would support André Joubin's theory of a pre-dominantly emotional relationship between Chopin and Delacroix. Moreover, Chopin's compositions are not mentioned in Delacroix's correspondence. We read, however, in a letter to F. Villot of 1846: 'Chopin m'a joué du Beethoven divinement belle: cela vaut bien de l'esthétique.'

On the other hand, we must mention the long extract of six pages which Delacroix copied into his *Journal* in 1851 from the articles which appeared under Liszt's name in *La France Musicale* in that year. In fact, for these flamboyant articles Liszt employed the ghost writers Marie d'Agoult and Carolyne Wittgenstein, who conventionally compare the studies, preludes, nocturnes and other compositions of Chopin to the miniature style in painting.

To complete this picture of Delacroix among the musicians of his time there were occasions when the painter of the *Massacre at Chios* would seem to have been ready to appreciate effects of instrumental colour in the works of Berlioz, namely the ghostly combination of three flutes and eight trombones playing over four octaves apart in the *Hostias* of Berlioz's Requiem. But he mentions nothing of the sort. Chopin, so we gather from Delacroix's sceptical comments, found this effect abhorrent (*Journal*, 13 April 1830).*

Are these reconstructions confirmed by contemporary evidence? I think they are. Attractions of the same nature are conveyed in an account of this relationship given by George Sand in her *Impressions et Souvenirs* (Paris, 1841).

> Chopin and Delacroix are attracted to each other, almost tenderly. They have many resemblances in character and the same qualities of heart and mind. On the artistic level, Delacroix understands Chopin and adores him. Chopin does not understand Delacroix. He values him, cherishes and respects the man; but he loathes the painter. Delacroix, of more varied qualities, appreciates music. He has a knowledge of music and understands it; he also has reliable and exquisite taste. He is never tired of listening to the music of

* A complete catalogue of the portraits of Chopin by Delacroix has not yet been assembled. From the information given by Julien Tiersot in *Lettres de musiciens écrites en français*, Vol. II (Paris, 1924) and the illustrations in Juliusz Starzynski, *op. cit.*, there appear to be five sketches and portraits of Chopin made by Delacroix, including two with a crown of laurel leaves. To these should be added the caricature of Chopin by Delacroix, the most arresting character-study of them all, reproduced in *Collection Musicale André Meyer* (Abbeville, 1961). In *La Revue du Louvre* (1963, No. 2), Dr Starzynski goes so far as to suggest that the figure of Dante (whose face is obscured from view) in *Le Plafond d'Homère* in the Luxembourg Senate was Delacroix's idealized conception of Chopin.

Chopin which he relishes and knows by heart. Chopin is moved by this adoration. But when Chopin looks at a picture of his friend he literally suffers and finds not a word to say. He is a musician, and nothing more. His ideas can only be translated into music. He has a mind of wide range and great subtlety; but he has no understanding either of painting or of sculpture. Michelangelo frightens him. Rubens exasperates him. Everything seemingly eccentric shocks him.

Presently George Sand enters into the debatable question of reflections—the reflection of colour in painting and the reflections of chords in music. It was this discussion that prompted Juliusz Starzynski to see the ultimate development of Chopin's harmonic ideas in the works of Kandinsky. I think we must read Starzynski's account with the knowledge that painters and musicians were groping at this early period towards the much later abstract stage in music and painting that has now become accepted; and therefore the many enigmatic or ironic undertones in this discussion must be seen as signs of apprehension at the revolution that lay ahead. George Sand's son, Maurice, himself a composer, opens up these fields of analogies.

Maurice wants Delacroix to explain to him the mystery of reflection, to which Chopin listens wide-eyed, in surprise. The master establishes a comparison between the tones of painting and the sounds of music. Harmony in music, he says, does not consist only of chord formations, but also of the relationship of chords, in their logical progression and in what I might go so far as to call their auditory reflections. Now painting follows the same laws. Give me that blue cushion and this red carpet. Let us place them side by side. You see that there where the two tones meet they rob each other. The red becomes tinged with blue; the blue is washed by the red and in the middle the colour of violet is produced. You may fill a picture with the most violent tones. Give them the reflection which binds them together and you will never be vulgar . . .

In answer to the question of Maurice Sand 'What of the reflection of a reflection?' Delacroix refers to 'the secret of the transparency of shadows', a theory which, according to Chopin, 'borders on alchemy'. A streak of diabolical irony was apparently not unknown to Chopin. Delacroix thereupon expounds on what he calls the principle of 'pure chemistry'. Chopin, who has been improvising, is no longer inspired. 'I haven't begun', he explains. 'Nothing comes to me. Nothing but reflections, shadows, reliefs which remain ill-defined. I am seeking colour but I do not find the underlying design.' 'You will not find the one without the other', says Delacroix, 'but you will find them both.'

'But supposing I only find the moonlight', Chopin retorts, rather amusingly, one must admit. 'You will then have found the reflection of a reflection', replies Maurice Sand.

Ironically and prophetically, one is almost in the world of Verlaine, Fauré and Debussy. It is as if the prophetic statement of Delacroix had already been fulfilled: 'What moves men of genius or rather what inspires their work, is not new ideas, but their obsession with the idea that what has already been said is not enough.' In the meantime the many interpretations of Delacroix's work provided by Baudelaire revealed to later generations the dual nature of his work. These interpretations did not merely recreate impressions of Delacroix's work; they actually created their spirit afresh. Baudelaire's main theory was that 'The art of the colourist belongs in certain aspects both to mathematics and to music.' Almost the whole of his art criticisms are therefore shot through with these elusive musical associations. But of course for Baudelaire, the pictures of Delacroix evoke not Cimarosa, nor Mozart, nor even Chopin, but Weber, the orchestral colourist, Weber whose works did in fact represent for Delacroix some kind of sudden, blinding novelty. Baudelaire saw, in the works of Delacroix, the spirit that Delacroix himself failed to see.

In his analyses of two of the key pictures of Delacroix, the *Femmes d'Alger* and *La Chasse aux Lions*, Baudelaire not only establishes the elusive nature of the musical undertones in Delacroix's work but emphasizes elements that Delacroix himself, as I have suggested, had only dimly perceived. Once again Delacroix's prophetic statement: 'What moves men of genius . . . is their obsession that what has . . . been said is not enough' receives a fresh interpretation. Weber, the precursor of Wagner, is constantly in his mind in these analyses. In *Les Femmes d'Alger* he discusses the sudden veerings from ecstasy to despair, offering a moral rather than an aesthetic interpretation, which is assessed in the chapter 'Baudelairean Criticism' (see page 67). Of *La Chasse aux Lions* he writes: 'This picture is a real explosion of colour—let us understand this word in its true sense. Never have more beautiful or more intense colours moved us in this way.' And he goes on:

> From a first rapid glance at Delacroix's pictures and later from a close examination of them several facts emerge. Seen from a distance—and this is particularly important—and without distinguishing or perceiving the subject, a picture of Delacroix immediately produces a sumptuous impression of gaiety or of melancholy. One might say of a picture of Delacroix that

like the art of the sorcerer or the mesmerizer, it projects its thought from a distance. This phenomenon derives from Delacroix's power as a colourist, from his perfect sense of agreement in the matter of colour tones and from the harmony pre-established in his mind between colour and subject. If I may be forgiven these linguistic subterfuges to express extremely delicate ideas, it would seem to me that this is colour that thinks for itself independently of the objects which it clothes. Also these admirable colour chords often evoke harmonies and melodies and almost a musical impression is often left by these pictures. A poet tried to express these subtle sensations in lines the strangeness of which may be excused by their sincerity:

> Delacroix, lac de sang, hanté des mauvais anges,
> Ombragé par un bois de sapins toujours vert,
> Où, sous un ciel chagrin, des fanfares étranges
> Passent comme un soupir étouffé de Weber.

Lac de sang: the colour red; *hanté des mauvais anges*: supernaturalism; *un bois toujours vert*: green, the complementary colour of red; *un ciel chagrin*: the tumultuous stormy backgrounds of Delacroix's pictures; *les fanfares de Weber*: ideas of romantic music awakened by harmonies of colour.

There we have it. Baudelaire, a critic of music as well as of painting, provides an interpretation of his own poem (it is from *Les Phares* in the *Fleurs du Mal*) which looks forward to the wider theory of the *Correspondances*. Elsewhere, in his study of 1863, Baudelaire states that Delacroix achieves his effects with the 'eloquence of a passionate musician' and perceives that the arts of the nineteenth century aspire to a condition 'in which they lend each other new powers'. But perhaps the most penetrating judgment from our contemporary view which Baudelaire gives of Delacroix is in his comparison with an opium-addicted state.

Edgar Poe says [in *A Tale of the Ragged Mountains*] that the result of opium on the senses is to endow nature with a supernatural interest providing each object with a deeper, a more purposeful and a more inflexible meaning. No need of opium to indulge in these marvellous states, when one responds to the fire of the mind, when the senses are sharpened, when one plunges into the transparent blue sky as into an abyss, when sounds become music, when colours acquire a manner of speech and perfumes suggest a whole new world of ideas. The painting of Delacroix reflects these heightened experiences of the mind. . . . What will posterity say of Delacroix? . . . It will say, as we say, that he united amazing qualities. Like Rembrandt he reached degrees of intimacy and magic. He was formal and decorative like Rubens and Lebrun, and he also displays an other-worldly sense of colour, as in Veronese. But he likewise presents an heroic and melancholy quality, an indefinable

quality of his own. Here was something entirely new, an artist without a predecessor, possibly without a successor. . . .

I imagine that this must be the finest Delacroix criticism we possess even to this day. Delacroix did, in fact, hear *Freischütz* in London and to musical people the parallel of Delacroix with Weber, with the opening of the *Freischütz* and *Oberon* overtures, for instance, shows an idea, a seed of thought, shared by the painter and the musician. It is time perhaps now to return to the queries put by Phoebe Pool on Delacroix and his relationship to the Impressionists, as well as to the collateral developments in music, set out at the beginning of the chapter. Why did the Impressionists consider light and reflections as the unifying elements? Why, likewise, did composers rely on instrumental timbre? Why did painters use a hog's-hair brush, that is to say a technique of division, and composers an ambiguous form of harmony? Baudelaire tells us that Delacroix was not only an artist without a predecessor, but possibly an artist without a successor. This opinion has been expressed in regard to all the great individualists of the nineteenth century. From one viewpoint each was a law unto himself, each created a world, and therefore none of the great nineteenth- or early twentieth-century artists was able to establish a school, a philosophy that was not soon to be challenged. From another viewpoint the opposite is true. Their work radiated throughout a circle of kindred spirits; it transformed, among an élite, the imaginative mind. 'Influence' becomes a key term in the critical vocabulary. The Impressionists, according to Cézanne, reached back to Delacroix. Composers were similarly aware of an early nineteenth-century ancestry. Paradoxically, in the light of present-day developments in concrete and electronic music and also in parallel movements in painting, each of these contradictory viewpoints is valid. The fact is that imaginative insights do not belong to the world of reason. It is enough if one is able to find in these regions, the right questions to ask.

5

'Pictures of Nothing'

'We never see anything clearly.'
RUSKIN

There was no artist of the nineteenth century whose scope of expression was as far-reaching or as extensive as that of Turner. The achievements of his contemporaries, Beethoven and Wagner, may have been more volcanic but they did not themselves carry through their ideas into worlds belonging to the middle of the twentieth century. This was the phenomenal achievement of Turner. It is as if a composer working in his youth in the style of Haydn and Mozart were eventually to reach out into the no-man's-land of electronic music.

There are many reasons supporting the fact that this drive towards abstraction could only have been undertaken by a painter. Turner lived from 1775 to 1851. The musical landmarks in Turner's lifetime include the supreme achievements in classical opera, *Don Giovanni* and *The Magic Flute*, in Romantic opera, *Freischütz* and *Oberon*, and in the nineteenth-century symphony, the *Eroica*, the *Pastoral* and the *Unfinished Symphony*. At the end of Turner's life, between 1843 and 1850, Wagner's early operas *The Flying Dutchman*, *Tannhäuser* and *Lohengrin* were given. Turner shares the ideas of Wagner, though principally of his later works, but he does not reflect the artistic experiences of Mozart or Beethoven. For instance, in his youth he was influenced by the styles of Claude Lorrain, Titian and Poussin and of the Dutch painters Van de Velde and Cuyp. This does not suggest anything of the formal or philosophical concepts of Mozart or Beethoven. Moreover, when Turner was later influenced by Rembrandt, he became obsessed by the sources of light, that is to say the light of the sunset, the moonlight and the firelight, an Impressionist concept which musicians had not yet been able to approach.

Some of Turner's strange compositional devices themselves suggest musical counterparts. Instead of leading the eye to a central vanishing

point, in the manner of establishing a tonal centre, he strove to embrace, in *Norham Castle* or the Petworth pictures, an ever-wider scene and to introduce extraneous diversions. Composers use a similar procedure in bitonality or polytonality consisting of the juxtaposition of tonal planes. Turner's later works were created within what seems to be a hollow sphere or a void. His double and foreshortened perspectives were used with a great sense of drama and fantasy and in a manner far in advance of his time. This drive to abstraction could only have been undertaken in painting since music is by its nature abstract. His later works, particularly his water-colours called by his biographer A. J. Finberg *Colour beginnings* (see Plate 8), anticipate the technique of present-day *tachistes*. Colour seems to be flung on with a palette knife and these late water-colour sketches have the qualities of action painting. Students of Turner's pictures frequently recall the order Turner gave to the sailors off the east coast in 1842. He was to be lashed to the mast in order to perceive the terrifying fury of the churned-up seas as a subject for the greatest of his seascapes, *The Snowstorm* (Plate 7). This picture, said Turner, 'no one had any business to like. I did not paint it to be understood. I wished to show what such a scene was like.' In fact he persisted in receiving the impact of first-hand impressions of nature, as Monet did and the later Impressionists. For instance, both Monet and Turner painted from a boat. In order to paint his picture *Rain, Steam and Speed* (1844), which is really a picture of light seen through rain, he had no hesitation in thrusting his head out of a railway carriage and in maintaining it there in the drenching rain.

Turner's work long remained little known outside England for the reason that the bulk of his work was bequeathed to London museums. But of course the work of a forward-looking genius cannot long remain isolated. Recent research by John Gage in *Colour in Turner: Poetry and Truth* (London, 1969) has shown the extent of Turner's influence in France, and this is where we may also see his musical influence even though it was often hidden or achieved at an underground level. Leaving aside the debatable question of Turner's influence on the Impressionist movement proper, resulting from the visit to London of Pissarro and Monet in 1870, we find that many other French artists expressed their allegiance to Turner. In Clive Bell's *Landmarks in Nineteenth-Century Painting* (London, 1927), not quoted by Gage, we find that in 1885 a letter signed by Boudin, Degas, Monet, the French painter of animals John Lewis Brown, Pissarro, Renoir, Mary Cassatt, Berthe Morisot and Sisley, addressed to Sir Coutts Lindsay, opened:

'A group of French artists united by the same aesthetic tendencies, struggling since ten years against convention and routine to bring art back to a scrupulous observation of nature, and passionately anxious to convey form in movement as well as such fugitive elements as light, cannot forget that they have been preceded in this direction by a great master of the English school, the illustrious Turner.'

This does not suggest that Turner remained an isolated figure removed from the main European art streams. His liberating colour theories were admired not only by the painters of later generations, but by writers, among them Proust, and by composers, particularly Debussy and Strauss (who mentions Turner in his revision of the Berlioz treatise). At an exhibition held in New York in 1966, the Director of the Museum of Modern Art, Monroe Wheeler, stated: 'The French Impressionists and their analysts and critics have, almost to a man, denied Turner's influence, and yet relationship of some sort is strikingly apparent. In all history, including art history, a kind of prophecy is inherent and inexplicable. Something in the spirit of the age, the affinities and rivalries of nations, and inter-weavings of one art with another, motivate individual artists of various schools, all at the same time, in the way of an unconscious response to the cultural matrix. Presumably none of the present-day abstract painters whose principal means of expression is light and colour had Turner and his life-work in mind; but looking back on their revolution, more than a hundred years later than his, we see a kinship.'

In the work of Turner, as we have seen, almost everything aspires to the musical state. This seemingly overbold statement is justified by the fact that the dream-like turbulent nature scenes of Turner, like the scenes springing from the same source in Wagner, have no antecedents. Turner and Wagner came upon this dream state in their portrayal of the elements instinctively. None of the early nineteenth-century painters or composers had this quality. The fact that their visions were expressed in a static or a fluid state is of little importance, since Turner and Wagner were concerned with movement, and music, according to an ancient definition valid still today, is 'the art of good movement'. Lord Clark must clearly have had this in mind in his analogies. I think we may investigate the techniques and mental processes which, Lord Clark implies, bound Turner and Wagner, and later Turner and Debussy. 'Visions and dreams', he says, 'were commonly applied to Turner's pictures in his own day, and in the vague, metaphorical sense of the nineteenth century they had lost their value for us. But with our

new knowledge of dreams as the expression of deep intuitions and buried memories, we can look at Turner's work again and recognize that to an extent unique in art his pictures have the quality of a dream. The crazy perspectives, the double focuses, the melting of one form into another and the general feeling of instability: all these forms of perception which most of us know only when we are asleep, Turner experienced them when he was awake.'*

Turner did not himself pronounce on musical questions in the manner of Delacroix but his conception of the fluidity of forms and of abstraction indicated an Impressionist spirit. More than this, his pictures constructed uniquely from principles of colour and light and 'aerial perspective' bring us into the heart of the later nineteenth-century musical movements. Air, light and their harmonic equivalent are likewise suggested in such works as Wagner's *Forest Murmurs* and Debussy's *Nuages*. Turner's musical aspirations coincided in parallel fashion with those of Delacroix—at least Delacroix in his limited knowledge of Turner is said to have been influenced by him—and he also shared the musical outlook of Gauguin. Borrowing a subject from life or nature, Gauguin conceived 'arrangements of lines and colours' which should represent 'symphonies and harmonies' without any vulgar sense of reality. These procedures 'should make you think, as music does, without the aid of ideas or images, [that is] simply by the mysterious relationships existing between our brains and such arrangements of colours and lines'.†

Before investigating more closely the roots of Turner's musical transformations—a word which in view of this nineteenth-century development I think we may use in a convenient sense—we may be helped by considering his work within a broad framework.

'I believe in Michaelangelo, Velasquez, and Rembrandt; in the might of design, the mystery of colour, the redemption of all things by Beauty everlasting.' Those are the words, in the form of a creed, spoken by Louis Dubedat in Bernard Shaw's *The Doctor's Dilemma*. They were perhaps inspired by Wagner's idealistic tales and articles, *Ein deutscher Musiker in Paris*. And here is Gauguin similarly inspired by Wagner. He is approaching a memorable event in the history of modern art, his decision to leave France, to break with Western civilization, and to share the civilization of the remote and other-worldly Tahitians.

* Sir Kenneth Clark, 'Turner's Look at Nature', The *Sunday Times*, 25 October 1959.
 † Sir Kenneth Clark, *Landscape into Art* (London, 1949).

'I haven't said goodbye to the artists who think as I do', he writes. 'It is enough for me to remember a certain statement of Wagner.' And he quotes a statement which, despite its off-putting grandiloquence, was nevertheless chosen by Gauguin to support his revolutionary creed. He tells us that Wagner wrote: 'I believe that the disciples of art will be glorified and that in the midst of celestial rays decked out with perfumes and wonderful harmonies they will return to live eternally in the divine source of harmony'*—a Messianic vision in fact of the artist. A playwright and a painter evoke the ideas of Wagner at critical periods in their development, and here now is a composer recalling the fertilizing power of Wagner's ideas. In 1913, deploring the meretricious values that were increasingly invading musical circles and the development of 'the fashion aesthetic' Debussy declared that he had the fortune to share the Wagnerian experiences which, regretfully, were not available to everyone.

I have purposely quoted together these opinions on Wagner of Shaw, Gauguin and Debussy to show the breadth of his influence, and this is where Turner must enter the same stream. The fact is that, as often occurs with the work of artists who live at a climax of a great development, Wagner built greater than he knew. His work opens up the era of psychological symbolism in music and leads to the collapse of musical chromaticism. These explorations of Wagner by no means suggest a pessimistic outlook for the future of music or the future of art. As Bertrand Russell observes in his memorable study on scepticism: 'Great ages and great individuals have arisen from the breakdown of a rigid system: the rigid system has given the necessary discipline and coherence, while its breakdown has released the necessary energy. It is a mistake to suppose that the admirable consequences achieved in the first moment of breakdown can continue indefinitely. No doubt the ideal is a certain rigidity of action, plus a certain plasticity of thought, but this is difficult to achieve in practice except during brief transitorial periods. And it seems likely that if the old orthodoxies decay, new rigid creeds will grow up through the necessities of conflict'†—

* In the English translation of these seven imaginary tales and critical articles, called by Wagner 'A German musician in Paris' (*Richard Wagner's Prose Works*, Vol. VIII, trans. by W. A. Ellis, London, 1898) many variations and insertions are given of Wagner's texts as they appeared in French and German journals. The phrase attributed by Gauguin to Wagner does not appear in this collected version though it is entirely appropriate to the spirit of certain tales, notably 'An End in Paris'.

† Bertrand Russell, 'On Catholic and Protestant Sceptics', in *Why I am not a Christian* (London, 1970).

by Rembrandt had he been born in India.' And the Goncourts conclude their enthusiastic account by invoking not only Rembrandt, but Rubens, Velazquez and Tintoretto.

Writing in *Le Mercure de France* (September 1894) on the occasion of the purchase of a Turner for the Louvre from the Sedelmayer exhibition, Camille Mauclair declares in the same superlative vein, making also some pertinent comparisons: 'Turner is one of the gods of the palette; his skill and sense of the pictorial medium belong to fairyland. A landscape of this painter is like a heap of precious stones, of faded gold and molten glass, of enamel and of yellow ore . . . Apart from his kinship with Claude Lorrain, Turner shows a relationship with certain pictures of Watteau. *L'Embarquement pour Cythère* is a Turner. And two French artists in this century continue his tradition: Claude Monet, who went further in the dissociation of harmonic colours, and Monticelli.' Turner, Mauclair accurately observed at this early date, 'serves as a bridge between Claude Lorrain and Claude Monet'.

Turner's works exhibited in Paris, forgeries as they apparently were, aroused amazement and ecstasy. In proof, moreover, of the extent of Turner's impact, indeed as a defence of his revolutionary visions, contemporary criticism was shot through with devastating streaks of irony and caricature. Nowhere is the sardonic style of Huysmans so brilliantly conveyed as in his chapter 'Goya and Turner' in his collection of essays *Certains* (Paris, 1889): 'One is confronted in the pictures of Turner with a complete confusion of pinks, burnt siennas, blues and whites, seemingly rubbed together with rag, sometimes taking a roundish form, sometimes running along in a straight line, or branching off into great zig-zags. A picture of Turner has the appearance of a print rubbed over with soft bread, or of a mass of soft, tender colours over which water has flowed on a sheet of paper and which is then closed up, the painter then coming along to touch it up with his paint brush. All sorts of amazing shades of feeling emerge from all this, particularly if, before closing the wetted paper, a few dots of white gouache have been thrown in.' This is what Turner's pictures look like close up, Huysmans goes on, 'but from a distance everything falls into place. Having been put off, we now see a marvellous landscape coming into view, a fairy-like vision, a spreading river above which we see the rainbow-hued rays of the sun. The vault of heaven disappears into infinity or merges into the horizon, the colour of which is mother-of-pearl. Then the vault is reflected and enters some glistening watery regions, almost soapy in texture, illuminated by the ghostly colour of

bubbles.' When reading Huysmans one is never quite sure whether he is a doubting Thomas or dumbfounded by Turner's novelties. He asks, for instance, 'Where, in which country, in which Eldorado or Eden do these mad lights blaze, are these torrential visions reflected in milky clouds with patches of fiery reds and with furrows of violet, like the depths of an opal?' He concedes, however, that these visions are real and aspires ultimately to a profusion of images in the manner of Turner himself: 'They are autumn landscapes, they are rust-coloured woods, running waters and forests shorn of their leaves. But they are also landscapes that fade away . . . celestial celebrations, imaginary rivers that reach into infinity and which are transformed into something completely fluid by a great poet.'

Turner, like every other artist, lives by the variety of critical assessments which he inspired, and it is consequently amazing to observe that over a hundred and fifty year ago, in 1816, Hazlitt in his Round Table essays in *The Examiner* produced a criticism of Turner which might apply to tachiste painting or *musique concrète* today. This criticism is all the more remarkable since it was written after Turner had painted, not one of his advanced later works, but the conventional *Crossing the Brook*. The arts, Hazlitt said, had a tendency 'to run into pedantry and affectation. . . . A musician, if asked to play a tune, will select that which is the most difficult and the least intelligible.' Shakespeare took delight in his 'conceits' and 'some artists among ourselves have carried the same principle to a singular excess'. Hazlitt went on to explain that 'we here allude particularly to Turner, the ablest landscape-painter now living, whose pictures are however too much abstractions of aerial perspective and representations not properly of the objects of nature as of the medium through which they were seen. They are the triumph of the knowledge of the artist and of the power of the pencil over the barrenness of the subject. They are pictures of the elements of air, earth and water. The artist delights to go back to the first chaos of the world, or to that state of things when the waters were separated from the dry land, and light from darkness, but as yet no living thing nor tree bearing fruit was seen upon the face of the earth. All is without form and void. Someone said of his landscapes that they were *pictures of nothing, and very like.*'

It is impossible for musical people not to see in those last words, 'Pictures of nothing and very like', images accurately conveying the evocative symbols of music in scene painting. The approach on the other hand to Ruskin, the greatest of all Turner critics, who was

eccentric and rhetorical but also some kind of penetrating biblical prophet, must be undertaken by a guide able to pilot us through the mysteries of his five-volume *Modern Painters*. I have certainly no pretension in this direction. It is nevertheless certain that we have no equivalent of Ruskin among the music historians of his time. Not even in the latter part of the nineteenth century were the early writers on the life and ideas of Wagner equipped, as Ruskin seems to have been in regard to Turner, to enter into and interpret Wagner's ideas with such freshness and lack of any kind of pedantry. Our music historians, Wagner's early biographers and the analysts of the *Ring*, not only lacked Ruskin's literary style; they were constantly concerned with polemical issues of a technical or social order, and they were anxious to collect biographical material not always with the capacity, however, to see its wider artistic significance. On the completion of his five-volume work on the ideas of Turner Ruskin states, 'There will be nothing left for the life but when he (Turner) was born and where he lived and whom he dined with on this or that occasion. All of which may be stated by anybody.' True enough, and we consequently have no orthodox biography of Turner by Ruskin. Though florid in style, Ruskin was a person of humility. 'He had more to learn than to teach', says one of the earliest of Turner scholars, A. J. Finberg. Like 'every intelligent young man . . . he makes nearly every blunder which a beginner can make'.

Here for instance are three of Ruskin's most illuminating passages on colour. In the first we are concerned with a phenomenon well known in music, namely that colour and form do not normally co-exist. The use in a broad sense of chromatic harmony has repeatedly shown this to be true. Ruskin writes (*Modern Painters*, II, p. 350):

> Colour without form is less frequently obtainable; and it may be doubted whether it be desirable: yet I think that to the full enjoyment of it, a certain abandonment of form is necessary; sometimes by reducing it to the shapeless glitter of the gem, as often Tintoretto and Bassano; sometimes by loss of outline and blending of parts, as Turner; sometimes by flatness of mass, as often Giorgione and Titian. How far it is possible for the painter to represent those mountains of Shelley as the poet sees them, 'mingling *their flames* with twilight', I cannot say; but my impression is that there is no true abstract mode of considering colour; and that all the loss of form in the works of Titian or Turner, is not ideal, but the representation of the natural condition under which bright colour is seen; for form is always in a measure lost by nature herself when colour is very vivid.

In his later philosophy, expressed in Volume IV, Ruskin sees the symbolical aspects of Turner's colour. One is reminded of the Red Moon in *Salomé* and in *Wozzeck*, and of the music of insanity which Strauss and Berg devised for these scenes, in reading Ruskin's account of the *Slave Ship*. The Red Moon in Debussy's proposed setting of the *Fall of the House of Usher* would probably have come into this category:

'He was very definitely in the habit of indicating the association of any subject with circumstances of death, especially the death of multitudes, by placing it under one of his most deeply crimsoned sunset skies. The colour of blood is thus plainly taken for the leading tone in the storm clouds above the *Slave Ship*. It occurs with similar distinctness in the much earlier picture of *Ulysses and Polypheme*, in that of *Napoleon at St Helena*, and subdued by softer hues in the *Old Téméraire*.

At this point I should like to relate these impressions of Ruskin to the theories of Heinrich Wölfflin in his *Principles of Art History*, the English edition of which appeared in 1932, that is to say when the colour infatuations of Stravinsky, Matisse and Picasso still persisted, but before doing so I should like to quote another passage in Ruskin (*Modern Painters* I, p. 149), even more florid but nonetheless relevant:

'Let not arguments respecting the sublimity or fidelity of *impression* be brought forward here . . . Turner's colour is glaring to one person's sensations, and beautiful to another's. This proves nothing. Poussin's colour is right to one, soot to another. This proves nothing. . . . We have been speaking . . . of the ordinary effects of daylight on ordinary colours. . . . It is a widely different thing when Nature herself takes a colouring fit, and does something extraordinary, something really to exhibit her power.'

Now all this is made perfectly clear in Wölfflin because he shows the dissociation of colour from the object (usually attributed to Kandinsky but in fact evident in European art long before). Again and again in reading Wölfflin one is reminded of the colour theory alluded to by late nineteenth-century French musicians: 'Puisque nous avons renoncé la couleur locale', was a favourite saying of Debussy in his conversations with the French imitators of the Wagnerian orchestra. This, in the light of Wölfflin's argument, tells us everything we wish to know about the colour sense common to musicians and painters. In Titian, Wölfflin writes, 'colour is in principle no longer something adhering to objects, but the great element in which things attain visibility, something coherent, uniformly moving and changing every minute . . . Titian, in the portrait of *Charles V* (in Munich) introduces a red

carpet, and Antonio Moro, in the portrait of *Mary of England* (Madrid) a red chair, both of which speak powerfully as local colour and impress themselves on the imagination as objects—as a red carpet and a red chair. This is *la couleur locale*. That is just the effect which later artists would have avoided. Velazquez's method in his well-known portraits was to repeat the given red on other objects—clothes, cushions, curtains, in each case slightly modified, whereby the colour easily enters into a combination detached from the thing and more or less parts company with the underlying object.'

Elsewhere in his study Wölfflin speaks of 'the power to perceive the world as a juxtaposition of patches of colour'. When this occurs, he prophetically declares, there will be fulfilled 'the great metamorphosis which forms the real content of the development of occidental art'. Wölfflin, obviously, was writing before the colour explosion, foreseen by Baudelaire, had become manifest in Van Gogh, in Matisse and in Messiaen. It was a statement of extraordinary perspicacity and foresight.

We are back to the almost indefinable regions of representation and abstraction. The representational technique belongs to painting but not to music; in fact in music any form of representation is impossible except by illusion or symbolical associations. This must account for Debussy's admiration for the 'mysterious' ideal in Turner—an abstract ideal belonging to the musical sphere. Richard Strauss similarly approaches the common territories of music and painting. In his edition of Berlioz's *Treatise on Instrumentation*★ Strauss refers to the 'classical' manner of orchestral writing as 'opposed to the *al fresco* treatment of the orchestra as introduced by Wagner. [*Al fresco* must in this sense mean Impressionist.] The classical stands in the same relation to the *al fresco* style as that of the Florentine painters of the fourteenth and fifteenth centuries [i.e. the followers of Giotto and later Masaccio, Fra Angelico, Uccello and Pollaiuolo] to the broad manner of Velazquez, Rembrandt, Franz Hals and Turner with their wonderfully shaded colour combinations and differentiated light effects.' The point Strauss is trying to make becomes clear enough when, as an example of the Impressionist style in orchestration with its 'differentiated light effects', he quotes the Fire Music in *Die Walküre*.

Both Ruskin and Wölfflin discuss this matter of clarity and suggestion. Ruskin is writing on Turnerian mystery (*Modern Painters*, IV, p. 53).

★ See *Treatise on Instrumentation* by H. Berlioz, *revised by* R. Strauss, trans. T. Front (New York, 1948).

Of all modern artists, Turner is the one to whom most people would first look as the great representative of this nineteenth-century cloudiness . . . every one of his compositions being evidently dictated by a delight in seeing only part of things rather than the whole, and in casting clouds and mist around them rather than unveiling them. . . . The first and principal thing to be submitted is, that the clouds *are there*. Whether we like them or not, it is a fact that by far the largest spaces of the habitable world are full of them. That is Nature's will in the matter. . . . Not only is there a *partial* and variable mystery thus caused by clouds and vapours throughout great spaces of the landscape; there is a continual mystery caused throughout *all* spaces, caused by the absolute infinity of things. *We never see anything clearly* . . . everything we look at, be it large or small, near or distant, has an equal quantity of mystery in it . . . all great work is indistinct; and if we find on examining any picture closely, that it is all clearly to be made out, it cannot be, as painting, first rate. There is no exception to this rule. *Excellence of the highest kind, without obscurity, cannot exist.*

I am sure it is right to say that in music despite the precision of pitch (which we suppose to be true) or the accuracy of dynamics, there is an element of obscurity, even of deliberate vagueness, in the notation of a musical score. No one has ever succeeded in defining the nature or even the appeal of music; it is by its nature nebulous, and for this reason alone music historians cannot approach the problems of musical style in the methodical manner of art historians. Where, for instance, do we find a music historian echoing the thoughts of Wölfflin: 'The unclear in itself is no problem for the sixteenth century. The seventeenth century recognises it as an artistic possibility. The whole of Impressionism rests upon it. To represent movement by obscuring the form (*cf* the rolling wheel) first became possible when the eye had found some charm in the half clear.'

Elsewhere in regard to conceptions of 'movement', which by their nature have long motivated the musical impulse, Wölfflin rather surprisingly states: 'The style of movement, or impressionism . . . tends to a certain unclearness. It is adopted, not as the product of a naturalistic conception . . . but because there is a taste for indeterminate clarity. Only in this way did Impressionism become possible.'

The point has been made. The further we proceed in the world of visual knowledge, the more complex is the optical and psychological interplay. This veiled indeterminate quality, of which Wölfflin speaks, leads us straight into the world of Marcel Proust. Proust was a later Baudelairean figure, and his imagination was nourished by Ruskin's revelation of the works of Giotto, Botticelli and Carpaccio.

Proust possibly derived inspiration from Turner's water-colours and certainly from Turner's pictures *The Harbours of England* (notably Scarborough and Plymouth). Elstir in *A la Recherche du temps perdu* reflects a certain visual conception peculiar to Debussy (in *Voiles*, for instance) consisting of a certain static quality in which the outlines are deliberately blurred—the mystery and the obscurity which were the ideals of Ruskin and Wölfflin. Jean Autret in his work *L'Influence de Ruskin* (Geneva, 1955) offers this analysis of Proust's ideas on Turner:

> Proust speaks of the characteristic nature of the early manner of Elstir using mythological subjects (*A l'ombre des jeunes filles en fleurs*: *Le Côté des Guermantes*). This is also typical of the nature of the early manner of Turner ... who was a product of the classical school and who painted scenes of classical mythology. In comparing the technique of Elstir with that of Turner, one finds certain striking resemblances. The narrator explains that one of the most frequent images in the seascapes of Elstir is that which obliterates any dividing line between the earth and the sea, and that it was this view repeatedly put forward that brought unity to his work. The narrator also says that Elstir's view of the shore ensured that the land and the sea were one (*A l'ombre des jeunes filles en fleurs*). Nor was there to be any clear dividing line between the sea and the sky, creating thereby a deliberate confusion between these three elements.

Jean Autret identifies the passage in Ruskin's account of Turner's *Harbours of England* which, he surmises, must have been in Proust's mind when conveying the confusion between the sea and the sky in *A l'Ombre des jeunes filles*:

> He first was assured of another fact, namely that the *Sea* was a thing that broke to pieces. The sea up to that time had been generally regarded by painters as a liquidly composed, level-seeking consistent thing, with a smooth surface rising to a water-mark on sides of ships; in which ships were scientifically to be embedded, and wetted, up to said water mark, and to remain dry above the same. But Turner found during his Southern coast tours that the sea was *not* this: that it was on the contrary a very incalculable and unhorizontal thing, setting its 'water-mark' sometimes on the highest of heavens as well on the sides of ships;—very breakable into pieces; half of a wave separable from the other, and on the instant carriageable miles inland; not in any wise limiting itself to a state of apparent liquidity, but now striking like a steel gauntlet, and now becoming a cloud, and vanishing, no eye could tell whither; one moment a flint cave, the next a marble pillar, and next a mere white fleece thickening the thundering rain. He never forgot those facts; never afterwards was he able to recover the ideas of positive distinction between sea and sky, or sea and land.

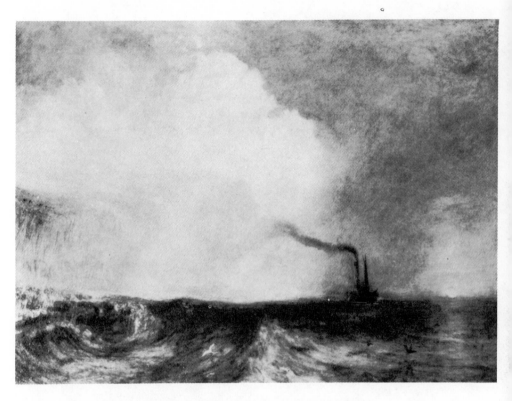

1. J. M. W. Turner: Staffa, Fingal's Cave. Oil

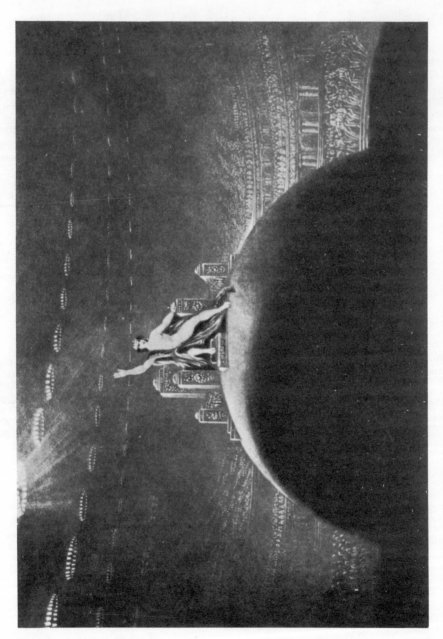

2. John Martin: Satan presiding at the Infernal Council (illustration for Milton's *Paradise Lost*, II. 1–5). Engraving

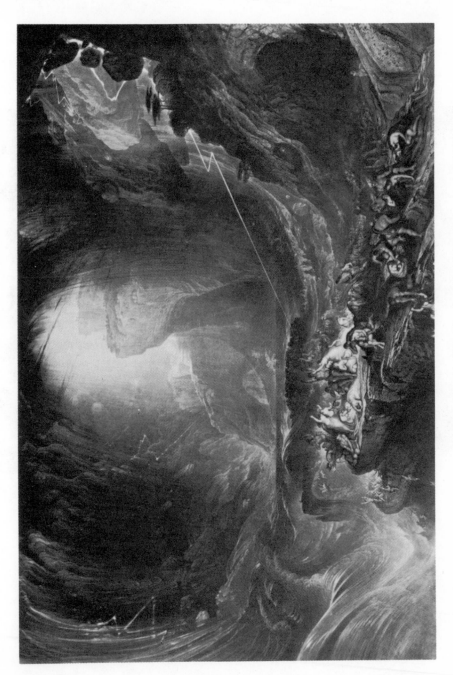

3. John Martin: The Flood. Engraving

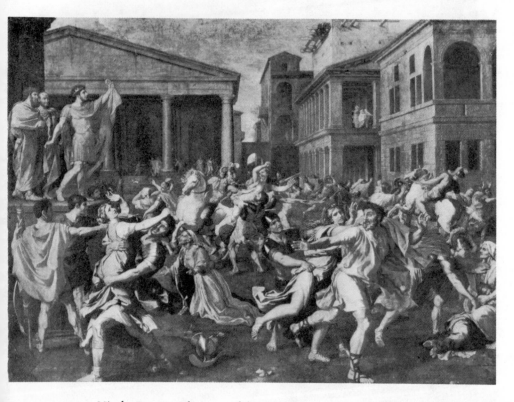

4. Nicolas Poussin: The Rape of the Sabine Women. Louvre, Paris. Oil

5. Nicolas Poussin: Lamentation over the dead Christ. Oil

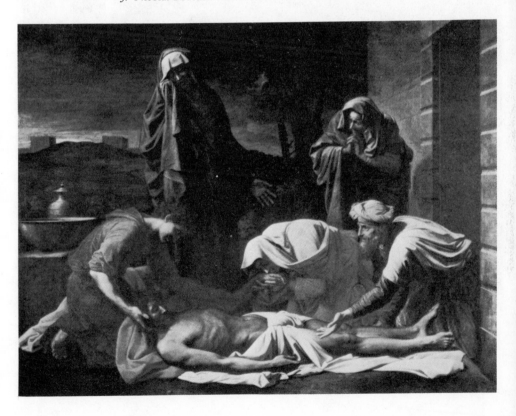

6. Eugène Delacroix: Femmes d'Alger. Louvre, Paris. Oil

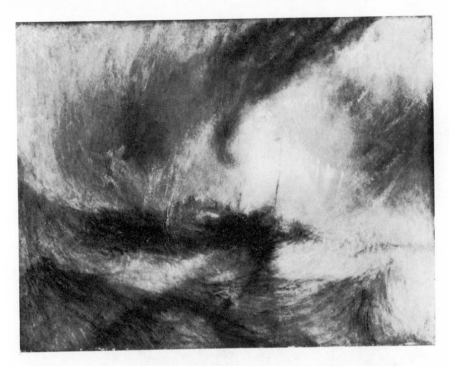

7. J. M. W. Turner: The Snowstorm. Oil

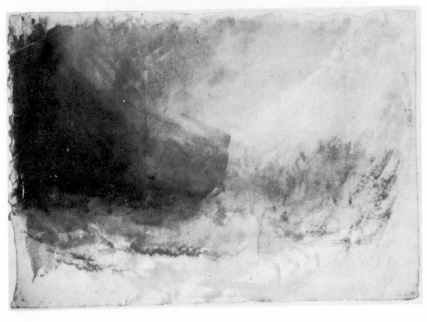

8. J. M. W. Turner: Colour Beginnings. Sketch

9. Odilon Redon: The Head of Orpheus floating on the Waters. Charcoal

Proust was one of the few artists of his time who admired both Turner and Wagner. Others were Debussy and Laforgue. They each saw the broad sensuous visions of these nature artists as an expression of a philosophy of hedonism. Proust was inspired by Ruskin but he might equally have been inspired by Shaw's brilliant assessment of Wagner as 'the brandy of the damned'. Unfortunately, Shaw seems to have been unknown to Proust. Yet he might easily serve as a link between Wagner on the one hand and Turner on the other.

It is evident that the empires of Wagner and Turner, subjugating between them the musical and pictorial movements of the nineteenth century, seemed not to have formed any alliance. Wagner was concerned with the philosophies of religious and social affairs, at least so he says in language that is often unintelligible; Turner with the wider worlds of contemplation and an impact on the senses in the manner of Rousseau. Yet two such powerful forces were not to be kept permanently estranged. They definitely shared an expression of the cataclysmic aspects of nature, Wagner in the Fire Music consuming Brünnhilde, Turner in such works comparable to Wagner as the several pictures of the Burning of the Houses of Parliament. Perhaps it is right to say that Wagner, driven on by a tyrannical domination (admirably analysed in Bertrand Russell's *History of Western Philosophy*), reflects the ruthless ideas of King Lear who, on the verge of madness, says:

> I will do such things—
> What they are yet I know not—but they shall be
> The terror of the earth.

In all Wagner's later operas, including *Meistersinger*, which nearly drove Ruskin mad, a powerful element of chromatic harmony is introduced which has remained to this day the most controversial issue in the musical language. The reason is simple enough. By the introduction of this 'colour' element—and chromatic harmony means precisely this—the form, the structure, the pictorial 'composition', as Ruskin and Wölfflin foresaw it, becomes gradually undermined. It would not at this stage be appropriate to trace the nature of the development of chromatic harmony from Wagner onwards, except to emphasize the potent colour principles that so often mark the glorious decline of an artistic civilization. Something is released from repression which, while it lasts, derives from a more powerful inspiration.

Let us, finally, reconstruct the original Wagnerian impression. In 1876, when the first criticisms appeared in *The Times* of the Bayreuth

performances, the effects recorded of the Wagnerian orchestra were not
far removed from Ruskin's descriptions of Turner: 'The orchestra
must forever be doing something—like a wind that is always blowing,
or a stream that is always flowing or trees that are always bending in
obedience to the scurryings of the breeze.' In accordance with the
modern outlook sexual problems nowadays provide the key to
Wagner's inner ideas.* Yet how refreshing it is to return, even
momentarily, and out of the Freudian hothouses, to the original
Nature-inspired ideas of Wagner.

One will always wish to bring some new focus to the Romantic
movement, and indeed the philosophical associations proposed by
Bertrand Russell set our scene precisely. 'The romantic movement is
characterized, as a whole,' he writes, 'by the substitution of aesthetic
for utilitarian standards. The earth-worm is useful, but not beautiful;
the tiger is beautiful, but not useful. Darwin (who was not a romantic)
praised the earth-worm; Blake praised the tiger. The morals of the
romantics have primarily aesthetic motives. But in order to characterize
the romantics, it is necessary to take account, not only of the import-
ance of aesthetic motives, but also of the change of taste which made
their sense of beauty different from that of their predecessors. Of this,
their preference for Gothic architecture is one of the most obvious
examples. Another is their taste in scenery.' †

But of course this is not the only element to be considered in the
complex nature of Wagner. One may be anxious to show Wagner's
connections with contemporary movements in painting, but before
doing so it is necessary to establish the tyrannical nature of Wagner's
character. Bertrand Russell refers to Byron as his model of a romantic
hero, and here again his observations are equally applicable to Wagner.

> This outlook [i.e. that of an anarchic rebel or a conquering tyrant] makes an
> appeal for which the reasons lie very deep in human nature and human
> circumstances. By self-interest Man has become gregarious, but in instinct
> he has remained to a great extent solitary; hence the need of religion and
> morality to reinforce self-interest. But the habit of foregoing present satis-
> faction for the sake of future advantages is irksome, and when passions are
> roused the prudent restraints of social behaviour become difficult to endure.
> Those who, at such times, throw them off, acquire a new energy and sense

* This approach dates at least from the end of the nineteenth century. See H. de
Gauthier-Villars, 'Bayreuth et l'homosexualité', in *La Revue blanche*, Paris, Vol. X,
No. 67.

† Bertrand Russell, *History of Western Philosophy* (London, 1969).

of power from the cessation of an inner conflict, and, though they may come to disaster in the end, enjoy meanwhile a sense of godlike exaltation which, though known to the great mystics, can never be experienced by a merely pedestrian virtue. The solitary part of their nature reasserts itself, but if the intellect survives the reassertion must clothe itself in myth. The mystic becomes one with God, and in the contemplation of the Infinite feels himself absolved from duty to his neighbour. The anarchic rebel does even better: he feels himself not one with God, but God. Truth and duty, which represent our subjection to matter and to our neighbours, exist no longer for the man who has become God; for others, truth is what *he* posits, duty what *he* commands. If we could all live solitary and without labour, we could all enjoy this ecstasy of independence; since we cannot, its delights are only available to madmen and dictators.

An amazing statement indeed from the atheist among modern philosophers. Mysticism and rebellion—all nineteenth-century art theories were founded on these principles—and indeed most people would agree on the dictatorial elements in Wagner and in a milder but no less authoritative form, in Turner. In the meantime, despite their divergent views, certain resemblances are inescapable. Turner's pictorial imagination is present surely in the music depicting the depths of the Rhine, at the opening of *Rheingold*; in the raging storm of *The Flying Dutchman*, both in the Overture and in the final act; in the storm invoked by Donner in *Rheingold*; in the flooding waters in *Siegfried*; in the hurricane terrors in *The Ride of the Valkyries*; and in the fire music of Loge. All these present pretty close parallels with Turner's ideas, not to speak of the nature motives that run through *Rheingold* and which also open and close *Siegfried*. All these musical or pictorial images—it is difficult to know on which level they originated—seem to emerge only partly from the composer's imaginative mind, and it was therefore not for nothing that Wagner suggested to King Ludwig that having invented the invisible orchestra he wished now to invent something even more fantastic, even more ethereal, and certainly something close to the painting abstractions a hundred years hence, namely the invisible stage.

A final observation needs to be made in regard to Wagner's peripheral connections with the world of painting. Wagner's Paris friends included a prominent figure in the art world, Frédéric Villot, a friend of Delacroix and curator of the Louvre. It was to Villot that Wagner dedicated his lengthy essay 'Letter on Music' elaborating his theory on music and the future. Villot was among the first art historians, writing

in *La Revue universelle des Arts* (January 1857), to call attention to the influence on French painters of Constable. Art historians are aware that at least thirty works of Constable had been imported to Paris by the dealer Arrowsmith and others, where their influence on Delacroix and the painters of the Barbizon school has been a subject for investigation by art critics down to the present day. I am not suggesting that Wagner was at all conversant with this controversial matter. Indeed he seems never to have accepted Villot's invitation even to visit the Louvre. But he made his own contribution to Villot's problems. In the musical sphere, and in the course of his famous 'Letter on Music' Wagner made it clear to Villot that he owed the success of his early operas, and of *Tannhäuser* in particular, to the manifold associations of colour. Wagner was no great literary exponent, and therefore he does not quite put it in this way. He says that he owes his early success to Weber. And Weber, on the authority of those who came directly or indirectly under his influence, meant one thing. It was colour.

6

Baudelairean Criticism

> 'They live to live; we, alas, we live to
> know ... only those will understand me
> for whom music provokes ideas
> of painting.'
> BAUDELAIRE

The first thing to say about Baudelaire, taking an eagle-eye view of
his vast influence, is that he was compelled wholly to become absorbed
in the great contemporary ideas of his time. Artists who submit to an
identification process of this kind normally open the way to oblitera-
tion. They are submerged. This is not the word one could ever use of
Baudelaire. Rising above these battles of ideas, Baudelaire became
infinitely enriched. For instance, many studies have been written on
Baudelaire's interpretation of Delacroix in whom, as an art critic,
Baudelaire saw himself reflected just as Ruskin was reflected in Turner.
It is therefore clear to us today that Delacroix would not have been
the artist he became without Baudelaire's revelatory studies. In the
literary sphere we face a similar problem. For many of us Baudelaire
stands out as the greatest poetic mind of the nineteenth century. Yet a
little less than half of Baudelaire's published works consist of transla-
tions of the hypersensitive Poe, works which Baudelaire actually felt
he had written himself with the result that Poe, a minor figure in
England and America, has remained almost to this day a fertilizing
creation of the French mind. This same response was aroused by
Wagner. Here Baudelaire was not only able to receive the full impact
of the early Wagner ('Il me semblait que cette musique était la mienne',
he wrote to Wagner after *Tannhäuser*). The hedonistic philosophy of
the *Fleurs du Mal* marked him out as the dominating literary figure in
the Wagnerian movement of his time.

These ideas were widespread during Baudelaire's lifetime. Who was
the man, Nietzsche wondered, best suited to meet the Wagnerian

impact? Without any doubt, it was Baudelaire 'more than half the time a bizarre madman'. He is 'a rake, a mystic; he is satanic but above all Wagnerian'. Elsewhere he is 'a kind of Richard Wagner without music. . . . He was possibly a man of corrupt taste, but precise and categorical and very sure of himself; in this way he exerts a tyrannical influence over the vague artists of today. As he was the principal prophet and advocate of Delacroix in his time he would now be the principal Wagnerian in Paris. There is much of Wagner in Baudelaire.'

I think it is right to say that this Wagnerian crusade on Baudelaire's part was largely intuitive. Baudelaire died in 1867, having heard only fragments of *The Flying Dutchman*, *Tannhäuser*, *Lohengrin* and the Prelude to *Tristan* conducted by Wagner in Paris in 1860, and the historic Paris production of *Tannhäuser* the following year. Yet these few works, a mere foretaste of the mature Wagner, inspired by far the most ecstatic literary descriptions of music produced in the nineteenth century.

Apart from the performances of Wagner in 1860 and 1861, Baudelaire seems never again to have heard Wagner's music played in concert halls or at the Opera. He heard Wagner played only in the casinos of Philippe Musard (a composer of light music known as the *roi des quadrilles*) and on the piano of a mental home to which he was admitted in the year before his death.

Curiously enough Baudelaire does not comment on the Prelude to *Tristan*, a musical counterpart, as we are now clearly able to perceive, of the indulgences and excesses of the earlier *Fleurs du Mal*. One can only conclude that Baudelaire, the poet of *La Géante* and *Le Possédé*, was unaware of the extent of his musical discoveries and was probably enraged, as was Berlioz at the concert which they attended together, by the chromaticism of *Tristan*. Berlioz's notorious article in the *Journal des Débats* (9 February 1860) described the Prelude to *Tristan* as 'a sort of chromatic groaning . . . full of dissonant chords in which the long appoggiaturas, replacing the true harmonic note, merely augment the cruelty'. Berlioz was revolted by the Wagnerian 'Music of the Future'; Baudelaire, however, saw it as the fulfilment of his ideals.

Writing in February 1860 while Wagner was completing *Tristan*, Baudelaire states: 'What I experienced was indescribable. . . . It seemed to me that I already knew this music . . . that it was *my own music* . . . I have often been aware of that state when one is penetrated or invaded by voluptuousness as if one were rising into the air or riding

through the sea. . . . Your music revived sensations peculiar to my outlook and my frequent practices.' Baudelaire was clearly referring to the effects of hashish and opium. Three months later, in May 1860, his opium essays were published under the title *Paradis artificiels*, well calculated to reflect the impact of Wagner's early works. Elsewhere comparisons with painting are suggested in Baudelaire's letter to Wagner: 'I imagine before my eyes a vast stretch of dark red. If this red represents passion', he writes almost in surrealist fashion, 'I see it growing gradually, through all the shades of red and rose to the glow of a furnace.' Van Gogh's imagination runs on other lines. He uses an abundant variety of colours which, however, when intensified, produce, 'as in Wagner's music', an effect of intimacy.* The essay on *Tannhäuser* of 1861, inspired by the over-quoted and somewhat sentimental line of E. T. A. Hoffmann, 'Les parfums, les couleurs et les sons se répondent', similarly explores the work of painters and the ecstasies of the drug world.† Leonardo da Vinci, Hogarth and Reynolds are surprisingly mentioned in this essay as examples of theorists establishing art principles in the manner of Wagner's philosophies of music and drama, while Baudelaire has no hesitation in hiding the fact that Wagner's 'despotic' music evokes opium visions.

Baudelaire's Poe translations, but above all his Poe criticisms, especially the study *Edgar Poe, sa vie et ses œuvres* (1856), show how, in the fashion of the twentieth century, critics assume a creative role. This occurs when criticism is fertilized by the subject of its analysis. Stravinsky and Picasso were critics of this order. Whether the reconstruction of the entire historical scene of music and painting was undertaken by these particular figures working as artists or as critics of genius is immaterial. Baudelaire did not admit of any such distinction. He was concerned to discover an artistic personality that should throw his own

* Van Gogh writes to his sister *c.* 1888: 'At present the palette is distinctly colourful, sky blue, orange, pink, vermilion, bright yellow, bright green, bright wine-red, violet. But by intensifying *all* the colours one arrives once again at quietude and harmony. There occurs in nature something similar to what happens in Wagner's music, which, though played by a big orchestra, is nevertheless intimate.' (*Complete Letters of Vincent Van Gogh*, trans. by J. van Gogh-Bonger and C. de Dood. 3 vol. London, 1958.)

† This line, or an adaptation of it, frequently appears in Baudelaire's works. It was first expressed by E. T. A. Hoffmann in his *Kreisleriana*: 'It is not so much in the dream state as in the preceding delirious stage, particularly when one has been immersed in music that a relationship is established between colours, sounds and perfumes.' The line haunted Baudelaire in his poems 'Correspondances' and 'Harmonie du Soir'; it is quoted from Hoffmann in the essay 'De la couleur' forming part of *Salon de 1846*; and it appears in the essay on *Tannhäuser* in the form of a quotation from 'Correspondances'.

ideas into relief. In Poe Baudelaire was able to perceive a key to the
inner workings of his own mind. Literal translations of Baudelaire's
mental insights (which incidentally were produced fifty years before
Freud) will hardly serve our purpose. A paraphrase is desirable.
Towards the end of his final essay on Poe's life and work Baudelaire
writes:

> Poe penetrates behind the nervous façade of his characters. He enters a subject
> as one enters a whirlpool. He works in depth yet there is no obscurity. His
> stories are prompted by a quirk, an odd theory, or some strange observation
> of Nature. . . . No one has hitherto expressed these phenomena of life and
> Nature in this way—the will to live, nervous relaxation (as in the slack
> strings of a musical instrument), unemotional tears, an interplay of delusion,
> doubt and reason, and the logic of the absurd. Elsewhere hysteria is challenged
> by will-power, tension by intellect. Thrown off his balance, a man may
> express pain by laughter. Behaviour is ephemeral. But it is open to scientific
> analysis and may reveal the nervous terrors that lead a man to evil. Grotesque
> and gruesome ideals are a mark of sincerity. It has often seemed to me that
> sincerity of this kind must be born of idleness, of virginity or of a repressed
> sensibility. The sight of blood flowing from the veins, wild gesticulations or
> shrieks echoing in the air, these must similarly belong to this irrational world.
>
> Anguish buried in this rarefied literature, also an apprehension of fears
> and the terror of wide spaces—Poe's characters and their surroundings are
> one. Like our Eugène Delacroix who reaches poetic heights, Poe's figures
> move against backgrounds of a purplish or a greenish colour, foreshadowing
> decay or an approaching storm.* His characters, or rather the one character
> that he reproduces, high-pitched in intellectual perception, a man of relaxed
> nervous disposition yet possessing an all-defying will-power and given to a
> manner of staring at objects with a tense, sword-like inflexibility until these
> objects grow out of all proportion—this man is Poe himself. And his women,
> transparent, sickly, languishing of strange maladies, their speaking voice a
> kind of music in itself—these women are Poe too, or rather by their idealism,
> their inner feelings and the monotonous persistence of their melancholia,
> they belong to the same cast of mind as their creator.

Another aspect of Baudelaire is illustrated in the tale of the dancer
La Fanfarlo and Baudelaire's autobiographical portrait Samuel Cramer.
We must constantly return to this analytical tale to see the manner in
which Baudelaire enlarged upon the ideas of Poe and E. T. A. Hoff-

* This comparison brought a sympathetic response from Delacroix, at any rate in
regard to his earlier works. Delacroix writes in his *Journal* of 'the sense of mystery with
which I had been greatly concerned in my painting'. Baudelaire was right, he maintains,
in perceiving in his early works 'the strange sentiment of idealism and the attraction to
terror' suggesting the spirit of Poe.

mann. Nourished by musical experiences, Samuel Cramer, a poet or
a painter, one is never quite sure, was at once 'a great loafer, an ambi-
tious man of woe and an illustrious wretch. Hardly ever in his life did
he receive more than half-formed ideas. The sunshine of laziness,
ceaselessly shining within him, brought him to a nebulous state,
annihilating also that spirit in him of half a genius. Of all the men
aspiring to greatness known to me in our fearful Parisian scene, Samuel
was conspicuous in failing to achieve a beautiful work—a sickly and
fantastic creature whose poetry emerges from the figure he presents to
the world rather than from his work itself, and who at about one in the
morning, seated before a blazing fire with the clock ticking, personifies
a god of impotence—a modern hermaphrodite god commanding an
enormous, colossal and indeed epic form of impotence.'

Baudelaire's vocabulary discloses the borderlands of creation and
sterility: 'How shall I bring forth this gloomy nature lit up with
lightning flashes, lazy also adventurous, of courageous schemes but
which miserably fall to pieces, a mind naïvely paradoxical but of
limitless imagination? One of Samuel's obvious faults was to believe
himself to be the equal of the objects of his admiration. His enthusiasm
for a fine book led him to conclude that it was a book good enough to
have been written by himself and to believe in the end that he had
actually written it.'*

Elsewhere imaginative and physical elements are indistinguishable.
Samuel 'would have sold his shirts for a man hardly known to him but
who nevertheless became an intimate friend—their friendship based
on the observation made only the previous day of the form of this
unknown man's forehead or his hand. . . . He himself became each of
the artists he had studied and each of the books he had read and yet,
despite this play-acting element, he remained wholly original.'†
The quest for knowledge (or for imaginative indulgence) was Baude-
laire's religion: 'They live to live; we, alas, we live to know. . . . Only
those will understand me for whom music provokes ideas of paint-
ing.'

It is here that the hypersensitive nature of Roderick Usher may be
seen as an inspiration of the delicately balanced Samuel Cramer. Both

* Émile Henriot discovered Baudelaire's notes for a lecture on the *Paradis artificiels* in
which he confesses that he was unable to say how much of this work belonged to himself
or to Thomas de Quincey. Similar 'amalgamations' (Baudelaire's word) have been
undertaken by present-day artists, among them T. S. Eliot, Alban Berg and Stravinsky.

† 'C'est en imitant que j'innove' declared Ravel, among the last figures in the Baude-
lairean tradition.

were musicians and painters. Usher suffered from a constitutional
nervous exacerbation. Pursued by fear, life would eventually ebb away.
The same malady affected his sister, the Lady Madeline. Our interest
in *The Fall of the House of Usher* today is in the nature of the music and
the painting of Roderick Usher foreshadowing developments of a much
later period. 'I was busied in earnest endeavours to alleviate the melan-
choly of my friend. We painted and read together, or I listened, as if
in a dream, to the wild improvisations of his speaking guitar.' The
descriptions of the improvisations played by Usher on the guitar
look forward to the final stages of our chromatic music.* 'His long
improvised dirges will ring forever in my ears. Among other things I
hold painfully in mind a certain singular perversion and amplification
of the wild air of the last waltz of Von Weber.† . . . I have just spoken
of that morbid condition of the auditory nerve which rendered all
music intolerable to the sufferer with the exception of certain effects
of stringed instruments. It was perhaps the narrow limits to which he
thus confined himself on the guitar which gave birth, in great measure,
to the fantastic character of his performances.' Usher's paintings with
their cultivation of a musical or vague quality in the tradition of Turner
or Delacroix, together, apparently, with an abstract or surrealist
tendency associated with Fuseli, show that Roderick Usher anticipated
the taut explosive nature of twentieth-century artists. 'From the paint-
ings over which his elaborate fancy brooded, and which grew, touch
by touch into vaguenesses at which I shuddered the more thrillingly,
because I shuddered knowing not why;—from these paintings (vivid
as their images now are before me) I would in vain endeavour to educe
more than a small portion which should lie within the compass of
merely written words. By the utter simplicity, by the nakedness of
his designs, he arrested and overawed attention. If ever mortal painted
an idea that mortal was Roderick Usher. For me at least—in the cir-
cumstances then surrounding me—there arose out of the pure abstrac-
tions which the hypochondriac contrived to throw upon his canvas an

* The quotation by Béranger at the head of Poe's tale runs:

 Son cœur est un luth suspendu;
 Sitôt qu'on le touche il résonne.

† The misattributed 'La dernière valse [or pensée] de Weber, was first published as No. 5
of the *Valses brillantes* by C. G. Reissiger, Weber's successor at the Dresden Opera, in
1824. Reissiger is said to have played the piece to Weber, to whom he presented a manu-
script copy. After Weber's death in 1826 Reissiger's piece was assumed to be the final
inspiration of the composer of 'L'Invitation à la Valse' and appeared in many instrumental
and vocal forms until the beginning of the twentieth century.

intensity of intolerable drive, no shadow of which I felt in . . . the concrete reveries of Fuseli.'

It is likely that in his art criticisms Baudelaire recalled Poe's evocations of Usher's imaginary paintings. He refers to the impressionist descriptions of 'mixed tones' and 'reflections' in nature, and has a wonderful passage recalling Constable's dictum that, as in musical effects, constantly changing by their nature, light and shadows never stay still.★ What prompts these reflections? A purely physical association, the image of a woman's hand, the hand of a sanguine woman, 'lean but covered by the most delicate skin where there is perfect harmony between the green strong veins projected like ridges and the blood-tinged tones of the knuckles. Rose nails are similarly contrasted with the greyish and brown tones buried in the joints.' Also, 'wine coloured lifelines in the palm are separated from an invading green and blue network'.† Nowhere, not even in the art of the *Intimistes*, are physical origins so clearly to be discerned.

Historians who acknowledge that colour induced in Baudelaire a state of euphoria comparable to the state to which he was brought by music are nevertheless left with the difficulty of defining his critical ideas in a broad musical and visual approach. This difficulty seems at first to be two-fold in that, despite the intensity of his response, Baudelaire was himself neither a painter nor a musician. In fact this was a virtue. Since Baudelaire could never be caught up in the evasions or complexities of critical jargons he was free to perceive, in the music of Wagner or the paintings of Delacroix, an irresistible freshness and warmth. Where do we find an assessment comparable to Baudelaire's wholly contemporary interpretation of Delacroix's *Femmes d'Alger*? As a critic, Baudelaire built here greater than he knew. A glum, melancholic mood pervades the pictures of Delacroix, 'even the most coquettish and florid of his pictures the *Femmes d'Alger*. One breathes some kind of heady brothel scene in this silent poem of an interior, overstocked with luxurious fabrics and personal belongings, a silent and reposeful interior which quickly leads to the ill-defined frontiers of dejection. Normally Delacroix does not paint women who are beautiful in the fashionable sense. Nearly all his women are sick in heart and therefore one is aware of an inner glowing beauty. Power is not

★ The undertones in the original can hardly be reproduced: 'Les ombres se déplacent lentement, et font fuir devant elles ou éteignent les tons à mesure que la lumière, déplacée elle-même, en veut faire résonner de nouveau.' ('De la couleur', from *Salon de 1846*). Baudelaire: *Œuvres complètes* (Paris, 1966).

† *Ibid.*

expressed by the shape of muscles but by a tension of nerves. It is not merely suffering that Delacroix is able to express but beyond this—and here is one of the miracles of painting—a moral suffering. A grave melancholy, which bleakly illuminates his works, is drawn from broad simple colours, from harmonic schemes massive like those of all the great colourists, and from a pitiful and moving character such as we hear in the melodies of Weber.'

Later, in his articles on Delacroix of 1855 and 1863, Baudelaire almost announces the theories of Debussy and Stravinsky. Delacroix's colour—he is referring to *La Chasse aux Lions*—'thinks for itself'; the subtle scheme of the colourist's gradations suggests 'mathematics and music'. Translations and identifications of this kind constantly fertilize the criticisms of Baudelaire. Not only do painters and musicians become chameleon-like figures in these artistic communions, but writers and poets, and Baudelaire himself chief among them, are effaced in this way.

The regions of Baudelaire's art criticisms of compelling interest for us today are those where he brings into relief the problems of the Impressionist era and even looks forward to twentieth-century problems. Had he lived to the age of sixty Baudelaire would have brought the same Impressionist appreciation to the works of Monet, Pissarro and Sisley. Criticisms of contemporary painting are to be found in his poetry. In the *Fleurs du Mal* there are several indications of the methods he was to use: the portrait of Daumier, Delacroix's picture *Tasso in Prison*, Manet's *Lola de Valence* and the epic poem *Une Martyre*, are illustrations in the most harrowing Baudelairean manner of amorous annihilation. Yet Baudelaire was a Janus figure upholding tradition but looking forward to Wagner and the future. Among the subjects of *Les Phares* (the sixth in the set of the *Fleurs du Mal*) are poems glorifying Rubens, Leonardo, Rembrandt, Michelangelo, Pierre Puget (the sculptor), Watteau, Goya and Delacroix. These were the artists in his Pantheon of whom he wrote, following his reference to 'the stifled sigh of Weber':

> Ces malédictions, ces blasphèmes, ces plaintes,
> Ces extases, ces cris, ces pleurs, ces *Te Deum*,
> Sont un écho redit par mille labyrinthes;
> Ces pour les coeurs mortels un divin opium!

It is interesting to note that Baudelaire wrote at great length on Constantin Guys, in whom he apparently saw a painter who would

eventually open a way to the *Olympia* of Manet, the *Bar aux Folies-Bergère*, originally in the collection of Chabrier, and *Le Moulin de la Galette*. The date of these criticisms was 1859–60. Constantin Guys had not the reputation of his earlier years. Baudelaire, however, brought an intuitive understanding to his oriental or fashionable sketches. At the end of Baudelaire's life Manet is praised for his *Guitariste* and for the introduction in France, as in the works of Chabrier and Bizet, of 'the Spanish genius'. Whistler, the last of the contemporary artists assessed by Baudelaire, presents a series of engravings at a Paris gallery in the form of improvisations depicting the banks of the Thames: 'a wonderful jumble of rigging, yards and rope; a confusion of mists, of furnaces and of smoke in corkscrew effects—the obscure, complex poetry of a great capital'.

Whistler, whose musical aspirations authorized him to entitle his atmospheric pictures *Nocturnes* and *Symphonies*, allows us to approach a curious development in the arts known as Synaesthesia. The 'colour and sounds' theory of E. T. A. Hoffmann had led to many attempts to 'translate' musical effects into their supposed colour equivalents. One of Hoffmann's images was that of his hero Johannes Kreisler presented as 'the little man in a coat the colour of C sharp minor with an E major coloured collar', a fantasy which must be described as thoroughly absurd. Yet this meaningless image was conceived by an outstanding critic of Beethoven. Was there some hidden alliance between the realms of sound and colour, an alliance which artists and musicians have hoped to establish since the eighteenth century and which has not been abandoned yet? There was surely an instinctive urge towards this end, at least this is the impression gathered from the colour and sound experiments of Newton and Goethe. The scientist and the philosopher were, however, obliged to abandon their efforts in the end for the reason that the measurements of sound and light waves do not correspond. For the same reason twentieth-century experiments show that this dual appeal succeeded only within a limited sphere, in the Loïe Fuller and Diaghilev ballets and in Diaghilev's opera productions. Thereafter, on the purely practical plane this union of painting and music, a *mal de siècle* as it turned out, approached disaster. Schoenberg's *Die glückliche Hand* and Scriabin's *Prometheus* contain examples of the utter failure of colour 'translations' of this kind.

True enough, the enlargement of the imaginative experience was approached hopefully. As a critic of painting, literature and music, Baudelaire brought the artistic experience out of an isolated rut

peculiar to the practice of one art or another. He aspired to this union of sound and colour in the manner of Wagner in the *Gesamtkunstwerk*, but it remained an unattainable aspiration. Hence the virtues he sees in the theories of Hoffmann, and hence the nebulous, indefinable, other-worldly musical ideal that underlies his work. There is a theory that our verbal language is merely a device of man for concealing his inner feelings, to which Baudelaire would have subscribed and which is illustrated in the deepening unconscious penetrations of nineteenth-century music.

Part Two

Orpheus Pursued

'All art constantly aspires to the condition
of music.'
WALTER PATER: *The Renaissance*

7

Baudelaire's Musical World

'La musique creuse dans le ciel.'
BAUDELAIRE

At the beginning of his poem entitled *La Musique*, Baudelaire has the suggestive line, 'Music often carries me away like a sea'—'carries me away' or perhaps 'possesses me' might be a better translation, for in the original—*La musique souvent me prend comme une mer!*—the use of the word *prendre* has obviously a sexual association. We have therefore straight away, in this highly charged line, the key to Baudelaire's musical philosophy: music is an infinite art, also indefinable, a tempestuous overpowering art by which one is submerged as by the sea, as indeed one is submerged in this same overpowering manner in the sexual act. At any rate, this was the connection that Baudelaire made in his mind; whether he experienced ecstasies of this order is doubtful. Probably not, and therefore, according to a well-known theory, his poetic expression of this comparison becomes all the more acute.

Some of Baudelaire's biographers, noting that he had planned to write a poem entitled *Beethoven*, believed that the ideas of *La Musique* reflect his response to certain works of Beethoven. I cannot accept this. In the first place it is impossible to say which works of Beethoven were heard by Baudelaire. Though he is referred to in the most general terms in the essays on Théophile Gautier, Théodore de Banville and Wagner, Baudelaire avoids mentioning the title of a single composition by Beethoven. Wagner was surely the composer who suggested this sensuous, orgiastic poem, the Wagner of *The Flying Dutchman*, by which, as we know, Baudelaire was overwhelmed and in which the sea music, similarly shot through with erotic associations, compels from the listener nothing less than a complete surrender.

Baudelaire was the first of the great French writers on Wagner, and he remains today the least pompous and also the least abstract of the early Wagnerian critics. He is certainly the writer whose ideas are

most keenly attuned to our modern ideas of the music drama. His famous essay of 1861, 'Richard Wagner and *Tannhäuser* in Paris', not only reconstructs for us the full force of the Wagnerian explosion; it explores for the first time the many critical and philosophical avenues associated with Wagner. It is amazing to find here, for instance, Baudelaire's pronouncement, frequently taken up in the twentieth century, 'All great poets naturally and fatally become critics.' 'It would be unthinkable for a critic to become a poet', he ironically adds, 'and it is impossible for a poet not to contain within him a critic.' There speaks the psychologist among the critics of Wagner: already a window is opened on to the later symbolical interpretations of his works. Also, this essay of 1861 amounts to a treatise on Baudelaire's conception of the critical method in music. The starting point, he held, for a criticism of *Tannhäuser*, or for any work of art, must be some kind of shock, a ravishment, a vision transformed from another world. Otherwise knowledge—technical knowledge, historical knowledge, or philosophical knowledge—has no emotional undertones, no wonder, no drive, no purpose. True enough. One is reminded of the order hurled at Jean Cocteau fifty years later by Diaghilev: 'Astonish me, Jean!' Indeed there was much in *Tannhäuser* to astonish Baudelaire—as we know, it was the work which not only produced astonishment among musical audiences but which actually provoked and encouraged hostility. Feelings ran high, and remained on this feverish level, as if music were exacerbating an open wound, up to and including *Le Sacre du Printemps*.

One of these days this phenomenon of hostility associated with music during this period must be investigated—it should help us to understand some of the baffling developments of the present day—but this is not quite the problem that preoccupied Baudelaire. 'Savagery', he bluntly states of the Venusberg music, 'has a place in the drama of love,' and in the spirit of the *Fleurs du Mal* he proclaims that 'the enjoyment of the flesh must always lead, by some ineluctable Satanic logic, to the delights of crime'. People today are no longer put off by the extravagance of Baudelaire's rhetorical language, but in any case his style, in musical matters, is often lightened by his inimitable irony. Following a catalogue of Wagner's languors and his ecstasies, of the realistic sighs and groans in his amorous music, it is reassuring to read that the overture of *Tannhäuser* presents 'the whole onomato-pœic dictionary of love'.

The Wagner–Baudelaire relationship is one of those key relation-

ships which, according to the way you look at it, seems to affect every later development. Let me contrast some of the ideas of Baudelaire with those of two other key figures of the nineteenth century, Goethe and Freud. It is often held that the essence of Romantic poetry is contained in the last two lines of Goethe's *Faust*:

> Das Ewig Weibliche
> Zieht uns hinan.

The setting of these lines in Mahler's Eighth Symphony is well known. They occur at the very end of *Faust*, chanted by the chorus:

> All things corruptible
> Are but a parable;
> Earth's insufficiency
> Here finds fulfilment;
> Here the ineffable
> Wins life through love;
> Eternal Womanhood
> Leads us above.*

Some people believe that these two simple lines are the greatest in German poetry. Perhaps they are. But they are also sentimental lines. Who today can believe this notion? Womanhood does not draw us above, upward. We are more inclined today to think of an invading idea of womanhood, the huge mother-figure which envelops and oppresses us. Eternal womanhood is uplifting, says Goethe, but the voluptuous women of Baudelaire's poems—his prostitutes, mulattos, and Jewesses, also his serpents, cats, and corpses—have the opposite of an uplifting function.

Here is the essential difference between, on the one side, Goethe, Beethoven, and Mahler—romanticists preoccupied with some kind of 'lofty' ideal—and, on the other, Baudelaire, Wagner, and Freud, inquirers into the hidden workings of heart and mind. These were the artists—and Freud must be included as an artist—primarily concerned with coming to terms with the forces of evil in human nature, with the concept of guilt, with sensuality. A relevant point is that several poems of Baudelaire emphasize precisely this concept of woman as an oppressor. The women in the poems of Baudelaire have tremendous limbs, they are enormous, they are ready to be ravished by a Titan. One of the early poems is actually called *La Géante*, the giantess, a fantasy vision of a mother-figure, as we should say nowadays, dwarfing

* Goethe, *Faust* Parts I and II, trans. by Louis MacNeice, Faber & Faber, 1951 and 1965.

her sensitive child. If we imagine the amazing impact first made by Wagner's heroic sopranos then the Baudelaire–Wagner relationship is seen in rather a new light. Some contemporary critics of Baudelaire and Wagner—their contention, though amusing, is illuminating— believe that the gigantic, voluptuous creatures in the poems of Baudelaire were a reflection of this new type of operatic animal.

Baudelaire, as we have seen, told Wagner that he imagined he might have written this music himself—*Il me semblait que cette musique était la mienne*—which is saying a great deal. Where today do we find figures who seem constantly to be losing their identity in this way—figures who are like some kind of artistic monster driven to regurgitate one by one each of the traditions by which they had been nourished—and yet who, despite this alarming activity, remain throughout unmistakably themselves? There cannot be much doubt as to who are Baudelaire's successors. Stravinsky and Picasso are today the principal chameleon figures of this kind. As we know, the contrasts in their successive styles are very marked. They are artists who are literally of many parts. And so it came about that Baudelaire, the rhetorical, flamboyant Baudelaire, was able to identify himself with a composer to whom, by his inner nature, he could hardly have been greatly drawn. Liszt, among Baudelaire's contemporaries, becomes a cherished figure. They correspond with each other and Liszt also becomes the subject of one of Baudelaire's prose poems (*Le Thyrse*). Perhaps it was the Satanic element in Liszt which aroused Baudelaire's admiration.

It was, however, the more acute nervous response discovered by Baudelaire, the *nouveau frisson* produced by his work, which brings him so near to the musical ideals of the nineteenth century. Certain of his poems seem to have been written on several planes:

> *Sois sage, ô ma Douleur, et tiens-toi plus tranquille.*
> *Tu réclamais le Soir; il descend; le voici:*

—those well-known lines, the opening of a poem set to music by another poet, Villiers de l'Isle Adam, and also by Debussy, open up several merging, or colliding memories: the night, peaceful or anguished; *le fouet de plaisir* [the lash of pleasure]; nostalgia for the bygone years; and then finally the command to listen, as in music, to night's approach:

> *Entends, ma chère, entends la douce Nuit qui marche.*

This is hardly a line suggesting the raw, bleeding chunks of Wagner or Liszt. Chopin is the composer whose musical mind is most closely attuned to this aspect of the *Fleurs du Mal*. The analogy is inescapable:

the same lyrical intensity, the same elegance of expression, but above all the same sense of prolonged experience. Oddly, these affinities have been questioned. It is true that Baudelaire was unable to forget his loathing for George Sand ('she has the mentality of a concierge and a prostitute' —though Baudelaire himself was not unattracted to prostitution) and the maternal relationship of George Sand with Chopin set up further complexities. This emotional response was thought to have distorted Baudelaire's artistic judgement though this theory has recently been refuted. Baudelaire and George Sand were united, it now appears, by the way in which their work constantly reverberates with musical associations. In particular, Sand seems to have anticipated Baudelaire in his line, *La musique creuse dans le ciel*, which is surely one of the most extraordinary things said about music in the nineteenth century.* 'Music burrows into the sky' would be the literal translation, but of course we miss here all the overtones of hollowness in the word *creuser*. Hollowness is normally created when one digs in the ground, downward. Baudelaire sees hollowness in the heavens and he thus, in this single line, as so often in his poetry, unites the horrors of emptiness, of nothingness, *le néant*, with infinity, with divinity. Readers of André Gide, who was a great Baudelairean, will remember that Gide believed that Chopin, also, did exactly this.

One of the reasons we are able, perhaps for the first time, today to see the full stature of Baudelaire, at any rate in the world of music, is that he makes us see those terrifying contradictions in his artistic mind. Nowadays every creative mind in music must feel that almost everything is within his grasp; and yet at the same time he must be haunted by the fear of everything slipping away, vanishing. Baudelaire saw this dichotomy and mastered it. Christopher Isherwood catches the real character of Baudelaire here. 'A deeply religious man,' Isherwood writes, 'whose blasphemies horrified the orthodox. An ex-dandy who dressed like a condemned convict. A philosopher of love who was ill at ease with women. A revolutionary who despised the masses. An aristocrat who loathed the ruling class. A minority of one. A great lyrical poet.'

These observations are not so far removed from musical matters as they may seem. The fact is that literary critics pay the greatest attention

* Thérèse Marix-Spire in *Les Romantiques et la Musique. Le Cas George Sand* (Paris, 1954) suggests that Sand not only absorbed the Baudelairean method from Senancour's *Obermann* (1804) but became herself a Baudelairean ahead of her time. In *Obermann* we read, 'C'est dans les sons que la nature a placé la plus forte expression du caractère romantique. . . . On admire ce qu'on voit mais on sent ce qu'on entend.'

to biography. They are always attempting to find out how it came about that that man, with all his indefinable complexities, was able to produce that particular work. This, surely, is the whole purpose of biography. Biographers of musicians do not quite take this view, possibly because music, by its nature, is far too nebulous to be closely associated with biographical events. Nevertheless, this strikes me as strange because the broad problems of the creative mind with which we have to deal are the same.

What I am suggesting is that the motivating forces in Baudelaire's mind—his almost aggressive sensibility, his preoccupation with money, his fierce attachment to his mother—are the same forces that determine the artistic character of certain musicians. I know that French critics are sometimes over-fond of making deductions from an artist's physical appearance, but André Suarès was surely right when, surprised by a portrait of Ravel, he declared that this was the younger brother of Baudelaire. One does in fact see the same curl of the mouth, the same half-shy, half-determined look in the eyes. One need not stop there. Someone might investigate their common preoccupation with the habits of animals—with cats in particular—also their common pre-occupation with strange outrageous clothes. A comparative study of Baudelaire and Ravel remains to be written. Each in his way was drawn to Liszt—to the demoniac, the play-acting, the virtuoso elements in Liszt. The frontiers in Liszt's mind are ill-defined. *Gaspard de la Nuit*, Ravel's most Lisztian work, was based on a set of prose-poems by Aloysius Bertrand which had earlier been the model for the prose-poems of Baudelaire. Therefore we may see reflections of Liszt in a literary work of Baudelaire and a musical work of Ravel—a curious, triangular situation in which Baudelaire, the disciple of Bertrand, dominates the scene. The spirit of *Gaspard*, though a refinement of that of Liszt's *Études transcendantales*, is in fact more closely drawn to the horrors of Bertrand's Hoffmannesque prose-poems.

The early Baudelaire songs of Debussy were calculated to reflect the lush Wagnerian overtones of the *Fleurs du Mal* but they are early songs, and I often think it is a pity Debussy did not attempt a Baude-lairean setting in his later years. In a way he did, of course, in his adapta-tion of Baudelaire's translation of Edgar Allan Poe's *The Fall of the House of Usher*.* Once we approach this harrowing tale, with its

* See Appendix F, *The Fall of the House of Usher*. Libretto for Debussy's projected opera. The libretto was adapted by Debussy from Baudelaire's translation of Poe's tale. The translation into English is made from Debussy's version.

disintegrated figures moving about in isolation, we are reminded that Baudelaire, like Poe, considered that the greatest of sins was the famous *ennui*—boredom. Debussy believed this too. These artists, so hypersensitive and so perceptive, were constantly haunted by the horrors of emptiness, *le néant*. Rilke, Sartre and Kafka were their successors. It is interesting to see that Mansell Jones, one of the most distinguished of Baudelairean scholars, writes of the '*goût du néant*' which Baudelaire shared with his contemporaries, and he goes on to speak of 'all the vagaries of boredom, rainy days, mists, snowflakes and thundershowers which will become favourite motifs with so many of his successors'. Indeed they do, for this particular province of Baudelaire leads straight into the world of Debussy's *Brouillards*, the *Jardins sous la pluie*, and, I think we may add, the snow scene of *Children's Corner*. With the knowledge that Debussy had long been a reader of Baudelaire, we may listen to this music as uncovering the first signs of boredom in the heart of a child.

Dealing briefly with one more of the many aspects of the Baudelaire–Debussy relationship, I should like to refer to a difficult and rather obscure matter. In an appraisal of Baudelaire's off-putting character, T. S. Eliot states that he was 'thoroughly perverse and insufferable'. He was 'a man with a talent for ingratitude and unsociability', Eliot goes on, 'intolerably irritable, and with a mulish determination to make the worst of everything; if he had any money to squander it; if he had friends to alienate them; if he had any good fortune to disdain it.' And then Eliot makes this penetrating observation: 'He had the pride of a man who feels in himself great weakness and great strength. Having great genius,' he explains, 'he had neither the patience nor the inclination, had he had the power, to overcome his weakness; on the contrary he exploited it for theoretical purposes.' By 'theoretical purposes' in this sense Eliot means artistic purposes—at least I think he does. And if I am right, this description follows exactly the frustrated, frequently self-destructive pattern in the lives of Debussy, Schoenberg, Berg and Stravinsky. An aggravated nervous response marks the later works of these artists. Such artists *were* self-destructive. Debussy and Baudelaire were among the artists constantly haunted by thoughts of suicide. Monet among the painters belonged to the same family and so did Van Gogh. I do not think we can begin to understand the painters who worked under the Baudelairean influence without first investigating this wide-ranging musical universe.

Wagner and Chopin, Liszt, Ravel and Debussy—it must appear that

Baudelaire's musical associations are pretty wide, and so they are. I believe that Baudelaire shows us connections between these composers that we would not otherwise perceive. He brings them—and others, too, Tchaikovsky, for instance, and Scriabin—into the heart of nineteenth-century poetic and psychological thought, and he makes them appear, different from each other as they are, all of a family. Baudelaire's ideas have become larger with time, also more penetrating, and therefore Alban Berg, as we see now, is surely a Baudelairean composer not only because he set poems by Baudelaire in *Der Wein*, but because *Wozzeck* itself could simply never have been conceived without the philosophy of the *Fluers du Mal*.

8

Redon and Valéry

'La musique m'ennuie au bout d'un peu
de temps.'
PAUL VALÉRY

Two art critics, a painter and a poet, were aware of the widening
musical inroads in nineteenth-century painting. 'I was born on a sound
wave. Every recollection of my early youth is mingled with music. . . .
It has entered the folds of my soul.' Those are the high-sounding
phrases of Odilon Redon, the first symbolist painter, and as some
believe the first surrealist painter, of our time. Though born in 1840,
he felt the art of the contemporary Impressionist painters to be cramped
or shallow ('low-ceilinged' was his word) and instinctively explored
a remote territory of his own. He brought forth a world of symbolical
fantasy, generally of gruesome associations in the tradition of Breughel
and Goya. Pastels and oils were used, but only late in his career. Most
of the early works are deliberately sombre drawings, charcoals and
lithographs.

Redon constantly refers to the musical nature of his symbolical art,
though unfortunately in obscure terms. 'Music', he writes in the
typical vein of Romantic criticism, 'promotes an acute sensibility more
powerful than passion itself. Music is a danger but a blessing for those
who can accept it.' True enough, but not exactly calculated to disclose
the symbolic enigmas in Redon's painting.★ Huysmans in his art
criticisms *Certains* was probably right in claiming that the ancestors
of a painter who illustrated Baudelaire's belief that 'truth is to be
discovered only in dreams' must have been poets or musicians. Huys-
mans, however, was unaware of Blake and could not of course have

★ These are discussed in *Le Monde Imaginaire d'Odilon Redon* by Sven Sandström (Lund,
1955).

read the illuminating article which Arthur Symons wrote on Redon and Blake shortly before Redon's visit to London.*

There is another reason for reviewing the work of Redon at this stage. In 1886, five years before the theories of Gauguin, Aurier and Maurice Denis, all of which aspired to an equation of musical and pictorial techniques, Teodor de Wyzewa in *La Revue wagnérienne* proposed a distinction between 'symphonic painters', or, as we should nowadays say, abstract painters, and representational painters. Redon was neither of these. He was a symbolical painter; and his profusion of fantasies was nourished in an obscure way by his musical aspirations. This is not so far-fetched as it may seem. Delaunay and Kandinsky aspired to this ideal, and the same is true of Paul Klee.

Readers of Redon's diary *A soi-même* are aware that his series of lithographs *Dans le rêve* is dominated by music, or rather the recollection of musical experiences.† This title might be a generic term for the whole of Redon's work including the fantasies inspired by Goya and his pastel of Schumann. A member of a musical family, Redon was himself a violinist. His intimate friend in the musical world was Ernest Chausson with whom he regularly played works for piano and violin and sometimes chamber works. With a group of Schumann enthusiasts they played the Schumann Quintet. A letter of Chausson to Redon begins, 'Mon cher Schumann'. Redon admired Beethoven and above all Schumann, for whom he developed a cult, possibly because of Schumann's attraction to Hoffmann. The inspiration Redon received from Schumann is mirrored in his charming pastel *Hommage à Schumann*. This consists of the profile of a young woman contrasted with a flower piece in brick reds and pale blues, obviously a symbolical work of some kind. What can these contrasts and symbolical designs signify? Apparently these were hermetic symbols which, in painting as in poetry, must remain obscure. Incidentally, it has not hitherto been

 * 'A French Blake: Odilon Redon' by Arthur Symons in *The Art Review*, July 1890. 'The sensation produced by the work of Odilon Redon', Symons writes, 'is, above all, a sensation of infinitude, of a world beyond the visible. Every picture is a little corner of space where no eye has ever pierced. Vision succeeds vision, dizzily. A cunning arrangement of lines gives one the sense of something without beginning or end—spiral coils, or floating tresses which seem to reach out winding or unwinding for ever. And as all this has to be done by black and white Redon has come to express more by mere shadow than one could have conceived possible. One gazes into a mass of blackness, out of which something gradually disengages itself, with the slowness of a nightmare pressing closer and closer. . . . I have called Odilon Redon a French Blake. The kinship is indeed wonderful.'

 † See Appendix E, 'Huysmans, Redon and Darwin'.

observed that Chausson, well-known for his delightful songs and chamber music in the Franck tradition, possessed one of the most important collections of nineteenth-century paintings.* This would merely have an anecdotal interest were it not for the fact that performances given by Redon and Chausson of the works of Beethoven and Schumann at Chausson's home were heard in what amounted to museum surroundings. One is reminded of the first concert of the works of Debussy heard in a gallery in Brussels hung with the paintings of Gauguin and Renoir, or of the quartets of Schoenberg performed at an exhibition of the composer's paintings in Vienna. The tradition persisted until after the first World War when works of 'Les Six' were given at a Society entitled *Lyre et Palette*.

Redon was in every way remote. He lived in a world of isolation, a segregated world, holding himself aloof from the contemporary movement in painting and music. His charcoal on chamois leather *The Head of Orpheus floating on the Waters* (1881) is a work of great serenity, remarkable, however, for the white triangle, symbolizing, according to Mlle Bacou and other authorities on Redon, the fear of insanity (see Plate 9). Redon refused Diaghilev's offer to provide the scenery for *L'Après-midi d'un faune*. On the other hand, he produced lithographs of Vuillard and Bonnard, themselves intimate painters though not of the darker regions of the mind. It seems incredible that among the works of Wagner Redon should have heard only *Tannhäuser*. Accordingly, when he was asked to produce lithographs of

* Details of this collection were assembled by Mr Ralph S. Grover of Easton, Pennsylvania, who has kindly communicated to me the following catalogue:

CARRIÈRE: *Portrait de femme; Tête de femme; Le baiser.*

COROT: *Rome, le parc et la villa Borghèse; Trouville, barque de pêche à marée basse.*

DEGAS: *Études de danseuse; Danseuse; Le bain; La danseuse étoile; Danseuse au repos; La danseuse aux bas rouges; Femme nue se coiffant; Les blanchisseuses; Portrait d'homme.*

DELACROIX: *Hamlet tente de tuer le Roi; Études de robes pour la Fiancée de Lammermoor, Études de costumes et de manteux masculins pour la même scène; Lion couché dévorant une proie; Arabe à cheval chargeant le sabre en main; Études de Marocains; Lion blessé, une patte levée; Page de Croquis; Lionne; Croquis d'hommes, de chevaux et de pattes; Étude de deux chevaux; Étude d'homme; Étude d'Arabe; La Paix, descendant sur la terre, vient consoler les hommes et ramener l'abondance.*

MANET: *Marine, temps calme.*

PUVIS DE CHAVANNES: *Orphée.*

SIGNAC: *La Seine à Argenteuil, effet de soleil.*

RENOIR: *Le Chapeau de paille; Tête de fillette.*

RIESENER: *Étude pour la Léda; Le Château de Chambord.*

MORISOT: *Sous la vérandah.*

GAUGUIN: *Un Pacage à la Martinique; Vue de la Martinique.*

Parsifal and Brünnhilde he resorted to stylized versions of these charac-
ters. These lithographs are in themselves remote—they lack the fantasy
normally associated with Redon.

The ten lithographs forming the series *Dans le Rêve*, on the other
hand, present a private world of dream visions and distortions con-
ceived in a manner far ahead of their time. *Eclosion* shows a terror-
stricken head emerging from a sea-shell. *Germination* discloses a graceful
profile of a woman encircled by floating, isolated heads. In *The Gambler*
there are three tree-trunks with a minute figure holding a die. *The
Gnome* presents a head with bristling hair, dilated eyes and with oak
leaves for ears shooting through the air like a cannon ball. The date of
the series *Dans le Rêve* is 1879. It would not be out of place in an exhi-
bition of the surrealist works of Picasso, with whom Redon was later
associated, nor among the works of the American symbolical painters
of the 1970s.

Other works of Redon have twentieth-century associations, notably
the drawing inspired by Pascal's line, *Le cœur a ses raisons que la raison
ne connaît pas*, which shows a muscular nude despondently wearing a
woman's headdress, his right hand hidden as he apparently clutches
his heart through a wide opening in his chest. Here is an obvious
anticipation of the Freudian influence. The musical inspiration of his
works is more difficult to define. 'My drawings inspire and cannot be
defined', Redon wrote. 'They determine nothing. They place us,
like music, in an ambiguous indeterminate world.'

Mallarmé was an enthusiastic admirer of Redon though, as a master
of the complex symbol, Mallarmé was bound to confess that even he
was sometimes baffled by the significance of Redon's *Hommage à
Goya*. He writes to Redon in 1885:

> I have been looking at your album of six lithographs [*Hommage à Goya*]★
> during the last two days and I am still exploring them. You have a great
> sincerity of vision and you bring other people to see things as you do. In
> the picture of a mad hermit you mysteriously introduce some poor little
> fellow, or so I should like to think. I shall keep this lithograph apart. The
> 'Head of a Dream' presents a flower growing in a swamp, a wonderful idea
> expressing the sordidness of our daily life. Other ideas or symbols seem to
> collide or collapse in the lithograph 'These embryonic creatures'. The
> 'Goddess of Intelligence' comes towards us out of a Nightmare. 'Dans mon
> rêve' is the pursuit of mystery. It tells us that there is no mystery, but there
> might have been, one can never be sure. I know no portrait of a head con-

★ See A. Mellerio, *Redon*, 1923. 'L'œuvre lithographié,' p. 181.

veying intellectual fear and horror in this way. The 'Strange Juggler' suffering in triumph is himself annihilated by his own juggling tricks.*

Gauguin was similarly drawn to the fantasies of Redon and indeed each of these figures remained remote, self-sufficient, creating for himself a private world. The *Lettres à Redon* include the historical document in which Gauguin informs Redon that he will abandon for ever the scene of European decadence. Wagner at the time of *Parsifal* had such a scheme in mind. He wished to leave the decadence of Europe for the ancient civilizations of the Near East, at least so he told Judith Gautier, where, apart from his interest in oriental philosophy, his indulgences would have found fulfilment. Gauguin's letter is dated 1890. He writes:

> The reasons you give for remaining in Europe are more flattering than convincing. My decision has been definitely taken, though since I have been in Brittany this decision has been modified. Madagascar is still too near the civilized world; I shall go to Tahiti where I hope to finish my existence. I believe that my art which you admire is only a germ and I hope to cultivate it there for myself in a primitive savage state. For this I need calm. . . .
>
> Gauguin is finished here, nothing more will be seen of him. You see that I am selfish. I shall take photographs and drawings, a whole world of friends with whom I shall continuously converse. Of yourself I shall remember all you have done and will see you in the form of a star.

And he concludes with a Wagnerian quotation mentioned in a slightly different form on page 53, in connection with the ideas of Shaw.

> I believe that the disciples of a great and glorious art form a heavenly tissue. Perfumes and melodious chords will return to the divine source of all harmony.†

The shadow of Wagner is almost inescapable in any view of the development of the painters and poets of this period. But of course the Wagnerian spirit became wholly transformed. This is apparent in a small number of works of Redon, but there is evidence that it determined the searching ideas of Paul Valéry. Speaking to the musical public at the *Cirque d'été* on the fiftieth anniversary of the Concerts Lamoureux—an odd occasion as it must seem to us, as if T. S. Eliot or Dylan Thomas had been chosen to commemorate an anniversary of the Royal Philharmonic Society—Valéry declared, 'Any literary history of the end of the nineteenth century which omits problems rooted in contemporary music will be pointless. Such a history will not

* *Lettres à Redon* presented by A. Redon and edited by Roseline Bacou (Paris, 1960).
† See p. 53.

only be incomplete and false, but incomprehensible.' The choice of Valéry for this occasion indicates the nature of the wider public of the Lamoureux Concerts. Valéry dwelt on a well-known poetic theory in which 'expressions devoid of their musical significance must be banished'. Baudelaire learnt to think in this way from the conductor Pasdeloup; and his followers were guided by the principal French Wagnerian conductor of the period, Charles Lamoureux.

Sometimes Valéry reflects the revolutionary ideas of his minor predecessor Jules Laforgue. 'The purpose of painting', he says, 'is indefinite. If its purpose were well defined in the form of an illusion of objects seen, or if it consisted of diverting the eye or the mind by a certain *musical* arrangement of colours and forms, then a simpler problem would arise.' We are almost in the world of Paul Klee. Valéry was a master of paradox. 'Music', he tells us, despite his Lamoureux address, 'bears down upon one after a certain time. The musical experience cannot be indefinitely sustained', he suggests. 'It is reduced in proportion to the work's intensity.' And he goes on: 'Music seldom retains its original appeal; it is seldom that its creative impulse is sustained. A work is created but only rarely is this creation nourished.' With shattering frankness he declares, 'La musique m'ennuie au bout d'un peu de temps'. Valéry was approaching the problems of repetition in musical form which he judged not by the analytical methods of the present day but in terms of architectural proportions as they were enunciated in the age of humanism. Delacroix and Stravinsky would in their different ways have subscribed to this view.

A cynical aloofness runs through all Valéry's writing on the arts. He was a penetrating critic of Degas. Monsieur Teste, his enquiring alter ego, was the model for Debussy's critical methods. He was a successor to Mallarmé though he has nothing of his master's turgidity. 'I am not over-fond of museums', he declares in a youthful diatribe. 'Nor am I enchanted by classifications or preservations. What is a tour of a museum?' our youthful critic continues. 'It is a walk held up in some strange way by the overwhelming sight, to the right and the left, of works of beauty. One picks one's way through the passage of protecting rails rolling from bar to bar under the impact of the master-pieces like a drunkard.'

Several solutions suggested themselves to Valéry in his controversial *Problèmes des Musées*: we must resign ourselves to superficiality, or turn ourselves into critics of erudition—'erudition is a defeat'. Alter-natively one becomes 'terrifyingly sincere' (*affreusement sincère*). But

above all it was the universal nature of the artistic expression that was alarming—a phenomenon that we nowadays cherish. In 1923, Valéry, comparing the profusion of artistic and musical masterpieces available to a restricted public of connoisseurs, could write: 'How could we in the world of music bring ourselves to listen to ten orchestras together?' Today we do somehow listen to this number of orchestras, not together of course, but contrasted one with another, which is more or less what Valéry meant. It is curious to recall, moreover, that long before our widening panorama of the arts was disclosed, satires were devised on musical profusion. In 1859 Baudelaire's biographer Charles Asselineau wrote a grotesque tale, *The Musician's Hell*. A composer is condemned to hear simultaneously all his compositions, good and bad, played on all the pianos of the globe. He flees from town to town in search of sleep, as if in search of the promised land until, driven to despair, he reaches the hemisphere of the beyond where night takes the place of day, giving him some respite. Only in this remote land where self-communion is at last possible does he find love as well as tranquillity, and a restoration of his faculties.

We must not expect to find in Valéry's sketchy art criticisms any penetrating assessment of the work of his Impressionist friends, including his aunt Berthe Morisot. He writes eloquently about the peculiar pleasures associated with a painter's work: 'A strange pleasure, a complex pleasure, a pleasure in the pursuit of which there are no obstacles, no bitterness, no doubt, nor even despair.' Further we read: 'The painter's materials are fascinating: nothing is more stimulating to the sight than the colour box or the well-covered palette. Even the sight of the keyboard produces less of a creative sensation, for it is merely a silent expectant object whereas the wonderful combination of lacquers and terra cottas, oxides and alum sings out in every key.' One is reminded of the description of *L'Après-midi d'un faune* given by Saint-Saëns: this is not a picture, merely a palette for a picture, a derogatory but, as it turns out, a wonderfully accurate description.

In his essay on Degas, Valéry emphasizes the importance of drawing and deplores the interest in landscape at the expense of the human figure. A poet with a mathematical training, Valéry believed that engravings and drawings offered a greater imaginative scope than colour. This theory, proving once again the limitations of the colour aesthetic, is illustrated, Valéry believed, in the drawings of Rembrandt, Claude, Goya and Corot. All great civilizations end in an explosion of colour, it was once observed, not an entirely accurate observation

perhaps, though it may certainly be applied to latter-day musical developments. Within the first three decades of the twentieth century Stravinsky's *Chant du Rossignol*, the work of a master orchestrator, was followed by the severity of the same composer's Piano Concerto, in which the deliberately barren orchestral accompaniment proclaimed the fashionable principle of the 'economy of means', and his neo-classical Piano Sonata. Debussy's appropriately entitled *En blanc et noir* for two pianos is roughly of the same period.

Valéry seems not to have been aware of the freshness of the École de Paris or of the allied contemporary schools, but he offered an example of original art criticism, half pictorial, half literary—the word picture cherished by the nineteenth-century novelists. His exposure of the magical functions of the human mouth is presented with the virtuosity of the Surrealists:

Le corps veut que nous mangions, et il nous a bâti ce théâtre succulent de la bouche tout éclairé de papilles et de houpettes pour la saveur. Il suspend au-dessus d'elles comme le lustre de ce temple du goût, les profondeurs humides et avides des narines.

Espace buccal. Une des inventions les plus curieuses de la chose vivante. Habitations de la langue. Règnes de réflexes et de durées diverses. Régions gustatives discontinues. Machine composées. Il y a des fontaines et des meubles.

Et le fond de ce gouffre avec ses trappes assez traîtresses, ses instantanées, sa nervosité critique. Seuil et actes—cette fourrure irritée, la Tempête de la Toux.

C'est une entrée d'enfer des Anciens. Si on décrivait cet antre introductif de matière, sans prononcer de noms directs, quel fantastique récit!

Et enfin le Parler. . . . Ce phénomène énorme à-dedans, avec tremblements, roulements, explosions, déformations vibrantes . . .*

* 'The body demands that we should eat and has built for us the theatre of the mouth, a succulent theatre lit up by projections of a fleshy or tufted nature whose function is to establish the realms of taste. Above these projections are suspended, in the form of a lustre for this monument of taste, the humid and the avid depths of the nostrils.

'The buccal cavity: one of the most curious inventions of the living being. It is the dwelling of the tongue, and it is also a kingdom of reflexes varying in duration. Gustatory departments are unconnected. Machines operate in complex fashion. Fountains are to be found, and furniture.

'There is also the extremity of the gulf of the mouth with rather treacherous pitfalls, sudden frights and attacks of nerves. At the threshold the skin is irritated. The Tempest of the Cough is unleashed.

'This was for the ancients an entrance to Hell. Without referring to one function or another, what a tale of fantasy.

All this is not to say that Valéry was averse to the colour sensations of the Impressionists—his description of the 'cruel' and the 'incomparable' blue glimpsed by Monet after his operation for a cataract is memorable. He recalls a magic sound sensation which Hoffmann in his *Kreisleriana* calls Euphon. He poetically suggests that a landscape of Corot evokes the transparent orchestral texture of the music of Amfortas in *Parsifal*.

In his youth Valéry was caught up in certain aspects of the Impressionist movement and as a poet presided over the arts in the manner of Mallarmé. In his maturity, however, he pursued the thin dividing line between sincerity and irony. Hence his determination to discard the concealing mask, or to 'kill his puppet', as he put it. This is the theme of *Monsieur Teste*, treatises on philosophy and poetry copied, to Valéry's dismay, in the title and treatment of Debussy's critical articles *Monsieur Croche*.

Having a mathematical mind, Valéry was also drawn to architecture, presumably the architecture of the Renaissance and the seventeenth century of which he sought a musical equivalent.* He tells us that his conception of the proportions of architecture resembled ideas of musical form and that the Greeks were aware of a resemblance between them, a theory endorsed, among others, by Bertrand Russell. Opera, according to this theory (presumably nineteenth-century opera: Valéry seems to have had no knowledge of the operas of Handel) represents not a contrast but a combination of musical and dramatic elements, and was therefore, in Valéry's wholly idealized view, unacceptable. This argument is difficult to follow. 'I said to Debussy', Valéry explains, 'that I foresaw an ambitious scheme built on a contrast of resources and conceived according to a rigorous plan. I would give to each element in opera a new function. The orchestra would have one function, singing another. Dramatic action, mime and dance would each be dealt with independently. The stage would represent several localities. There would be numerous levels and floors with different groups in each department. Light and scenery would be submitted to the same conditions.'

'And lastly Speech. This weird phenomenon is set in motion therein with tremors, rumblings, explosions and resonant distortions.'

'Bouche' de *Mélange*
Paul Valéry: *Œuvres* Vol. I
ed. Jean Hytier, 1957

* See R. Wittkower, *Architectural Principles in the Age of Humanism* (London, 1952) and the discussion of Poussin and the musical modes in Chapter 3.

Debussy was of course not easily able to give serious attention to this scheme of a surrealist and thoroughly unpractical nature. Was it something of a hoax? Later Valéry suggests to Debussy the libretto for an opera on Orpheus, also proposed to him by the critic and orientalist Victor Segalen, 'Now I am going to say something outrageous', Valéry writes. 'Could you not write something double?' What could this possibly mean? A schizophrenic Orpheus? A split, a recondite, an abstruse work, or rather sketches for a work written under the double influence of music and painting to which may be added the triple impact of poetry and mythology?—how can this better be defined than in Valéry's own poem?

> Que fais-tu? De tout.*
> Que vaux-tu? Ne sais,
> Présages, essais,
> Puissance et dégoût . . .
> Que vaux-tu? Ne sais . . .
> Que veux-tu? Rien, mais tout.
>
> Que sais-tu? L'ennui.
> Que peux-tu? Songer.
> Songer pour changer
> Chaque jour en nuit.
> Que sais-tu? Songer
> Pour changer d'ennui.
>
> Que veux-tu? Mon bien.
> Que dois-tu? Savoir,
> Prévoir et pouvoir
> Qui ne sert de rien.
> Que crains-tu? Vouloir.
> Qui es-tu? Mais rien!

* What are you doing? Everything.
 What are you worth? Cannot say. Forebodings, sketches, power, disgust.
 What are you worth? Cannot say.
 What do you want? Nothing, but everything.

 What do you know? Boredom.
 What can you do? Dream, Dreams to change day into night.
 What do you know? Dreams to change one form of boredom for another.

 What do you wish? My well-being.
 What must you give? Knowledge, foresight, and power, serving however, no purpose.

 What do you fear? Will-power.
 Who are you? No one.

Où vas-tu? A mort
Qu'y faire? Finir,
Ne plus revenir
Au coquin de sort.
Où vas-tu? Finir.
Que faire? Le mort.

Where are you going? To death.
For what reason? To the end and never to return
To my rotten fate.
Where are you going? To the end.
And what for? To play dummy.

'Chanson à Part'
from *Pièces diverses*

9

Irony

'Vous me dîtes aimer: je ne puis pas.'
JULES LAFORGUE
Letter to Charles Henry, 1882

'Why are these clownish musicians allowed to make music in Bay-reuth?' Cosima Wagner wrote in a state of uncontrollable fury after a performance in Germany of Chabrier's light-hearted opera *Le Roi malgré lui*. In order to banish any suggestion of ironic poetry from her mind—'beastly trivialities' was Frau Wagner's outraged description of Chabrier's café-concert music—she engaged for purely therapeutic reasons a pianist to play to her far into the night the mazurkas of Chopin. The date of this confrontation between Wagner and Chabrier is 1890.* But of course it was by no means an isolated example of the clash between the popular and the sophisticated styles. Long before, a parting of the ways had been marked out by Nietzsche who had proclaimed the prelude to *Carmen* to be a 'brilliant piece of circus music'. On the one hand the amorous Bayreuth sublimations; on the other, the illusory retreats of play-acting or the dumb pierrot shows, of irony and frustration and of human tragedies enacted not on a spiritual plane, but in the streets, in the circus or the bull-ring, as in *Carmen*; in the fair-grounds resounding with barrel-organ music, as in *Petrouchka*, creations in the spirit of Jules Laforgue and which are reflected in the pictures of Toulouse-Lautrec, Picasso, Rouault and Seurat.

The world of Laforgue has remote origins and, again, it reaches far into the future. It also establishes an important revolutionary outlook. We are concerned of course principally with the correlation or extension of Laforgue's ideas in the worlds of music and painting. The sardonic qualities of the works of Toulouse-Lautrec and Picasso and the corresponding Pierrot works of Debussy, Stravinsky and Schoenberg

* The relationship between Chabrier and Wagner is discussed in Appendix G, 'Chabrier, Wagner and the Painters of their Time'.

could hardly have developed in the way they did without Laforgue's example. Fortunately, we may be guided in our investigations by the excellent study of Georges Jean-Aubry, 'Laforgue et la Musique', published in *La Revue de Genève* in October 1921.

To begin with, says Jean-Aubry, Laforgue created a manner of feeling, a school of ironic thought, anti-romantic, 'clownesque', readily recognized by a band of discreet disciples. The long tradition of irony was renewed by Laforgue not quite in the manner of Baudelaire, though the younger artists of those days—Jean-Aubry was writing in 1921 at the time of the foundation of 'Les Six'—increasingly responded to his work.

Revelatory art criticisms were written by Laforgue, among them his *Salon of 1886*, but the musical influence of Laforgue had not hitherto been fully dealt with. He did not even belong to the nineteenth-century poets whose work attracted composers, and he certainly wrote no musical study comparable to Baudelaire's study on *Tannhäuser*. The fact is that Laforgue lived in Germany in the 1880s and it is suggested that he would hardly have been able to develop his ironic approach to romantic music had he lived in France at this time. This may not be altogether true. On the other hand, had he not tragically died at the age of twenty-seven he would certainly have acclaimed the first signs of French 'Impressionist' music—apparently Laforgue did not know Chabrier—in the way that he had acclaimed the Impressionist painters. Jean-Aubry, an intimate friend of Debussy, states: 'Those of us who mentioned Laforgue to Debussy remember how attached he remained to him, frequently showing affinities in his writings and his conversations with the poet of *Pan et la Syrinx* and *Lohengrin fils de Parsifal*.' These two works belong to the satirical morality plays of Laforgue, the *Moralités légendaires*, quotations from which are frequently buried in Debussy's letters and articles.

Financially, Laforgue was hard pressed in his early twenties in Paris, where he was chiefly attracted to literature and painting. The singer Sanda Mahali was his only musical friend. In Germany where he lived from 1881 he formed a close friendship with the violinist Eugène Ysaÿe and his brother Théo, the pianist. From the moment he arrived in Berlin he was plunged into the turbulent musical streams. 'I do not spend a day without listening to music', he writes; and later: 'The same kind of life in Berlin: snow, beer and music . . . what is there to do in Berlin except hear a great deal of music?'

On looking more closely into Laforgue's remarks it would seem that

he was by no means greatly moved by the music he heard in the Berlin concert halls. He was happy enough working at his poetry while Théo practised the piano. But this did not alter his opinion of the piano as the traditional instrument used as a safety-valve for the literary aspirations of young ladies. Now literary romanticism was Laforgue's *bête noire*, and he never tires of demolishing the romantic dream world. The piano and its romantic associations becomes an obsession in his poetry. In the *Complainte des pianos qu'on entend dans les quartiers aisés* we read:

> Take hold of the Soul so well nourished by literature
> Pianos, pianos, in the well-to-do neighbourhoods . . .
>
> These children what are they dreaming of
> In these boring refrains?

This bantering tone is extended to the piano repertory itself including, as Jean-Aubry is compelled to remark, the admirable but unfortunate Chopin. Jean-Aubry was writing in 1920 and was unaware that half a century later we should be looking to authenticity as the ideal in performance. Laforgue was uninterested in authenticity; he lived in an age of demolishment. The studies of Chopin are 'eternal' and the same epithet is applied to the Variations of Beethoven and the Fugues of Bach.

None of the expressive classical instruments finds favour with Laforgue from which we may reasonably conclude that this excellent poet simply had no feeling for music. Jean-Aubry—and this is where we may see the nature of Laforgue's innovatory ideas—looks beyond this evidence. If Laforgue pokes fun at romantic music it is for reasons of his own. The fact is that Laforgue cultivated a hankering, a passion, an obsession for the music that belongs not to the sophisticated concert hall, but to the *bal musette*, the spectacular Parisian street, the circus. The violin is a popular ballroom instrument and the same is true of the cornet and the flageolet. Above all Laforgue, like Stravinsky, is attracted to the barrel-organ. 'Open wide your heart, my poor painful beast', he writes in one of his two heartfelt laments for this prince among the beggarly street instruments. Nowadays this reaction against romantic music may itself seem old-fashioned. But as matters have turned out Laforgue's ideas were prophetic. Apart from the Pierrot or circus music of Debussy, Stravinsky and Schoenberg, Laforgue's ideas show the beginnings of *musique concrète*: street scenes are portrayed in music as in contemporary Impressionist music. The operas of Wagner, incidentally, do not enter into Laforgue's condemnation of romantic

music. As an Impressionist his appetite for Wagner was insatiable, and he was aware of a great advantage over his literary contemporaries in France. He heard all the operas of Wagner, including *Rienzi*, though not *Parsifal*, and his comments on them are to be found where we should expect to find them, in his art criticisms. Impressions of nightly visits to the famous Renz circus, representing the dual aspect of Laforgue's world, can also be traced in his art criticisms but they are conveyed chiefly in the Pierrot poems and his correspondence.

Laforgue has always enjoyed a wider reputation in England than in France where he is still regarded as a dilettante addicted to the Pierrot world. 'Vive Rimbaud, à bas Laforgue!' proclaimed Picasso. Rimbaud was a self-styled warrior, a revolutionary; Laforgue remained, or appeared to remain, a more timid figure. Poe was likewise associated almost entirely with a minor form, the detective story, at any rate in England and America where he demonstrably failed to arouse anything approaching the sensitive response of Baudelaire. Laforgue presents a similar problem. His seediness or his gloom may not in the first place be discerned in the *Complaintes* or the Pierrot poems but in T. S. Eliot's *The Love Song of J. Alfred Prufrock*:

> The yellow smoke that runs its muzzle on the windowpanes,
> Licked its tongue into the corners of the evening,
> Lingered upon the pools that stand in drains,
> Let fall upon its back the soot that falls from chimneys,

A sordid vision of the same nature is given in the 'Preludes' from *Prufrock*:

> Sitting along the bed's edges, where
> You curled the papers from your hair
> Or clasped the yellow soles of feet
> In palms of both soiled hands.

The bourgeois hell of Prufrock is drawn, as Eliot confesses, from the monotonous scenes of Laforgue (*Ah! que la vie est quotidienne*) notably in *Couchant d'hiver*:

> Grelottants et voûtés sous le poids des foulards
> Au gaz jaune et mourant des brumeux boulevards,
> D'un œil vide et muet contemplent leurs absinthes,
> Riant amèrement, quand des femmes enceintes
> Défilent, étalant leurs ventres et leurs seins.

Other provinces of Laforgue's mind were explored by Pound and also by Joyce. Pound detects three distinct poetic mannerisms to which he

gives weird names: *Logopœia*, the poetry of verbal associations but
which also includes fantasies and word play such as *sexiproque* or
ennuiversel; secondly *Phanopœia*, visual poetry remembered, for instance,
in the description Laforgue gives of the breasts of Elsa in *Lohengrin fils de
Parsifal* which are so little chubby that, covered by saucers, the unfor-
tunate bride is made to resemble the typically emaciated girl acrobat
figures in the early pictures of Picasso; and finally *melopœia*. These are
poems which attempt, as in Mallarmé and Hopkins, to create effects
comparable to the nebulous musical state.* Concrete meanings in these
poems, notably the *Derniers Vers*, cannot be defined. But there are
other poems in this category inspired by music mingled with street
sounds—what we should nowadays call *musique concrète*. The subjects of
these poems include the monotonous strumming at the piano of a
'Chopin waltz threadbare and stale as love', heard in the course of an
afternoon stroll. Perhaps Laforgue was at heart a vagabond. He was, as
we have seen, the poet of the empty heartless barrel-organ. In a letter
from abroad he writes: 'Here I am in a street full of palaces and monu-
ments which is to say that one never hears the autumnal sighs of the
barrel-organs—the barrel-organs, my good Paris friends . . . I am still
waiting to hear the one that is played at about five o'clock at the gates
of the Luxembourg.'†

Born in 1860 of French parents in Montevideo, Laforgue was
educated at Tarbes where he was a failure in all subjects but religion.
This did not prevent him from becoming an atheist and an anarchist.
He enjoyed two sinecures, first as secretary to the art critic Charles
Ephrussi and later as reader to the Empress Augusta in Berlin. It is said
that he had no use for the contemporary fashion of *ennui* for the reason
that he was himself enslaved by something worse than boredom, the
boredom of impotence, physical perhaps, so one gathers from his
poems and tales, and possibly an artistic impotence which paradoxically
did not prevent him from showing signs of genius. Certainly his life
was clouded by some kind of obscure tragedy—the characters in his
satirical tales are invariably drawn to suicide. The guilty Salomé
plunges to her death. Hamlet sticks pins into the statue of his lecherous
mother. Lovers, once their desires are fulfilled, become intolerably

* Laforgue's influence on English literature is dealt with in 'L'Héritage de J. Laforgue',
in *La Revue de littérature comparée*, Paris, January–March 1969. See also 'The Place of
Laforgue in Ezra Pound's Literary Criticism' by N. Christoph de Nagy in *Jules Laforgue
and the Ironic Inheritance*, ed. by W. Ramsey (London, 1969).

† G. Jean-Aubry, *op. cit.*

ugly; and the impotent Lohengrin disappears into the heavens in the form of a swan.

Though he was inspired on many levels, Laforgue was restless. He admired Turner and thought of himself as another Ruskin. In the end he felt that he had missed his vocation. He should not have been a poet at at all, at least so he told the singer Sanda Mahali, but a clown.

His slender poem *Pour le livre d'amour* is self-explanatory:

I could die tomorrow and I have not loved. My lips have never touched the lips of a woman. None has given her soul to me by a look, nor have I been brought to her rapturous heart. Through one's nervous being one suffers for the whole of nature, for men and women, the wind, the flowers, the universe and for one's lack of purity. Love has been spat upon and the flesh mortified. With overweening pride one steels oneself against life. One is alone, a slave of instinct, but instinct is to be defied. Everywhere men of stature and women of gentle appearance, whose chastity needs repair, everywhere one reflects that the great were brought into this world by the foul groans of beastly couplings and by an accumulation of filth for three minutes' ecstasy . . .*

His letters, on the other hand, show a philosophical acceptance. Writing in 1882 to the physicist Charles Henry of the Memlings in the Louvre, he says:

You say: love. I am unable to do so. I can no longer love from the heart, and anyhow that would not constitute love. An intellectual love, yes. But this wouldn't be love either, and the woman who would inspire me with such an intellectual love, where is she? A sensual love? No more successful than the rest. Desire does not spring from abundance. When boredom sets in hour by hour I fancy I am moved by desire but they are false desires. And so I am intolerably bored. Fortunately I love poetry, books, good pictures and water-colours, natural scenery, women's clothes, people of an exceptional character. In a word the whole kaleidoscope of life. But one almost reaches the end in this wretched manner when life has only the interest of a kaleido-scope, don't you agree? Anyhow we know nothing.†

The art criticisms show yet another approach. No critic saw so clearly into the early manifestations of Impressionism in music and painting as Jules Laforgue. Painting must provoke a 'visual orgasm', Laforgue maintained, otherwise it will produce only 'an effect of senti-mental platonic love, an expurgated effect, or of love unlocalized!'

* *Le Sanglot de la Terre*, Paris, 1913.

† Laforgue's published and unpublished correspondence is listed in H. Talvart et J. Place's *Bibliographie des auteurs modernes de langue française, 1801–1949*, Vol. 10 (Paris, 1949).

Music must similarly be reduced to 'sound vibrations' measured by the 'auditory nerve'. Some writers believe that Laforgue's critical ideas reflected the theory of certain scientific writers of this time, among them Helmholtz and Charles Henry, who were attempting to measure aural and visual sensations by physical means. Perhaps these scientific methods play a part in Laforgue's criticisms; perhaps this dual approach brought a new perspicacity to his judgements. For towards the end of his short career he was able to throw a new light on to what, as we now see, were the Impressionist methods of Wagner. He was writing of an exhibition in Berlin: 'The principle of [coloured vibrations] is particularly obvious in the works of Monet and Pissarro . . . where the textures consist of tiny dancing touches of colour, spreading out in all directions, each struggling for supremacy. There is no single melody in these works; the canvas is itself a living, varied symphony, like the "voices in the forest", in the theories of Wagner, which similarly compete for an overall impression.'*

This deliberate confusion of music and pictorial images reflects the methods used by Wagner in his famous *Zukunftsmusik*. Here Wagner, pleading for a keener perception of the sounds of nature, seems to have had in mind the translucent texture of his *Forest Murmurs*. Anticipating the language of the Impressionists, Wagner speaks of a 'silence growing more and more alive', of 'a new power of observing' and of 'hearing with new senses'. The listener also perceives, in the manner of the Impressionist critics, 'with even greater plainness the infinite diversity of voices waking in the wood'.† Laforgue's observation must thus represent the first attempt to relate Impressionist methods in music and painting. Pissarro's mature works date from 1866 and Monet's *La Grenouillère* was painted in 1869. But before this Wagner's *Forest Murmurs*, in its original form in Act II of *Siegfried*, was written between 1857 and 1865. In the textures of all these works the same translucent, multi-coloured methods are used.

Laforgue was thus well qualified to draw a comparison between Wagner and the Impressionists. As early as 1880 he also writes to Gustav Kahn of a broadly based scheme, a sort of recapitulation of history, which in different forms was later taken up by Picasso, Debussy and Stravinsky: 'I have the idea of a book written in a very special style. I shall take each painter who has created a world: Vinci, Watteau, Fra Angelico, Michelangelo, Jordaens, Cresebecke, etc., Van Dyck, Ruys-

* *Œuvres complètes: Mélanges posthumes* (Paris, 1903).
† *Richard Wagner's Prose Works*. Vol. III. Trans. by W. A. Ellis (London, 1894).

dael, Delacroix, Prud'hon, Rembrandt, etc. It will consist of a series of studies in which by an accumulation of words well chosen (meaning and sound) and of certain facts relating to the painters, I will create the feeling of the world created by this painter. My chapter on Watteau, for instance, I have built up by introducing one of the poems of the *Fêtes galantes* of Verlaine.'

There were attempts at this type of word or sound painting in Laforgue's *Paysages et Impressions*. He writes of a park, probably with Pissarro in mind: 'November—despite plans for replanting the borders in mosaic fashion, how rapidly as one looks out from the large terrace windows has the autumn garden deteriorated. Here is the whole length of the arbour with girders and columns and with clusters of black nerves in the form of vine shoots, and on the ground a bunch or two of sickly anaemic yellow leaves. Moss stone steps lead to a sandy terrace where iron garden furniture and sandstone mythology are combined. This fountain has never played in sunlight, and the frozen pool reflects the dull chalky sky, also, the well groomed groves leading to the river.'

Toulouse-Lautrec was certainly one of the artists closest to Laforgue. His evocation is unmistakable:

A Spring evening on a bench on the grands boulevards near the Variétés. A brilliantly gas-lit café. A cocotte dressed in red consumes a bock at one table after another. Upstairs, a dark, quiet room with lamps and tables—a reading room. The floor above is again brilliantly illuminated. Flowers, perfumes, a ball.

Music is not heard amidst the noise of the street crowded with carriages, pedestrians and programme sellers. Yet dancing can be seen: men in morning clothes and boiled shirts correctly lead their partners in blue, pink, lilac or white. The dancing can be seen but the music cannot be heard.*

Wagner helped to open up a new province of Laforgue's imaginative mind, that is to say on a remote, almost inaccessible level. This plane he described in the terms of Eduard von Hartmann, the pre-Freudian psychologist, as the plane of the 'Unconscious, law of the world'. In Berlin he hears three performances of *Tristan* in the course of a single year and in the next ten performances of *Die Walküre* and *Siegfried*. Laforgue's many-sided approach to the arts was relieved, as we have seen, by the bright extrovert attractions of the mundane circus. 'So long as their quarterly allowance lasted [presumably that of Théo Ysaÿe and Laforgue]', writes Georges Jean-Aubry, 'they went to the Renz

* Marie Brunfaut, *Jules Laforgue, Les Ysaÿe et leur temps* (Brussels, 1961).

Circus *every evening* [which is difficult to correlate with Laforgue's
Wagnerian commitments].' This is confirmed in a letter to Sanda
Mahali: 'Are you an admirer of the circus? I have spent five consecutive
nights there.' Jean-Aubry's criticism of 1921 is still valid. 'The fresh
crude colours of the circus immediately attracted this early Impression-
ist, whilst the agility of the circus figures and the melancholy comedy of
the clowns were a revelation for this writer still in search of his style.
. . . Born later, or even if he had lived the normal span of years, he
would probably not have remained insensitive to the refinements of
what is rightly or wrongly called Impressionist music. One can imagine
his pleasure in Debussy's *Nocturnes* or Ravel's *Histoires naturelles*;
equally, illustrations of his writings by Toulouse-Lautrec would not
have been out of place, nor would his enthusiasm for Gauguin. . . . He
had discovered the aesthetic of the circus and of "Parisian folklore"
before Cocteau and Auric. Certainly he would have responded to
Petrouchka and been amused by Poulenc's *Cocardes* and Milhaud's
Bœuf sur le toit. The full range of Laforgue's modernity has yet to be
discovered.'

Indeed, we may certainly include in the Laforguian world Schoen-
berg's *Pierrot Lunaire*,[*] *L'Histoire du Soldat* or *Renard* by Stravinsky,
Debussy's *Gigues*, based on Verlaine's poems *Streets*, with its organ-
grinder of Laforguian associations, and its modern counterpart, Wal-
ton's *Façade* on the poems of Edith Sitwell, herself aware of the terrors
of the mind peculiar to Laforgue. These artists cultivated a dangerous
fantasy, not the realistic situation itself—also a tenderness and a naïvety
and a compulsion to elude reality. The numerous Harlequin pictures of
Picasso, notably his early undated *Pierrot with Flowers* (see Plate 10)
illustrate this tendency.

In 1922 Laforgue's Pierrot world was echoed in the Duino Elegies of
Rainer Maria Rilke. In their commentary on the third Elegy of Rilke,
J. B. Leishman and Stephen Spender state: 'Here Rilke confronts that
physical basis of life which has so often seemed to make man's higher
aspirations meaningless, which held Swift in a condition of fascinated
repulsion, and which, at times, seems even to have upset the balance of
Shakespeare.' The fifth Duino Elegy was inspired by Picasso's *Les
Saltimbanques*, also by Rilke's memories of the circus acrobats in Paris,
who are 'pitifully assembled there on their "threadbare carpet"', and
who 'suggest the ultimate loneliness and isolation of man in this

[*] In 'Variations Schoenberg', *Contrepoints* No. 7, Paris, 1951, André Schaeffner dis-
cusses Schoenberg's text by André Giraud in relation to the ideas of Laforgue.

incomprehensible world'. Though Rilke's philosophy of impotence and the life-and-death perils of the circus can hardly be conveyed by extracts, lines such as these may nevertheless show an extension of Laforgue's ideas:

> Nicht an dir, ihn fühlendes Mädchen, an dir nicht
> bog seine Lippe sich zum fruchtbaren Ausdruck.
>
> (Not to meet yours, girl feeling him, not to meet yours
> did his lips begin to assume that more fruitful curve.)
>
> <div align="right">(from the Third Elegy)</div>

> Du, der mit dem Aufschlag
> Wie nur Früchte ihn Kennen, unreif
> täglich hundert Mal abfällt vom Baum der Gemeinsam
> erbauten Bewegung . . .
>
> (You, that fall with the thud
> only fruits know, unripe,
> daily a hundred times from the tree
> of mutually built up motion . . .)
>
> <div align="right">(from the Fifth Elegy)</div>

The appeal of the circus which increasingly held musicians and painters enthralled is movingly described by Charles Ferdinand Ramuz,* Stravinsky's collaborator in *L'Histoire du Soldat*. Crowds are anonymous but they are united by an inescapable fate: 'One thing is certain—as these townsfolk come and go, a man and a woman together, one friend and another, or together as groups, apparently united, able to observe and to feel, to communicate with each other, to agree, believing also in a common understanding—one thing is certain, that each of these individuals finds himself amongst other individuals, and nothing more. It is certain, too, that each must die. And it is also certain that one is alone in life and alone in death.' These good townsfolk were transported into another world ('Ô solitude tu nous quittes') by the acrobats of the circus and by the trapeze girl: 'On a glass shelf are jars of paint and coloured pencils. They need only be swivelled around for she is a painter. All the painters' devices are known to her. Painters are concerned with the live body. They transfigure, she is the transfiguration of herself.' Ramuz also recaptures the dramatic sensation of entering the circus gates. 'Is one submerged in noise or in silence? In neither, but in music—the music of preparation and of comment.' He was probably also the first writer to perceive an attraction to the death

* 'Le Cirque', *La Nouvelle Revue Française*, Paris, 1 December 1931.

instinct in circus acts: '[The trapeze acrobat] first of all places her hands on her lips throwing kisses in opposed directions. Then we are completely forgotten. Leaping from the ground to which, unlike ourselves, she was never bound, she manages to escape death. Watching her, we similarly escape from ourselves and from death too, though only momentarily and in an illusory form.' Music acquires another function in this escapist world. 'She is outstretched up there and her exaggerated breathing suggests the waves of a lake. A dance tune is heard and she is away . . . an embodiment of the spirit of music, advancing or returning upon itself, and in the form of vaporous mists or clouds. Lighter and ever lighter, she leaves us with the knowledge that we have not the slightest notion of a sense of time.'

Laforgue's influence seems to have become more clearly defined since Jean-Aubry first indicates his musical and pictorial associations, so that we may read today with renewed inspiration the desperate account of Laforgue's pathetic spirit in *Petrouchka*, written by Dame Edith Sitwell when the Diaghilev productions were at their height:

> In *Petrouchka* we see mirrored for us, in these clear sharp outlines and movements, all the philosophy of Laforgue, as the puppets move somnambulantly through the dark of our hearts. For this ballet, alone among them all, shatters our glass house about our ears, and leaves us terrified, haunted by its tragedy. The music, harsh, crackling rags of laughter, shrieks at us like some brightly painted Punch and Judy show, upon grass as shrill as anger, as dulled as hate. Sometimes it jangles thin as the wires on which these half-human puppets move; or a little hurdy-gurdy valse sounds hollow, with the emptiness of the hearts of the passing people, 'Vivant de can-can de clochers, disant: "Quel temps fera-t-il demain? Voici l'hiver qui vient. . . . Nous n'avons pas eu de prunes cette année" '.* But sometimes the music has terrible moments of darkness, as when the Magician gropes in the booth for his puppet Petrouchka. And there is one short march, quick and terrible, in which the drum-taps are nothing but the anguished beat of the clown's heart as he makes his endless battle against materialism. And we know that we are watching our own tragedy. Do we not all know that little room at the back of our poor clown's booth—that little room with the hopeful tinsel stars and the badly painted ancestral portrait of God? Have we not all battered our heads through the flimsy paper walls—only to find blackness? In the dead Petrouchka, we know that it is our own poor wisp of soul that is weeping so pitifully to us from the top of the booth, outside life for ever, with no one to warm him or comfort him, while the bright coloured rags that were

* Laforgue, 'Hamlet ou la suite de la piété filiale' (*Moralités légendaires*). See *Œuvres complètes*.

the clown's body lie, stabbed to the heart, in the mire of the street—and, with Claudius, we cry out for 'lights, lights, more lights'.*

Street music, heart music—we move a little further into the despair of the musical mind. I do not think that Cosima Wagner need have been moved to her towering rage by Chabrier's tentative efforts in the *Petrouchka* tradition. With hindsight, of course, the jig-saws of the whole romantic century fit into place. Besides, as we have seen, the circus world had been blasted open by *Carmen*.

The Prelude to *Carmen*, with its prominent use of drum, triangle and cymbals, had been accurately described by Nietzsche, in Laforguian fashion, as a 'brilliant piece of circus noise', an opinion endorsed by Jean Cocteau who discerned that Nietzsche had 'praised in *Carmen* the crudity that the present generation found in the music hall'. And *Carmen* had been heard by Wagner himself, though what his opinion was of the circus music of the Prelude we shall never know.†

* Edith Sitwell, *The Russian Ballet Gift Book* (London, 1921).

† The references for the investigations of these opinions of *Carmen* are *Friedrich Nietzsches Randglossen zu Bizet's Carmen*, ed. by H. Daffner, Regensburg, 1912; and H. W. Klein, 'Bizet's admirers and detractors'; *Music and Letters*, Oct. 1938. Wagner heard *Carmen* in Vienna in 1875. Far from being aroused by the coarse music-hall Prelude against which Bizet's great drama of human passion is so ironically set, Wagner was drawn to the conventional Micaela–Don José duet. Nietzsche heard *Carmen* in Genoa in 1881 and, as is well known, attributed to this work an 'African' sensuality. 'Music must be Mediterraneanized' was his famous declaration in *The Case of Wagner*. The fact is that, as A. Schaeffner has shown (*Lettres à Peter Gast*, Monaco, 1957, Vol. I, p. 179, and Vol. II, p. 227) Nietzsche had been reading Alphonse Daudet's description of the French Riviera in his novel *Le Nabab*. He speaks of Daudet's 'harsh description of its African character', and of the scene of 'motionless palm trees, slender trunks, with their drooping tops creating showers of green lining the blue seas with their thousand regular slats.' Is this allusion to the stark, primary colours of Bizet's orchestration in *Carmen* too far-fetched? Not at all. Schaeffner tellingly relates this scene to the pictures of Matisse and Dufy. I hardly think it is possible to listen to *Carmen* again without some evocation of these great Mediterranean painters of our own time.

IO

The Orphic Legends

'In the end we shall have had enough of
cynicism and scepticism and humbug,
and we shall want to live more
musically.'
VAN GOGH

In 1907 Debussy was impressed by an account of the mechanism of the
musical imagination which took the reader far into the world of
fantasy. This was *Dans un Monde sonore* by Max Anély, the pseudonym
of Victor Segalen.* This tale in the style of Jules Verne, who as long ago
as the 1860s had written his tales of imaginary journeys to the centre of
the earth and to the moon, was an early literary attempt to use the tech-
nique of science fiction. Not only did this curious tale reawaken some of
Debussy's earlier notions on the function of the imaginative mind but
it brought him into terms of close friendship with Segalen who, like
Debussy himself, lived in a world of heightened sensations.

When Victor Segalen died in 1919, at the age of forty-one, little was
known about the literary works of this obscure ship's doctor. Only
three volumes of his writings had been published. They were *Les
Immémoriaux*, based on the Polynesian researches of William Ellis and
others, which was illustrated with sketches and pictures by Gauguin;
Stèles, a commentary on Chinese proverbs and poems privately printed
at Peking; and a volume of word pictures, *Peintures*. Borderlands
between the arts in these works frequently overlapped. Traveller, doc-
tor, teacher and archaeological explorer, Segalen belonged to a famous
line of explorers in China,† and his essays on painting and music
published since his death show him to have been one of the last of the
romantic humanists. His visits to Tahiti and the Marquesas Islands

* *Mercure de France*, Paris, 16 August 1907.

† Segalen's association with the archaeologist Edouard Chavannes and the scope of his
scientific missions in China are described in 'Segalen et l'archéologie chinoise' by V.
Eliseeff (*Cahiers du Sud*, Marseille, September 1948).

produced works less spontaneous than the works of Rimbaud, but not less profound in insight. He was a later, more erudite Rimbaud and though he was a hard-headed professional doctor, an organizer of archaeological missions travelling to the Far East with his wife and children, he still craved the vagabond pursuits of contemporary poets and painters. The whole of his life was thus dominated by his attraction to the two great outlaw giants of his time, Gauguin and Debussy. These figures he was determined to emulate. Segalen had numerous literary and operatic plans for co-operation with Debussy, coloured either by Chinese influences or his infatuation with Gauguin.* He declared that he had understood nothing of the Marquesas Islands and the Maoris until he had assimilated the work of Gauguin, and indeed his *Hommage à Gauguin* remains today the most illuminating criticism of the artist's work. Similarly his correspondence with Debussy, particularly the long letters written to him from China, and his play *Orphée-Roi* written under Debussy's guidance, help us to see his dormant, unrealized ideals.

Segalen's principal excursion in the musical sphere was the science-fiction fantasy, *Dans un Monde sonore*. The narrator Leurais, returning to France from a scientific mission in Papua, is appalled to find his friends André and Mathilde bordering on a state of insanity. André lives in a world dominated by some ill-defined phenomenon of sound. Mathilde is not yet in this unenviable state. Nevertheless in her fantasy world she cannot hear in darkness while in the normal world she is content to be guided like other more reasonable human beings, by the grosser senses of sight and touch. In André's view only the sense of sound is understandable and therefore beautiful. Living in a room where muted harps, whistling flames and hydrogen lamps convey exquisite auditory pleasures—rather like the devices used by some of our bolder musical explorers of today—André is almost entirely isolated. Mathilde, panic-stricken in her attempt to unite the worlds of fantasy and reality, appears as the figure of Eurydice while Leurais incarnates the spirit of Orpheus. Looking forward to the surrealist ideas of the inter-war years André declares: 'Orpheus was not a man nor a being living or dead. Orpheus is part of our changing ideas of humanity; the need to hear and to be heard; the will to live and to create in sound (*de créer dans la sonorité*). Orpheus is the symbol of our escape from the sordid sensations of sight and touch. An actual figure of Orpheus never existed, only

* See Henry Bouiller, *Victor Segalen* (Paris, 1961) and André Schaeffner, *Segalen et Debussy* (Monaco, 1961).

Orphic powers which, having reached their zenith, enable us now
to pronounce a judgement on the world of the past.'* Segalen the
explorer seems to shadow forth here some later scientific theories. 'It is
as if there had been a sonorous substance containing elements of other
senses: breadth and movement, that which could be seen or touched.
. . . I would concede that in the course of this evolution there might
have been beings, early stages of the human being, who outdistanced
other human beings and opened up new lines of thought. These beings
could have been called "Orpheus" beings, as other earlier "Prome-
theus" beings caused fire to rage. It thus came about that gods were
made of these precursors, these discoverers of the wider realms of
sensibility.'

There are surely elements of incoherence in this fairy tale until
Segalen introduces into his fantasies some severely practical allusions.
The whistling flames produce the sound of a major third. Leurais
defines music by referring to the theories of Ptolemy, Helmholtz and
Hugo Riemann. '*Dans un Monde sonore* is a very successful piece in a
wholly unexplored domain', Debussy commented, but adds: 'One
would hope that your readers will appreciate what you wish to convey.
It is nevertheless doubtful, for most of them will never admit that they
can neither hear nor see.' True enough: it was Segalen's contention,
however, that the artist's world is more astounding than his public
would admit. The legend of Orpheus, moreover, as interpreted in this
tale, brought an immediate response from the composer drawn to the
fantasies of Poe. Gluck's treatment of the Orpheus legend, Debussy
maintained, presents only its historical aspects, a sort of Greuze, and
completely disregards the conception of Orpheus as the original mis-
understood genius. The work was to have been Debussy's 'lyrical testa-
ment'. Sound, drawn from the circumambient air, was Debussy's ideal
in this unwritten opera, not at all the sound-wave invasion emanating
from gramophone or radio known to us today, but a rarefied ideal in
which the role of Orpheus would be entirely wordless.

Fantasy, too, marks Segalen's evocations of the Tahitian scene in his
Hommage à Gauguin. Debussy in the Orpheus opera wished to suggest

* Authorities on Greek civilization believe that Orpheus, if he existed, was addicted
to music only in the earlier forms of the legend. According to Bertrand Russell (*History
of Western Philosophy* (London, 1961)), the Orphics 'believe in the transmigration of souls;
they taught that the soul hereafter might achieve eternal bliss or suffer eternal or temporary
torment according to its way of life here on earth'. Also, Orpheus, or the Orphic legend,
with which Segalen and Debussy were apparently concerned, 'substituted mental for
physical intoxication'.

an almost abstract form of his operatic figures composed out of silences and elements of understatement. Music disappears, or it is imagined or only suggested. Segalen gives us a similar evocation of the pictures of Gauguin. He revives them in the imagination by an original method. First of all, referring to Renoir's retort on learning of the departure of Gauguin for Tahiti, 'On peut si bien peindre aux Batignolles', Segalen states, 'Let us not forget that glowing skies and the fires of hell can very well be painted without any personal experience on the part of the artist; that Turner was able to light up his canvases working in the back shop of a London basement; that Rimbaud, before conveying the vast expanse of the sea with its undercurrents and its torrential flows, had never seen the sea.'

With the recollection of Gauguin's Tahitian scenes and of the description Gauguin gives of himself to his wife: 'Je suis un grand artiste et je le sais. C'est parce que je le sais qui j'ai tellement enduré de souffrances pour poursuivre ma voie, sinon je me considérerais comme un brigand'—with this description in mind Segalen's word paintings in his *Hommage* evoke every detail of a Gauguin canvas.

The male Maori cannot be forgotten once he has been seen nor can the Maori woman once she has been loved. Paul Gauguin was able to love in this island and to perceive these beings, amber-coloured and nude, as no one else had perceived them. They can be compared to no other human species.

Great athletes with mighty muscles, they are beautifully proportioned presenting in repose some kind of underlying dynamic force. Their limbs are lithe rather than angular. As for the Maori face, with its squarely planted nose, this has been boldly encircled by the painter's brush. The Maori eyes, closely placed apparently in order to lengthen the range of vision, seem to be drawn on the level of an imaginary painted surface. They have nevertheless the capacity to burrow into the bush or some other hidden recess, also to assimilate a confiding look. The lips are blue-blooded and full-fleshed. Their bearing is accustomed to burdens but in movement it gives the impression of juggling with its own weight. They are great swimmers across vast stretches of water; they are divers who plunge into the translucent sea; or as navigators they are seen in full sail on the lakes. They are festive musicians and huntsmen with an instinct for the wild beasts' lairs. Asleep in the drowsy night, they attract some god-like soporific spirit into their limbs reflected in the ritual of their regular breathing.

Women are like young men. They are tall, graceful, also adolescent, until the approach of old age. Animal attributes are happily incorporated. Limbs do not float away from the body. From shoulder to finger-tips the Maori woman describes a continuously moving line. The form of the arm is

elegantly tapered. Hips are inconspicuous and may belong to one sex or another. . . . The Maori woman does not belong to the category of the diminutive figures of Laforgue [or in fact the circus *saltimbanques* of Picasso] fashionably relieved of unnecessary tissues. Pregnancy, rarely seen, is sightly. Other impressions are the healthy thighs, the slender knees 'looking at one squarely in the face' as Gauguin observed, the mobility of the two legs, or presenting in repose an image of mighty columns, and ultimately the large elastic foot. The hair, opaque in texture, fragrant and slightly waved, reaches the loins which may be seen without immodesty. These are designed to mark the rhythms of pleasure and of dance. . . . The eyes have a phosphorescent gleam, the neck is slender and the breasts are perceptible only at the first birth of passion.

The Maori woman offers two incomparable rewards, the grain of her skin and the fragrance of her breath. Unpolished like dull crystal, the Maori skin is the most beautiful of all natural coats. Neither burnt nor decomposed by the sun, its true colour is amber-olive in which may be perceived green reflections. Delicate and delicious to the touch, it invites an endless caress. Attracted principally to ripe fruit and live fish, the Maori woman exhales these natural odours in her fragrant breath a suggestion of which can only be caught in the painter's evocative associations.

And here is Segalen's ethnological explanation of Gauguin's plunge into the exotic infinities of art: 'Neither white, nor yellow, nor black, the Maoris have not the insipidity of European nudes, nor our false eye-lid formations, nor mongolian features, nor prominent cheek-bones, nor an oval moon-shaped appearance, nor the crinkly hair of the Negro. One beholds their enigma, in life as in death, under the title which Gauguin gave to his picture: "*D'où venons-nous—Que sommes-nous—Où allons-nous?*"' (see Plate 11).

Segalen, who arrived at Tahiti on 23 January 1903, never met Gauguin. Nearly five months later, on 8 May 1903, Gauguin died at Hiva-Oa. But Segalen was present at the sale of Gauguin's belongings at Nuku-Hiva, the residence of the administrator of the Marquesas Islands and where his boat the *Durance* had docked. Returning to Hiva-Oa he describes Gauguin's home and also reveals the origin of the title of his unfinished play on Gauguin's life, *Le Maître du Jouir*:

No trace of habitation, only signs of rooting the cabin from the soil. Above the lintel could be discerned the motto of those who enter, MAISON DU JOUIR, with its nominative form of the verb, so appropriate to Gauguin's abode and yet almost indecent if used elsewhere. From right to left long sculptured panels brought into relief by colour. 'Soyez amoureuses', proclaimed one of them, 'et vous serez heureuses'. Two mute shrouded figures

disappear as if fleeing towards the love scene, while a third rears in fear or honour or joy. The second panel tells us 'Soyez mystérieuses et vous serez heureuses'. Visions penetrating the wood like spectres seem to have been assembled from the further side of space and look towards a country beyond evil and good or any kind of known existence.*

Nearly all Segalen's work conceals a musical aspiration and in 1907 he dedicated to Debussy a study on Maori music, or rather a study of this music in decline entitled *Voix mortes: Musiques maori* and which he published in the *Mercure Musical* (15 October 1907). This technical study follows the main themes of the novel inspired by Gauguin's discovery of Tahiti, *Les Immémoriaux*. Music was part of the communal free life of the islands, there was no distinction between spectators, listeners and executors. Each group contributed to forms of musical exaltation. The Lutheran and later the Catholic missionaries stifled the indigenous spirit and this was afterwards extinguished by the influence of popular drinking songs from the United States. However, we can imagine the evolution of Maori music from our knowledge of its earlier forms. We will have seen therefore the ideal to which it aspired, Segalen explains, its growth and decline.

The study is divided into five sections: the musical ideal followed by notes on instrumentation and particularly descriptions of the use of the flute, the marine shell and the drum; the quality and timbre of the voices; the nature of binary and ternary rhythms; and the decadence of melody and of instrumentation. The study presents a remarkable anthology of impressions from earlier travellers, particularly Captain Cook 'and his philosopher and companion Forster'. (There is a bibliography of works published between 1792 and 1902.)

In his introduction to the reprinting of this essay in *Segalen et Debussy* (1961) André Schaeffner notes, 'Segalen's journey to the Polynesian Islands dates from 1903–4. Polynesian music was in its death throes at this time but it was not dead. Between the two world wars ethnographers and travellers interested in exotic civilizations, among them Alain Gerbault and André Ropiteau, heard in some of the remote island traces of songs which they noted and recorded.' 'It is most strange', Debussy commented in 1907, referring to this moribund music. 'No other study of this kind has interested me to this extent.

* The reference is to Nietzsche's 'Prelude to a Philosophy of the Future', *Beyond Good and Evil* (*Jenseits von Gut und Böse*), Leipzig, 1886. Segalen was a great admirer of Nietzsche and saw Gauguin as a Nietzschean superman. The daughter of a priest who attended Gauguin during his last days told Segalen: 'Il n'y a plus d'homme maintenant' ('Journal des Iles', *Mercure de France*, May 1956).

People who usually take it upon themselves to write about such subjects appear to have no idea of the colour of the music they write about.'

Just as the tale *Dans un Monde sonore* contained the seeds of the play *Orphée-Roi*, so the study on Maori music, *Voix mortes*, contained the elements of another play, *Le Maître du Jouir*, in which the figure of Gauguin plays the leading role. *Le Maître du Jouir* was referred to in the original form of *Voix mortes*. But these pages, branching out into a new conception of Maori culture, were suppressed, at Segalen's request, in the final form of the study. Published for the first time in *Segalen et Debussy*, they show how an outlaw artist is endowed, according to Segalen, with a god-like nature. Having already embraced the hedonistic pagan principles of the Maoris, Gauguin is seen, we are told, in sketches for this play, in the role of the Emperor Julian the Apostate. In the fourth century it was the Emperor Julian who attempted to establish paganism as a state religion in the Near East. In the play of Segalen he extends his rule to the Southern Pacific Islands. In a letter of March 1907 to Debussy, Segalen gives a rough account of the manner in which this scheme was to take shape: 'A European of powerful personality, the painter Gauguin for example, arrives in these islands. He is saddened and irritated by the state to which the islanders have been reduced by "civilization". His aim is to resuscitate their ancient ideals. He will give them back their gods, the images of which he will carve out of wood. He will revive their traditional games and their pagan enthusiasms, also their exultant *joie de vivre*, as it was known to travellers before the arrival of the missionaries. Gauguin's efforts will be dealt with, also his approach to success and the *fêtes* he organizes. . . . We shall see his failures and ultimately, perhaps, his death.' In a letter to Jules de Gaultier in October of the same year, Segalen expands on these ideas:

I return to Tahitian society at the point where it was left in the last pages of *Les Immémoriaux*, in a state of complete religious and moral disintegration. But I return a hundred years later, in our own times, and I shall attempt to superimpose the profile of one of our white contemporaries who, in the place of laws, dogma and moral preaching, will attempt to bring back to the Islanders what they have lost: the joyous, naked life. This man, the painter Gauguin, who died in the Marquesas Islands did in fact partly sketch out such a profile. At all events he dreamt of becoming this ideal man. What one will have to do is to reconstruct his dream. This was a pure dream on Gauguin's part, moreover, and his awakening was all the more painful. This shows his struggle against, and the defeat he sustained, not from honest Christian missionaries but from the administrators, the police and the teachers who,

though convinced in their faith and humanitarians, were just as dangerous as the missionaries.

This play was left unfinished but it was Segalen's wish in the last years of his life to spend a further period of six months in the Polynesian islands in order to complete the work.

Though dissimilar in manner, Gauguin and Debussy shared many sources of inspiration. Their first sponsors were the brothers Gustave and Achille Arosa, both collectors of Impressionist paintings. Gauguin's exotic conceptions may be traced to his early experiences sailing to remote parts of the world, while Debussy discovered the haze and the sunlight of the Atlantic and the Mediterranean. Powerful exotic influences mark their work: the painter and the composer were attracted to the Japanese artists Hokusai, Hiroshige and Utamaro. From the Paris Exhibition in 1889 Gauguin took with him to Tahiti photographs of the frieze of a Japanese temple and an Egyptian wall-painting. Debussy at this same exhibition became acquainted with the pentatonic music of the Javanese gamelan.

They were guided by a philosophy of fatalism and instinct. In *Avant et Après* (translated by Van Wyck Brooks as *The Intimate Journals of Paul Gauguin*—London, 1952), Gauguin writes: 'Philosophy is dull if it does not touch any instinct. . . . In the child, too, instinct rules reason.' Debussy in his *Entretiens* with Segalen states: 'Everything with me is instinctive, unreasonable. . . . I have no experience at all. Instinct, that's all.' Situations carried to extremes frequently reached the verge of suicide. In some obscure manner these heightened sensations compelled them to perceive painting and music as arts producing interrelated sensations. Delius bought Gauguin's picture *Nevermore*. Gauguin's idea was that his paintings 'should provoke thoughts as music provokes thoughts, without the help of ideas or images, simply through the mysterious relationships which exist between our brains and these arrangements of lines and colours'. Like many artists before him, among them Delacroix and Poussin, he was said to have had a mania for bringing painting back to the musical state.

Segalen was thus a bridge-builder, like some of the more scholastic of the Impressionist painters. 'One learns the aesthetic laws of colour', Seurat declared, 'as one learns the rules of musical harmony.' This might have been acceptable over a certain period of nineteenth-century experiments when 'rules' in the arts prevailed. Segalen's *Les Immémoriaux* and *Peintures* were not only conquests of this synaesthesia movement;

they belong to the great autobiographical works of the nineteenth century: the letters of Pissarro to his son and the letters of Van Gogh. A third work of this self-revelatory nature may be added, the publication in nine volumes of the letters of Mendelssohn.

Indeed we should be groping in the dark in the obscure regions of synaesthesia without the observations on sensation and theory in the letters of Pissarro. In 1883 Pissarro writes to his son: 'Aestheticism is a kind of romanticism more or less combined with trickery, it means breaking for oneself a crooked road. They would like to make something like that out of impressionism, which really should be nothing more than a theory of observation, without entailing the loss of fantasy, freedom, grandeur, all that makes for great art. But not eccentricity to make sensitive people swoon.'*

Social and political ideas, even anarchism, which would nowadays seem to have been wholly divorced from Impressionist theories, were, on the contrary, directly relevant, as Pissarro was aware: 'The bourgeoisie frightened, astonished by the immense clamour of the disinherited masses, by the insistent demands of the people, feels that it is necessary to restore to the people their superstitious beliefs. Hence the bustling of religious symbolists, religious socialists, idealistic art, occultism, Buddhism, etc. Gauguin had sensed the tendency . . . the Impressionists have the true position, they stand for a robust art based on sensation, and that is an honest stand.'

Two principles determined the methods of Pissarro, the enemy of pretension and obscurity. Sensation should replace false idealistic beliefs. He was suspicious of any kind of fabricated theory. He tells his son in 1892, 'Work, seek and don't give way too much to other concerns, and it will come. But persistence, will and *free* sensations are necessary. One must be undetermined by anything but one's own sensation.' The correspondence between Pissarro and Paul Signac has a similarly contemporary value. 'I am certain that the neo-impressionist technique,' writes Signac, the author of the scientific treatise *De Delacroix au Néo-Impressionisme*, 'when completely disburdened of certain obscure and obstructing elements . . . can alone lead to harmony, light and coloration.' To which Pissarro spontaneously retorts: 'Damn it all, then make something that has life! . . . I don't give a fig for the method if the result is poor.' He emphasizes the same point in a later letter to his son: 'How rarely do you come across the painters who know how to balance two tones. I was thinking of Hayet who looks for noon at

* C. Pissarro, *Letters to his son Lucien* trans. by L. Abel (London, 1944).

midnight, of Gauguin who, however, has a good eye, of Signac who also has something, all of them more or less paralysed by theories. I also thought of Cézanne's show in which there were exquisite things, still lifes of irreproachable perfection, others much worked on and yet unfinished of even greater beauty . . . Why? Sensation is *there*.'*

A hidden secret was nearly always buried in the romantic mind—an outburst of madness, perhaps even a drive to suicide; or we may find this same romantic mind blighted with megalomania. Van Gogh reaches the boundaries of these excesses in almost every direction. He was a colourist as Delacroix and Wagner were colourists, at least so we gather from his letters. 'In a picture', he writes, 'I want to say something comforting in the way that music is comforting'; and he adds, 'In the end we shall have had enough of cynicism and scepticism and humbug and we shall want to live more musically.' To musical people Van Gogh's aspirations must seem merely rhetorical or picturesque. But he was on the contrary unusually clear-sighted. He wished 'to paint men and women with that something of the eternal which the halo used to symbolize and which we seek to convey by the actual radiance and vibration of our colouring'. Not madness but the music of Wagner must be the refuge, at least so it seems from the letter written to Van Gogh's sister in 1888. He had enumerated the variety of colours on his palette, those, that is to say, that appear in the quotation from this letter on page 69. And to musicians Van Gogh's conclusion becomes, in this different context, even more moving. 'By intensifying *all* the colours, one arrives once again at quietude and harmony. There occurs in nature something similar to what happens in Wagner's music which, though played by a big orchestra, is nevertheless intimate.'†

Segalen's restricted work does not reach the dimensions of Pissarro and Van Gogh. His energies had been spent in archaeology and literature, and he died mysteriously at the age of forty-one. 'Don't draw back', he tells the reader of his prose-poem *Fresque en laine*. 'Don't leave this bewilderment. Don't create a space between what you see and yourself. Approach this "Fresco in Wool" as a loved one. Contact is

* Pissarro, *ibid*. Pissarro's comments on the pointillistic technique and on the abundance of light and sound theories adopted by painters and musicians refer to a growing preoccupation with technique for its own sake. In another letter to his son we read: 'I think continually of some way of painting with the dot. . . . How can one combine the purity and multiplicity of the dot with the fullness, suppleness, liberty, spontaneity and freshness of sensation postulated by our impressionist art? This is the question which preoccupies me, for the dot is meagre, lacking in body. . . . Isn't it senseless that there are no Turners [i.e. in the Louvre].'

† *The Complete Letters of Van Gogh*.

necessary for the quiet of the heart and the fingers. Place upon it your fingers and the slenderest part of the wrist showing the veins. . . . Gracious and mellow, this is down where the palm, the elbows, the knees, all that becomes painful elsewhere—even sight, penetrates and indulges in delight. . . . This is not a painting, yet richer in tone and denser in colour.' Shortly after the composition of this fresco, 'not a painting', as he said, the collaborator of Debussy and the historian of Gauguin, who had opened his career with a thesis on Wagner, was found dead in a forest in his native Brittany, a volume of *Hamlet* open by his side. Unaccountably life had left him. Henry Bouiller, his biographer, relates how he had subjected himself to the closest of analyses. He was a victim neither of syphilis, nor of tuberculosis, nor of a heart condition, nor of any known ailment. Then what had possessed him? Life simply receded, he died unaccountably, and with him dreams of Orphic legends, Chinese civilization and Polynesian music.

I I

'Brothers in Art'

'Burn the museums'
Hildebrand in Debussy's play
Frères en art

There has long been a vast amount of theorizing on the correlation
of the sensations, possibly the philosophies, of music and colour.
This concept reaches back to antiquity, and it is also a concept
eagerly pursued by painters and composers today. Instruments have
been constructed such as the eighteenth-century ocular harpsichord,
invented by the French Jesuit priest Louis Bertrand Castel, in which
coloured tapes representing harpsichord wires presented a colour
pageant in a darkened room. In our own time Scriabin and Schoenberg
have experimented with the projection of light by colour organs as an
embellishment, possibly as a visual ideal, notably in *Prometheus* and
Die glückliche Hand. It was a goal eagerly pursued at various intervals
throughout the ages yet never so ardently as at the present time.
Amazingly, it was never attained. What could have been the reason?

Perhaps the failure of these efforts has a rational or an irrational
basis, one cannot say. In the first place sound and colour are produced
by vibrations, but any kind of vibrational correspondence cannot
coalesce for the reason that the vibrations of sound are infinitely lower
than those of colour. Newton and Helmholtz put forward many com-
plicated theories on this subject which are difficult for us to understand
since the correlation of sound and light theories which they proposed
had no justification, unlike Newton's law of gravity, and in any case
they were never utilized. The one great mind suggesting a correspon-
dence of these theories and who seems to have influenced painters and
musicians is Goethe. It is not surprising that art and music historians,
amazed that Goethe remained persistently attached to his treatise *Zur
Farbenlehre* (*The Theory of Colours*), should have dismissed this work as
involved and obscure. Professor John Gage, however, has now shown

that Turner took the translation of Goethe's *Farbenlehre* by his friend
C. L. Eastlake very seriously. Professor Gage has interpreted and
evaluated Turner's notes on this treatise, enabling him to offer us a key
to the technical basis of Turner's colour schemes which we do not find
in the criticisms of Turner by Ruskin. Whether we shall ever discover
the extent of the impact made by Goethe's *Farbenlehre* on an artist of an
entirely different order, namely Anton von Webern, is difficult to say.
It appears that Webern similarly made voluminous notes on Goethe's
Farbenlehre, presumably with the aim of finding a musical reflection of
Goethe's theories. All that one can say at the moment is that a fascinat-
ing field of research lies ahead: a comparison or a correlation of
Goethe's colour theories in the works of such seemingly dissimilar
artists as Turner and Webern.

There may at the same time be a purely instinctive approach. From
our musical viewpoint, Bertrand Russell was surely right when he
observed that there is no reason to suppose that we know any more
about space than we know about sound or colour. This will surely be
endorsed by musicians engaged in 'concrete' or electronic research, and
although one may be put off by the results of some of their explora-
tions, these composers are obviously moved by a sound intuition.
Returning for a moment to Turner, John Gage suggests that an artist
and scientist working before the first World War, named Wallace
Rimington, gave evidence of Turner's theories in a 'colour-concert'
held in London in 1895. The fact is that Rimington, like his far greater
musical contemporaries, had embarked on a laudable but wholly un-
practical venture. All of which leads us to see that aspirations towards a
correlation of sound and colour resulted in a release of works through-
out Europe nearly every one of which reached the heights of our
European musical civilization. But of course they remained aspirations.
The ultimate realization of this ideal was denied.

Realization was denied but not this deep-seated aspiration. The truth
of Pater's prediction, that all art aspires to the musical state, was trium-
phantly proclaimed in the Diaghilev ballet. Of course it was never
imagined that any of the Diaghilev productions, with the possible
exception of *Petrouchka*, was, in the sense of a combined art-form, a
success. Diaghilev achieved something more than a success. For a brief
moment he brought into reality the ideals of Delacroix, Weber and
Baudelaire. His public was moved by a spirit of enterprise. This con-
ception was by no means peculiar to Diaghilev. In a brilliant study by
Martin Cooper of the ideas of Scriabin and his associates ('Aleksandr

Skryabin and the Russian Renaissance', *Studi Musicali* No. 2 (Florence, 1972)) the aspirations of Scriabin are shown to be closely allied to those of the abstract Russian painter Vassily Kandinsky, set out in *Über das Geistige in der Kunst*. Kandinsky joined the contemporary German artists and settled in Munich (an art centre admired by the youthful Picasso). As in the nineteenth century, a musical ideal was at the basis of Kandinsky's pursuit of pictorial abstraction. Scriabin's *Prometheus*, with the introduction of a colour organ, was a move in the direction of the unification of the arts but failed to reach its goal for reasons previously mentioned.*

It may be that a sense of frustration undermined composers working towards a unified goal, among them Debussy, Strauss, Schoenberg and Stravinsky, and that at the very moment of their efflorescence they were under a compulsion to withdraw, to form exclusive groups or societies or brotherhoods and to pursue their aims within a closed circle. A theatrical play named *F.E.A.* (*Frères en Art*), which has remained unpublished, was actually written on this subject by Debussy. It was obviously not conceived as a play for a successful theatrical production; it is too rambling. But its allusions and undertones may help our search for a solution.

Shortly after the appearance, in 1895, of the *Proses lyriques*, the only work in which Debussy was inspired by his own texts, he embarked on a scheme of writing theatrical plays and even had the idea of founding a literary review. About 1890 Debussy had made the acquaintance of the brothers René and Michel Peter, sons of a prominent personality in the medical world, Dr Michel Peter, the adversary and also the cousin of Pasteur. Ten years younger than Debussy, René Peter had aspirations as a playwright and from 1894 onwards published light comedies and tales written in association with Georges Feydeau, Robert Danceny and others. Peter, at the same time, happened to be the friend of Marcel Proust, who mentions him in affectionate terms in his correspondence with Reynaldo Hahn: 'Peter is a delightful man, most intelligent in a

* The vast literature on the Diaghilev era has not disclosed the whereabouts of the décors themselves of two of the treasures of the Diaghilev collections: the décor of Matisse for the revised version of Stravinsky's *Le Chant du Rossignol* (1920), and the décor of Picasso for Stravinsky's *Pulcinella* (1920). Sketches only by Matisse and Picasso for these ballets appear in the books on Diaghilev by Boris Kochno and John Percival.

Schoenberg's ideas on a new type of mechanical organ to accompany the proposed filming of his opera, *Die glückliche Hand*, are set out in his letter to Emil Herza of about 1913. The colour principles associated with this opera are discussed in a letter to the Intendant of the Berlin Opera of 1930. (See A. Schoenberg, *Letters*, ed. by E. Stein, trans. by E. Wilkins and E. Kaiser, London, 1958.)

manner which I would have never have imagined and unfailingly kind.'
René Peter lived with his family at Versailles. It was during his stay
there in 1906 that Proust conceived the project of a theatrical play in
co-operation with Peter on the subject of a husband who, torn between
his love for his wife and his attraction to prostitutes, is driven to suicide.
Proust later admitted that he lacked the courage to write this piece but
that he used the idea in *Du Côté de chez Swann* where Swann frequents
brothels in the hope of understanding Odette.*

Though this episode in René Peter's dramatic career follows his
association with Debussy, it nevertheless indicates the sensitive type of
mind of the author with whom he was to write the play *La Tragédie de
la Mort*, for which Debussy had written a *Berceuse*. Peter had the weird
notion of employing the composer as a teacher of dramatic art. It is
almost inconceivable that, over a period of four years, according to
Peter, Debussy gave bi-weekly lessons in theatrical script-writing.
What is less astonishing is that the lessons proved a hopeless disappoint-
ment. *L'Herbe tendre*, *L'Utile Aventure* and *F.E.A.* are titles of plays
written jointly by master and pupil. These strange ventures, of which
the first two were left unfinished, perhaps not even begun, belong to
the period 1895–9. Debussy considered *F.E.A.* to be an amateurishly
written piece not to be produced before the performance of *Pelléas*.

Our knowledge of the manuscript of the play, in the possession of
Monsieur André Meyer, presents an entirely different picture. Passages
published by Peter do not correspond with the original. The play was
said to have been abandoned; the manuscript, on the other hand, proves
that it was brought to a satisfactory conclusion. In the last edition
of his memoirs Peter adds a footnote: 'A musical amateur recently
discovered the complete manuscript of *F.E.A.* written entirely in
Debussy's hand.' The work, 'most curious in nature', was written years
after the collaboration of the musician and the author and even
apparently without Peter's knowledge.

Discussions between critics, painters and musicians contain allusions
to Monet, Rodin, Ruskin and other contemporary personalities who
are not otherwise mentioned in Debussy's writings. The figure of the
English art critic, Redburne, suggests both Swinburne and George
Moore. He is the hero of the play and is discussed in the section on the
concealed impersonations of the play (see p. 128).

Everyone at the time of the appearance of Debussy's works was

* See Marcel Proust, *Correspondance générale*, vol. IV, p. 114, and *Du Côté de chez
Swann*, Vol. I, pp. 230–7.

aware of the composer's curious and persistent cultivation of irony. It was calculated to conceal his wounded sensibility. Erich Heller's book, *The Ironic German*, reveals the same phenomenon in the works of Thomas Mann, presented, however, without understatement. This is odd: irony without the necessary laconic element is immediately blunted. The reverse of irony, if one may say so, at any rate irony of the larger-than-life size, may be found in Mahler and later in Schoenberg and his followers. Influences in the writings of Debussy, stylistically amateurish to be sure, derive from Laforgue and Valéry. Irony is swift, rapid and short-lived. The ironic, or perhaps sardonic, works of Mahler and Schoenberg are not exactly 'short-lived'. And irony marks a wounded sensibility, perhaps something more than sensibility. Maltravers, a painter, in Debussy's play has this to say on the subject of sensibility and talent:

'Stop this silly habit of talking about talent as if it were anything extraordinary. Whenever you utter this word the fortune of X or Y seems to haunt me. Actually talent is spurious, counterfeit, a synonym for mediocrity. No fool would think of using talent in connection with Michelangelo, would he, or Rodin. This is a word for art-lovers whose delight is to create confusion and who anyhow have something evil in them. They form the majority, and the majority is right. We shall die, that is certain, and we shall die stifled by the all-pervasive laziness and inertia of Mediocrity.'

Almost every statement in these discussions between musicians, painters and writers is presented as an enigma: the dividing line between sincerity and irony is slender. There is no plot in the play apart from the unrealized scheme of founding a mutual assistance society. Accordingly, in these conversation pieces the nature of the play is established not so much by the characters themselves as by their style and associations—as in the theatrical works of Maeterlinck. It may reasonably be imagined that the highly sardonic tone of the play was provoked by bitter disappointments. We know, moreover, how often during this period Debussy was himself haunted by the compulsion to commit suicide. Are we to take the play at its face-value, as a commonplace comedy of Bohemians, or is there something behind this bourgeois façade? A strange scene is that in which the economic principles of the *F.E.A.* Society are proposed. We are offered an extremely practical economic scheme, a middle-class dream, in fact, in the form of a caricature of the Bohemian ideals of the young Debussy. It is clear that Debussy shared with Baudelaire and Wagner a compulsion to acquire

money—by borrowing as a rule—and that this compulsion had a psychological rather than a material basis. In this compulsive manner their creative ventures were supported. Now obviously there could never be any fraternal considerations in these ventures. Yet here is how this egotist, this magnificent egotist of genius, presented an ironic conception of a mutual assistance society:

DURTAL. The capital of the Society is divided into shares of 500 francs half of which provides a working capital from which we shall deduct our overheads—rent, publicity, etc. Naturally, the subscribers we shall call upon will not be wealthy and we shall require a considerable sum of which MM. Hildebrand, Talencet and others, myself included, will provide an advance. We shall also provide the 500 francs required by those recommended to us for their talent, or those who, like yourself, M. Redburne, wish to be associated with us or who happen to be the discoverers of unknown artists.

REDBURNE. But this would create a benefit society not acceptable to everyone.

DURTAL. But there is more in it than that. Members share the running of the society as well as the profits, including the profits of a work sold by the intervention of the Society. Let me point out to you that we shall allow no trade price and no bargaining to the detriment of the artist and his work. It will therefore be easy enough for the artist, however susceptible, to relieve himself of his advance since he will himself have contributed to the costs.

REDBURNE. Splendid! Now what will you do with the works that remain unsold?

DURTAL. They will revert to their owners. This will necessitate the setting up of a scheme of Profits and Losses, and at the same time a reserve fund drawn from a percentage on the takings.

Now these economic ideas are diametrically opposed to anything in the nature of Debussy's financial fantasies. They are in the nature of the theories of certain popular French dramatists, contemporaries of Maeterlinck, and ridiculed by Debussy at the time of *Pelléas*.

It would seem incredible that the ideas of Debussy should correspond with those of the Anarchist movement, but certain allusions in the play suggest that this alliance was in fact foreseen. Debussy uses the term *anarchiste* several times in *F.E.A.* and also in his correspondence with Pierre Louÿs. He warns his friend that 'the anarchists are waving their red flag in my head'. Maltravers, the painter in the play, and Rabaud the sculptor are 'almost anarchists'. Elsewhere in the course of a long tirade on the subject of popular art Maltravers says, 'I come from the working

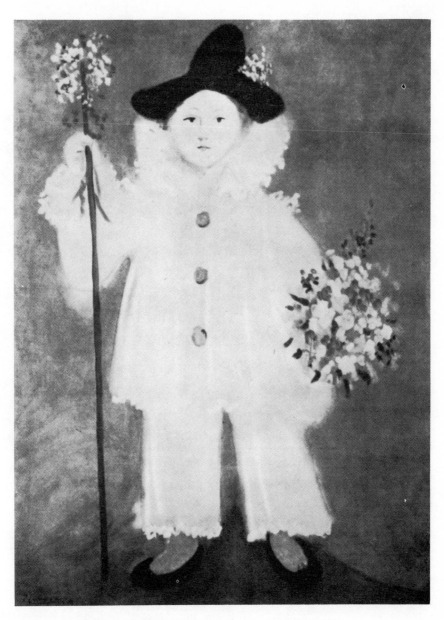

10. Pablo Picasso: Pierrot with Flowers. Oil

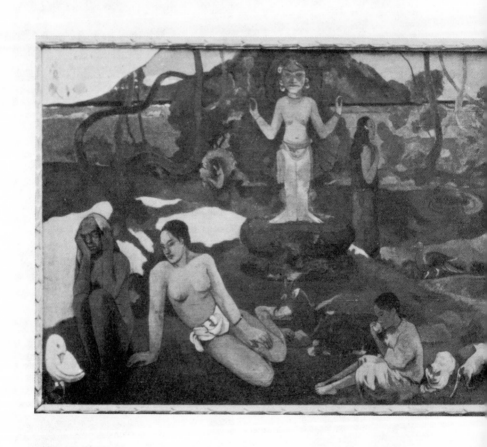

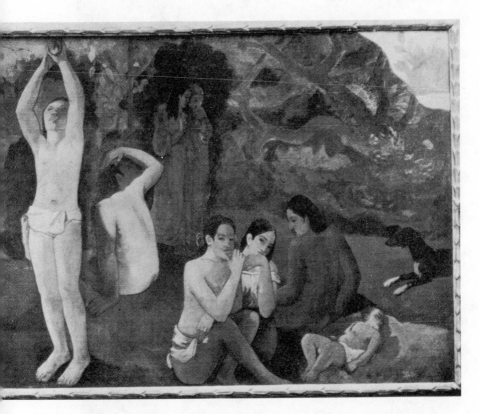

11. Paul Gauguin: 'D'où venons-nous? Que sommes-nous? Où allons-nous?' Oil

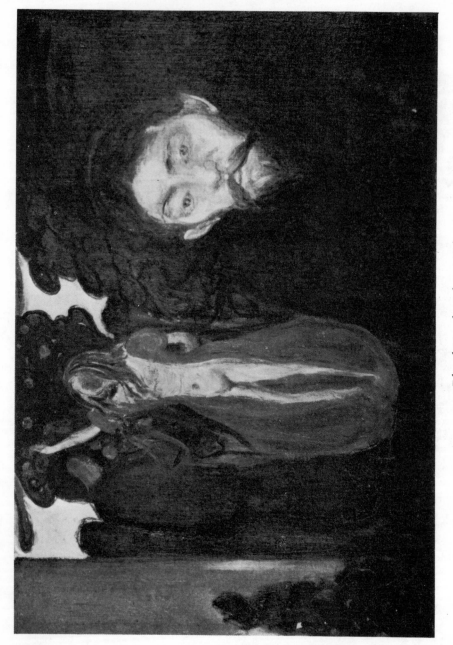

12. Edvard Munch: Jealousy. Oil

classes, and I'm not ashamed of it. I also believe that from this melting pot of suffering and hatred, from this power of the people alone, great works may emerge. The only trouble is that the working classes are not drawn to art. They feel they are intruders or a poor relation. In almost all the documents of Anarchy isn't it true that there is never a question of the popularisation of Art? Is this unfortunate? I don't think so.' André Gide and Félix Fénéon, the editor of *La Revue Blanche* in which Debussy wrote regularly, belonged to the group of intellectual anarchists, the aim of which, as opposed to the political movements operating under this name, was simply the cult of individualism. Pissarro in his letters to his son Lucien speaks at length of anarchy in this sense. 'You are right, the bulk of the poor do not understand the anarchists', he writes in 1892. 'However, there is no use pretending, if people are in a funk it means they sense they are faulty. Have you read the interview with Zola? While calling these people ideologists and utopians, he is prepared to fight for logical methods, demonstrating the absurdity of the anti-scientific theory. That's running with the hare and hunting with the hounds. So the people must free themselves by scientific methods. Quite an order, for when we are ruled by scientific minds don't imagine that their government will be any the less despotic.'★

Apart from the idea of this social and political movement it is worth noting that between 1893 and 1895 the three volumes of the *Journal de Delacroix*, one of the most important artistic documents of the period and which had remained in the hands of Pierre Andrieu, a disciple of the painter, were published for the first time. It is likely that Debussy may have been influenced by some of Delacroix's ideas on parallel developments in music and painting.

Anarchist principles are apparent in this play, and so are esoteric principles. An esoteric as opposed to a commercial fraternity is proposed—hence the name F.E.A. 'The idea of the foundation of a "Society of musical Esotericism" doesn't exactly belong to the sixteenth century', Debussy tells Ernest Chausson. 'However, we have repudiated the old-fashioned romantic concept of "local colour" [presumably in principles of orchestration and harmony]. The desirable aims would be to found a school of Neo-musicians where one would attempt to maintain the symbols of music in their original state.' Van Gogh in a letter of 1888 to Émile Bernard gives an extraordinary description of how this same proposal should be approached: 'The material difficulties of a painter's life make collaboration, the uniting of painters

★ C. Pissarro, *Letters to his son Lucien*.

desirable (as much as in the days of the Guilds and St Luke). By safe-guarding their material existence, by loving each other like comrades-in-arms instead of cutting each other's throats, painters would be happier and in any case less ridiculous, less foolish and less culpable . . . If only painters agreed to collaborate on important things! The art of the future will show us examples of this perhaps!'*

Alas, Van Gogh's ideas were not fulfilled and nor were those of the Pre-Raphaelite Brotherhood. Towards the end of his life Bizet had foreseen an Empire controlled by the great geniuses of painting and music. It was a fantasy of course but not an unreal fantasy. 'I dreamt last night', he told Guiraud, 'that we were all at Naples living in a charming villa; and under a purely artistic government. The Senate consisted of Beethoven, Michelangelo, Shakespeare, Giorgione—and a few others of this rank.' 'A few others'? How ideal a government!

But the root ideas of *Frères en Art* is surely to be found in *Les Plaisirs et les jours* of Marcel Proust. Speaking of an English friend, Proust writes, 'We foresaw as in a dream the plan of living more and more in prox-imity with each other in a group of magnanimous men and women, sufficiently removed from foolishness, vile and evil to feel ourselves protected from their vulgar attacks.' In the same spirit Proust tells Madame de Noailles, 'I should like to be in some great monastery where you yourself, dressed in white, would be the adored abbess.' Now what was this great monastery? It was the monastery of the dreams of Debussy, the centre of his 'Esoteric Society', where he would hear 'the last mass of Palestrina'.

It is perhaps time to attempt an identification of the characters of this play. Many of them escape us: Rabaud the sculptor, Valady the musi-cian and Talancet the painter, as well as other less important characters such as Pardieu the engraver and Anculac an amateur. But Hildebrand the painter, St Diaz the art critic and Redburne the English art critic are real enough. Adolf von Hildebrand was not a painter but a sculptor and an art historian. His book *The Problem of Form* looks forward to ab-straction and was apparently known to the young Picasso.† Diaz de la Peña, who must impersonate St Diaz, was a disciple of Delacroix and a painter of the Barbizon school. He sought in his wooded landscapes movements of shadow and light leading eventually to abstraction. One is reminded, once again, of the statement made to Constable, 'Remem-ber that light and shadow never stay still.' This is exactly what the

* *The Complete Letters of Van Gogh.*
† See Sir A. Blunt and P. Pool, *Picasso: The Formative Years* (London, 1962).

painter tries to achieve, and it is also that which, by the static nature of painting, can never be achieved. Only music, *ars bene movendi*, can convey this natural phenomenon. Hence the drive to Impressionism, and beyond Impressionism, to abstraction.

The most striking character, as we have mentioned, is the hero of the play, Redburne, the English art critic. Is he Swinburne? We know that Debussy in his youth admired Swinburne whom he knew through the translations of his friend Gabriel Mourey, and there are indeed occasional suggestions of Swinburne's idealism in this character. But the figure more obviously evoked by Redburne is George Moore, noted for his red hair and whiskers, and recalled clearly enough in Debussy's pseudonym. Moore's judgements were spontaneous and they were remarkably shrewd. He encouraged amateur collectors, for instance, to acquire the works of Degas. 'Buy the pictures of Degas', he declared with great foresight, 'and your children will be millionaires.' Not for nothing was the collection of Chabrier noted for its Degas. Moore had published an outstanding work on the French Impressionists* and assessed the work of Debussy with boldness, as we gather from his letters to Lady Cunard.† No one except Ruskin had written on painting in a more lively and penetrating manner. In his *Modern Painting*, but especially in his writings for *The Hawk*, there are passages on the social organizations of artistic life that might have been taken textually from *F.E.A.* or from the letters of Pissarro and Van Gogh.

In my novel *A Modern Lover* [published in 1883, Moore writes in *The Hawk* on 17 December 1889, when the French Impressionists were first shown in London], I imagined a band of young men united by one aspiration—Art for Art's sake—animated by one aestheticism, love of modern London life; and I described these young men refusing to prostitute their art in base commercialism, standing resolutely together, determined not to go to the public, but to make the public come to them. At the time I wrote, no such aestheticism and no such society existed. The only fact I had to build upon was the Pre-Raphaelite Brotherhood . . . But their aestheticism was very different . . . The ideas I then gave utterance to were already in the air; I was merely the first to name them, and attempt some definite description of the tendency that was then faintly astir. These ideas have not slept an hour since in the last seven years . . .

* *Modern Painting* (London, 1892). Between 1886 and 1893 several books, novels and memoirs of Moore had been translated into French, including *Les Confessions d'un jeune Anglais* in *La Revue indépendante* (March–August 1886). See G. P. Collet, *George Moore et la France* (Paris, 1957).

† See George Moore, *Letters to Lady Cunard, 1895–1922* (London, 1957).

'Art for Art's sake' threw up some envious notions, but *F.E.A.* presents the theory of 'Discussion for the sake of Discussion'. One might almost be listening to the voice of Pierre Boulez when Hildebrand, the art historian, proclaims:

> All right! Burn the museums, the libraries, all that represents a respect for the past which you disown or otherwise find useless.
> REDBURNE. I agree. I don't mind burning the museums so long as it were merely an antiseptic means of destroying mediocrity. If I had created a great work I shouldn't want to condemn it to a museum for ever.
> MALTRAVERS. As for libraries, Hildebrand, they merely contain changing aspects of Truth. Truth is not in books. Truth is in forms or the colour of the sky.

Elsewhere emphasis is placed on sensation, on things seen and things heard. Here is a conversation between Hildebrand, the German critic, Redburne, the English critic, and Maltravers, the French painter.

> MALTRAVERS. This theory of effort is senseless, and where does it lead? To some kind of monotonous office life, to a bottled up existence, or to the dejection of an old bachelor. A creative artist has no understanding of work in this sense. Thank you for nothing!
> REDBURNE. Careful, we are not just among ourselves.
> MALTRAVERS (*paying no attention*). Art is a flame alive at dawn or in the colour of gold and blood at sunset. It arises from the sunset, [. . .] and here you are turning it into a mathematical formula.*

We know these ideas well enough from Debussy's critical essays. An allusion to Ruskin, however, brings this play of ideas into the contemporary field. In a deliberate entanglement of reality and disguise, Redburne is introduced to Hildebrand. Whereupon Redburne replies in these odd terms: 'My dear Sir, your face is well known to me from our London bookshops. Your portraits are sold as widely as those of Ruskin and Miss Langtry.' One need not be over-concerned with Lillie Langtry, the celebrated actress known to Whistler and Oscar Wilde and whose portrait was painted by Millais. But the reference to Ruskin must leave us with eyes wide open. It is well known that the book of Robert de la Sizeranne, *Ruskin et la Religion de la Beauté*, which appeared in 1895 had greatly impressed Marcel Proust. It now becomes clear that Proust shared with Debussy his conviction that Turner was 'le plus

* Mathematics, however, was seen as the basis of music in Debussy's critical articles.

grand créateur du mystère dans l'art'. This is the place to quote a relevant passage on Ruskin from the biography of Marcel Proust by George Painter.

> Ruskin also led Proust to one of the most striking aspects of Elstir ... In giving to Elstir powers which belonged to so many different painters—the cathedrals and Normandy cliffs of Monet, the racecourse subjects of Degas, the gods and centaurs of Gustave Moreau, the firework nocturnes of Whistler, the bathing girls of Renoir—Proust suggested not only the contemporary reality of the imaginary painter, but also his superiority, since his greatness included theirs. But Elstir's salient quality is one in which he differs from the other impressionists ... whereas Monet, for example, works by decomposing colours and their outlines, without wishing, however, to disguise the fact that it is a tree or a sail that he is showing us, Elstir's art lies in what the Narrator calls 'ambiguities' and 'metaphors'; he reproduces the moment in which we are so far from knowing what it is we see, that we think it is something else ... The most frequent metaphor in his seascapes was one which made sea seem land, and land seem sea. In these characteristics Elstir differs from any of the French impressionists, and resembles Turner.*

Frères en Art may lead us into a maze of by-ways which is sometimes bewildering. But here, in the interpretation of Turner by Ruskin, or rather in his reinterpretation through the eyes of Proust and Debussy, where the sea and the earth merge, we may glimpse once again the unconscious functioning of the imaginative mind, brought now into the Impressionist world where *le précis et l'indécis se joint*, and where the confusion of musical and pictorial symbols attempts once more to break through.

The French hegemony has long persisted in English and American art circles, and I hope I have gone some way to showing that though there are certain cultural heritages—Graeco-Roman, Nordic or Slavonic—nationalism, in its narrow nineteenth-century sense, has long been superseded. In our widening panorama, German Expressionism, largely dominated by Schoenberg, Kokoschka and the influence of the Norwegian artist Edvard Munch, has become firmly established, though the French, the cosmopolitans of the musical world contrary to a common impression, were constantly alive to powerful alien impacts. Among the Expressionist painters, Munch was well known in France, as was Van Gogh of course, and so at an early date was Schoenberg. Schoenberg may have taken longer to have become absorbed in our

* George Painter, *Marcel Proust*, Vol. I (London, 1959), p. 280.

own musical scene, guarded as we have been by our native irony, not to be abandoned even now.*

'Burn the museums', says Hildebrand in *Frères en Art*. This would not have been the opinion of Schoenberg, Debussy's exact contemporary—exact in the sense that their preoccupations with the Laforguian world, with colour obsession, and with abstraction coincide within a few years.† The allegiances of the less fastidious Schoenberg, if we may believe Theodor Wiesengrund Adorno, embraced the entire eighteenth and nineteenth centuries: 'The slightest criticism of any of the masters since Bach he found intolerable.'‡

Not for nothing was Schoenberg a practising, indeed a professional painter, a member of the *Blaue Reiter* group associated with Kandinsky and also with Kokoschka, the leader of the fraternal *Die Brücke*, who painted Schoenberg's portrait in 1924.

Schoenberg started to paint in 1907 and between 1908 and 1910 he produced two-thirds of his ninety pictures. These consisted mainly of oils and water-colours. There were also pen-and-ink and Indian ink drawings, crayons and charcoals.§ Most of his works are in private collections, and have not been shown, as far as I have been able to ascertain. Schoenberg seriously pursued a painting career in his youth, and the question arises of his disappointment in this sphere. This was reflected, one may surmise, in the bitterness, the aggressiveness even, of some of his correspondence, which was usually concerned with the lack of comprehension of his revolutionary music, a common enough experience, as one very well knows, among the composers of his period.

In a discussion on Munch¶ Lord Clark likened the anxiety of the

* Anatole France in *Le Jardin d'Epicure* gives us the clue: 'The irony I invoke is in no way cruel. It mocks neither love nor beauty. It is even-tempered and kindly disposed. If laughter is aroused anger is appeased, and it is irony which teaches us how to make fun of the malicious ones whom, without her aid, we might be so foolish as to hate.'

† The relevant works are: Schoenberg, *Pierrot Lunaire*, 1912.
Debussy: Cello Sonata (originally entitled *Pierrot fâché avec la lune*), 1915.
Schoenberg: *Orchestral Variations*, 1927–8.
Debussy: *Images*, 1906–9.
Schoenberg: *Quintet*, 1924.
Debussy: *En blanc et noir*, 1915.

‡ See T. W. Adorno, *Prisms*, trans. by S. and S. Weber (London, 1967), p. 171.

§ Information kindly supplied by Josef Rufer from his lecture entitled *Schönberg-Kandinsky: Zur Funktion der Farbe in Musik und Malerei* given in Vienna, October 1970.

¶ Munch was attracted to the Danish poet Jans Peter Jacobsen, held to be the first Danish Darwinist, as were Delius and Schoenberg, who used Jacobsen's texts for his *Gurrelieder*. Munch, Jacobsen, Schoenberg, and Delius thus form an harmonious quartet in a limited number of works (principally the *Gurrelieder* and Delius's *Fennimore and Gerda*).

painter's famous *Shriek* to *Le Sacre du Printemps*. I think this may be a mistaken analogy. Munch belongs in all his terrifying expressions of despair and anxiety to the Schoenberg persuasion. It looks as if Schoenberg must have been aware that the spirit of his music hardly reached the shattering penetrations of Munch. Not even the exhilarating *Pierrot Lunaire* or the masterly *Orchestral Variations* approach the truly alarming world introduced by the Norwegian painter. The well-known *Jealousy* painted by Munch in 1887 (see Plate 12) is nearer the visual ideal of this movement. Berg's affinities with him are more easily discernible.

The influence of Munch, who lived in Germany from 1892 to 1908, throughout the whole Expressionist era, was enormous. This was because his paintings sprang from conflicts in the darker regions of the mind, such as the conflicts of puberty, melancholia, anxiety and terror, found also in Maeterlinck and Ibsen. He influenced the *Brücke* painters, particularly the violent Emil Nolde, rather than the *Blaue Reiter* group, and he opened the way to the understanding in Germany of Gauguin and Van Gogh. There is no evidence that Schoenberg was drawn to Munch and his followers, and indeed one may well wonder whether Schoenberg's *Pelleas und Melisande* would have had a subtler or a more tragic quality had he known Munch's work. Schoenberg was principally drawn to Kandinsky, born of what we must call a mongrel musical and pictorial heritage, and the tempestuous Kokoschka.*

It is doubtful whether, following Schoenberg's works written between 1908 and 1915, the pursuit of harmonic or orchestral colour for its own sake could have been greatly advanced. A European halt was called. Hence the looking backwards, the return to the past, taking the form of the twelve-tone or serial systems, said to be traditional and forward-looking at the same time, and provoking an enviable abundance of explanatory literature.

Frères en Art was not merely a French or an English conception. Closed circles of this kind were common enough in Berlin and Vienna,

In his study of the friendship between Munch and Delius (*Apollo*, January 1966), John Boulton Smith convincingly shows an affinity between the flowing lyrical folds in the art of Delius and a certain *art nouveau* aspect of Munch seen in *The Sick Child*, the *Dance of Life* (1900) (the title also of Delius's symphonic poem) and *Melancholy* (1894–5). But the powerful Expressionist works of Munch reach beyond Delius's secluded world.

* In 1967 the Marlborough Art Gallery in London exhibited the six fans painted by Kokoschka for Alma Mahler. They are a sardonic counterpart of the contemporary French style of ladies' fans as described by Debussy and Mallarmé. Robert Melville rightly noted that the Kokoschka–Mahler fans created the impression of 'frustration' and 'boredom with one another'.

notably the 'Society for Private Musical Performances'. Like the well-known *Blaue Reiter* publication of 1912, edited by Kandinsky and Franz Marc and including a bit of everything going, the Private Music Society was cosmopolitan in character. One has the impression, however, that musical works, though not the paintings, introduced from foreign countries were more or less tolerated. Ravel was admitted to the fold, but not Debussy. A kindly disposed critic allows him to be named 'the Klimt of Music'. Satie's miniature piano pieces were given at Vienna at one of Schoenberg's musical gatherings, Satie's intimate observations, printed in the score for the performer's private encouragement, having been boldly declaimed on the stage, thereby drowning the performance of the music.

Organization was the guiding principle, as of course it must be in any work of art, though Schoenberg's inflexible organization leant in the direction of tyranny. Hence his great reputation as a teacher against whom his pupils were sometimes inclined to revolt, while certain of his tyrannical pronouncements have embarrassing associations with the dictatorial pronouncements of his time. But, as I say, nationalism is gone, vanished, buried and with it, one hopes, the Superman notions. Among the more Puckish members of Schoenberg's circle was Heinrich Apostel, drawn to Alfred Kubin's novel *Die andere Seite*, enlarging upon the fantasies of Redon and Poe. He summed up the new technique in simple terms: 'One note, a tone; two notes, a relationship; three notes, a law.' They were very fond of laws at that time in this part of the world, unaware that Beethoven and Wagner were the great law-breakers of all time.

Music, like painting and like literature, despite a language barrier, could never tolerate mere nationalism. That was the lesson of Edward Dent and Romain Rolland, the great international historians of earlier years. Alas, their Utopian visions receded. Preciosity invaded the civilized French, garishness overcame the Italians and Germany was almost paralysed by some kind of elephantine disease. A gloomy prognosis? Well, pessimism brings a reward of its own. We may be wrong. 'What a wonderful surprise awaits you!' announced the gleeful monk to his lay visitor convinced there was no after-life.

Schoenberg had certainly been more powerfully drawn to the colour principle than any of his contemporaries, including Scriabin—it is eloquently expressed at the conclusion of his *Harmonielehre*—and, at the height of the colour development, he was also more violently opposed even to admitting any suggestion of colour into the sphere of a com-

poser's technique. It was all or nothing. The Quintet of 1924 declares war, it was said, on colour, as does the Piano Concerto of Stravinsky of the same period. Apart from his early Wagnerian works, Schoenberg remains, therefore, very strong meat.

The fact is that the treatises of our polemicists, Adorno and Boulez among them, on Schoenberg's break with the colour ideal and his subsequent pursuit of a mathematical ideal—for this is what the Schoenberg phenomenon amounts to—are endlessly fascinating so long as they are tempered with the philosophies of Walt Whitman ('Do I contradict myself? Very well then, I contradict myself.') and of the even more contradictory truths of *Alice in Wonderland*. Was Schoenberg an anarchist or a traditionalist? We are left to make up our own minds. Perhaps neither. Now that Munch, and his disciple Nolde, are becoming better known we may be helped in setting up a hierarchy among the Viennese *Frères en Art*.

Schoenberg's followers believe they have found a manner, through the dodecaphonic and serial systems, of reinterpreting the music of past ages. It may be that I have no capacity to grasp these abstruse notions. Yet I think it would take the minds of many great men, probably of a mathematical order, Descartes, Newton or Leibnitz, to pass an opinion on the pursuit, let alone the success of any such claim. Even Russell, if he were alive, would probably think twice about admitting this problem into the spheres of logic.

THE BERLIOZ–STRAUSS TREATISE
ON INSTRUMENTATION

It is hardly possible nowadays to devise a manual for orchestrators. The introduction of electronically produced sounds and of tape recordings makes the earlier instrumental treatises seem wholly remote. The last comprehensive guide for orchestrators is Gardner Read's *Thesaurus of Orchestral Devices* (London, 1953), and here it is categorically stated that 'nothing seems to date more quickly than an orchestration text book'.* But this is not to say that earlier treatises, useful to composers over a limited period, have not also a wider historical significance. Indeed, theoretical works on the orchestra such as those of Gevaert (1885), greatly admired by Strauss, Widor (1906), in the form of a revision of the Berlioz treatise, and Rimsky-Korsakov (in Steinberg's edition, 1912) often illuminate forgotten stylistic secrets of the orchestra or analyse problems of instrumental combinations that would otherwise elude us.

Strauss's revision of Berlioz's *Treatise*† similarly illuminates a period of orchestral history, perhaps the most critical in the transition from the nineteenth to the twentieth century. It reveals the many links between the orchestra of Berlioz, rooted in Gluck and Weber, and the orchestra of Strauss and his contemporaries based on Wagner. By 1904 (the date appended to the foreword) Strauss had written his principal symphonic poems and was engaged on *Salomé*—that is to say, he had himself written the most resplendent of the post-Wagnerian orchestral works. He therefore felt able to state that although Berlioz's treatise 'stressed the aesthetic aspects of orchestral technique, giving the careful reader a

* In the *History of Orchestration* (London, 1925) Adam Carse lists the works on orchestration published between the Berlioz *Treatise* and Rimsky-Korsakov's *Principles of Orchestration* (English version, 1922). 'All', he declares, 'begin to be out-of-date from the moment they are written.' Richard Strauss in his foreword to the Berlioz *Treatise* is similarly cautious: 'In the art of instrumentation the question of theoretical books is highly problematic.'

† Berlioz's *Grand Traité d'Instrumentation* (Paris, 1843) was twice translated into German, by J. C. Grünbaum and Alfred Dörffel. Minor additions and corrections were supplied by Felix Weingartner in 1904. Richard Strauss's edition, *Instrumentationslehre*, appeared in 1905. Strauss's comments and additions to Berlioz's *Treatise* appeared separately in French under the title *Richard Strauss, Le Traité d'Instrumentation d'Hector Berlioz. Commentaires et adjonctions co-ordonnés et traduits par Ernest Closson*, p. 92 (Leipzig, 1909). Strauss's edition was translated into English by Theodore Front under the title *Treatise on Instrumentation by Hector Berlioz, enlarged and revised by Richard Strauss* (New York, 1948).

vision of the whole Wagner', it nevertheless contained 'gaps' likely to render the whole work obsolete. Refraining from changing Berlioz's text in any way, he added technical details (particularly in regard to the valve mechanism of the brass instruments) and described new achievements, 'especially in Wagner's work'.

'Instrumentation is, in music, the exact equivalent of colour in painting', said Berlioz in *A travers chants*, thereby indicating a parallel development in painting—the movement which began with the colour theories of Delacroix and which is particularly relevant to the rise of the Romantic orchestra. This was a parallel but not an identical development: colour is a metaphor in music, despite the fact that Baudelaire and before him E. T. A. Hoffmann had proclaimed an interpenetration of this concept of colour among musicians and painters. A certain confusion in artistic theories may have resulted from Baudelaire's overbold theories—by his nature he was drawn to the whole empire of sensation—and certainly the concepts of colour in music and painting have frequently overlapped. Strauss's foreword to the *Treatise*, written at the height of the era of the Impressionist orchestra, reveals an obsession with instrumental colour. In a review of earlier developments he assesses the symphonies of Haydn and Mozart ('one might almost call them string quartets with obbligato woodwind and noise instruments, horns, trumpets and timpani, to reinforce the tutti'), and also the symphonies of Beethoven. These, he maintains, likewise 'cannot hide the mark of chamber music'. Surprisingly, he asserts that the symphonies of Beethoven were dominated by 'the spirit of the piano', meaning presumably that the lay-out of Beethoven's scores was determined by keyboard associations; and he adds that this same pianistic character 'completely dominates' the orchestral works of Schumann and Brahms—a generalization of doubtful accuracy. The freedom of the string writing in Beethoven's last quartets is not to be found in his symphonies; it is recaptured, Strauss declares, in the string writing in *Tristan* and *Die Meistersinger*. 'Colouristic effects alien to the style of chamber music' are observed in Gluck and Weber before they become a means of expression complete in themselves in the works of Wagner.

All this indicates a bias in favour of the contemporary orchestra: Strauss, the Mozartian, was obviously arguing a point here. However, having proposed this somewhat unorthodox summary he proceeds to evaluate the Romantic achievement of Berlioz. Was Berlioz primarily a symphonic or an opera composer? Perhaps, Strauss suggests, 'he was not dramatic enough for the stage and not symphonic enough for the

concert hall', though he concedes that 'he was the first to derive his inspiration from the character of orchestral instruments' and that in his attempt to combine stage and concert hall 'he discovered new and splendid resources for the orchestra'. In these, as in other observations, Strauss was echoing the spirit of an age too overwhelmed by the spirit of Wagner to respond to the ideals of Berlioz and his predecessors, Gluck and Weber. He writes, for instance, that Berlioz 'failed to justify his use of dramatic effects in symphonic works' since he was primarily a 'lyrical or epic' composer. Berliozians take the opposite view. They maintain that it was precisely Berlioz's lyrical or epic nature that destined him for the stage and that ultimately triumphed in *Les Troyens*. In fact, Berlioz often anticipated Wagner's orchestral methods, as Strauss admitted in his foreword. Nor did Strauss's criticisms stop there. 'This bold innovator', he writes, 'had no feeling at all for polyphony'—he was referring to the fact that Bach brought nothing to Berlioz's technique.* Dramatic ideas cannot be presented in music 'without rich polyphony'. There speaks the composer of the decorative embellishments in *Till Eulenspiegel* and *Salomé*; there speaks the Wagnerian nurtured on Bach. Two civilizations face each other in these composers—Berlioz drawn to the lyrical elements of the orchestra, Strauss involved in a complex multicoloured treatment.

One is aware that this opposition is treated by Strauss, in the course of his revision of the *Treatise*, with playful malice.† Illustrations from Gluck,‡ whose works form the foundation of Berlioz's orchestral ideas,

* In the *Treatise* Berlioz had written a paragraph on organ fugues, which normally consisted, he said, of 'twisted and tangled phrases', producing a continuous 'commotion of the entire system'; also that they presented an 'appearance of disorder' and that they contained 'detestable harmonic absurdities appropriate in depicting an orgy of savages or a dance of demons'. To this Strauss replies: 'Although I share Berlioz's opinion regarding organ fugues, this whole paragraph seems to me to be inspired by his purely personal hatred of the polyphonic style in general—a hatred not generally shared even by the admirers of Berlioz's genius. In this respect the German and the Latin are at logger-heads.'

† Strauss was surely aware of the long-drawn-out conflict between Berlioz and Wagner, and of Berlioz's revolting conception of the Prelude to *Tristan*, calculated, as he believed to produce impressions of aural and emotional cruelty. This opinion, first published in the *Journal des Debats*, appears on page 68 and was subsequently reprinted in *A travers chants*, Paris, 1862.

‡ In the unfinished preface written for the *Principles of Orchestration* in 1891 Rimsky-Korsakov, like Strauss, proclaims the value of contemporary scores: 'Fairly modern music will teach the student how to score—classical music will prove of negative value to him. It is useless for a Berlioz or Gevaert to quote examples from the works of Gluck. The musical idiom is too old-fashioned and strange to modern ears; such examples are of no further use today. The same may be said of Mozart and of Haydn.' In search of historical authenticity we nowadays reverse this judgment; we wish to revive the impact of earlier orchestral styles.

are invariably contrasted with illustrations from Wagner. Referring to one of the numerous effects of the string *tremolo** expressing 'unrest, excitement and terror', Berlioz quotes the scene of the oracle in Act I of *Alceste*.† Played near the bridge, it produces, Berlioz graphically states, 'a sound similar to that of a rapid and powerful waterfall'. He also describes an 'undulating *tremolo*', which had fallen out of use even during his lifetime, and which consisted of slurred notes played at a slow speed so that none of the performers played the same number of notes in a bar. This 'wavering or indecision', favoured by Gluck, was 'perfectly adapted to render uneasiness or anxiety'. Strauss does not comment on these strange other-worldly effects. His examples of the string *tremolo* include Siegmund's call, 'Wälse, Wälse', in the first act of *Die Walküre*; the monotonously raging storm 'with the whipping of the rain and hail by the wind' at the beginning of the opera (the famous D octave on violins and violas); and 'the rustling of the leaves and the blowing of the wind' produced by chromatic harmonies at the beginning of the second act of *Tristan*. Though nowadays despised, imagery of this kind, pictorial or psychological, frequently lights up the poetic processes of a composer's mind. The *tremolo* has a remote history, but mutes, judging from Berlioz's examples, seem at that time to have been used only sparingly. Gluck's *Alceste* (Act II, 'Chi mi parla') and the sudden transition from muted to bright tones in the *Queen Mab* scherzo are Berlioz's only examples; nor does Strauss conspicuously add to these effects by illustrations from *Die Meistersinger* and *Tristan*. In 1904 Strauss might have given examples of some of the entirely novel muted string writing in Debussy and Mahler.

Abundant quotations from five of Gluck's operas are given by Berlioz, and it is again Gluck who is his model for the use of the viola. Acting as a precursor, in *Harold en Italie*, of the present-day vogue for the viola, Berlioz refers to 'the terrible persevering murmur of the violas' and 'particularly to the timbre of its third string' in *Iphigénie en Tauride* (when Orestes falls asleep with the words 'Le calme rentre dans mon cœur').‡ Elsewhere melodies on the high strings of the viola are

* Only a personal choice of orchestral devices is made by Berlioz, and this also applies to the supplementary examples of Strauss. In the preface to his voluminous *Thesaurus* Gardner Read writes: 'If every example of the use of the bow tremolo in the strings had been given, there would literally have been room for nothing else in the book.'

† English edition of the Berlioz–Strauss *Treatise*, p. 13. Other musical examples mentioned in the text can easily be identified by reference to the excellent index in this edition.

‡ 'To the viola, the Cinderella of the String Orchestra, Gluck was the fairy godmother who rescued the instrument from a mean position and made it not only independent and

said to achieve miracles in 'scenes of a religious or ancient character'. Strauss, confronted with these choice examples, falls back automatically on the scores of Wagner and refers to the more deeply coloured passages in *Tannhäuser*, *Lohengrin* and *Die Meistersinger*. There is apparently more agreement in their approach to Gluck's treatment of the woodwind. Berlioz was inspired by the low sustained notes on the flute (which actually have a trumpet quality) in *Alceste* and in Agatha's prayer in *Der Freischütz*; Strauss was drawn to this same effect in *Lohengrin*.* The third act of *Armide*, in which Armide sings 'Sauvez-moi de l'amour', is Berlioz's modest example of an oboe melody, whereupon Strauss counters with extended oboe melodies from Berlioz's own works, namely those in *King Lear*, *Benvenuto Cellini* and the *Fantastic Symphony*. The cor anglais is illustrated by the well-known passage in the 'Scène aux champs' (so romantically described), and by its use in the first and second acts of *Lohengrin*. Gluck and Wagner face each other in their very different use of trombones and cymbals.

A forgotten world of instrumental colour can be reconstructed if we look behind these marginal remarks of Strauss. Berlioz was aware of the affinities between the orchestra of Gluck and the orchestra of Weber: both display the same freshness of woodwind colour, the same sense of graded colours in string writing; Strauss, on the other hand, was aware of Weber's affinity with Wagner. He realized that the separate colour schemes sought out by Weber in his combinations of divided strings led to Wagner's infinite wealth of string coloration. But it was above all the motives inspiring Weber's woodwind writing, particularly his clarinet writing, that set Berlioz's Romantic heart alight. In one of the most eloquent passages in the *Treatise* he speaks of 'those coldly threatening effects' in the lower register of the clarinet, producing 'those dark accents of quiet rage which Weber so ingeniously invented'. His description of the clarinet in *Der Freischütz* forms an exquisite vignette of Romantic writing which I will quote in the original French, so marvellously does Berlioz evoke the changing colour in the range of this instrument.

indispensable, but discovered in it an individuality which was quite its own, a peculiarity of tone-colour with which no other member of the string family was endowed.' (Carse, *op. cit.* p. 157.)

 * 'Modern masters generally keep the flutes too persistently in the higher ranges', Berlioz comments. 'The flutes predominate in the ensemble instead of blending with it.' 'Very true indeed!' adds Strauss, writing before *Daphnis et Chloé* and *Le Sacre du printemps*.

Je n'ai jamais pu entendre de loin une musique militaire sans être vivement ému par ce timbre féminin des clarinettes, et préoccupé d'images de cette nature, comme après la lecture des antiques épopées. Ce beau soprano instrumental si retentissant, si riche d'accents pénétrants quand on l'emploie par masses gagne dans le solo en délicatesse, en nuances fugitives en affectuosités mystérieuses ce qu'il perd en force et en puissants éclats. Rien de virginal, rien de pur comme le coloris donné à certaines mélodies par le timbre d'une clarinette jouée dans le médium par un virtuose habile.

C'est celui de tous les instruments à vent, qui peut le mieux faire naître, enfler, diminuer et perdre le son. De là la faculté précieuse de produire le lointain, l'écho, l'écho de l'écho, le son crépusculaire. Quel plus admirable exemple pourrai-je citer de l'application de quelques-unes de ces nuances, que la phrase rêveuse de clarinette, accompagnée d'un tremolo des instruments à cordes, dans le milieu de l'Allegro de l'ouverture de *Freyschütz*! N'est-ce pas la vierge isolée, la blonde fiancée du chasseur, qui les yeux au ciel, mêle sa tendre plainte au bruit des bois profonds agités par l'orage? O Weber!

Strauss goes only part of the way with Berlioz in his evocation of romantic forests and twilights. He was writing in a more realistic age, his remarks reflecting passionate, underlying associations. The clarinet, he says, which has 'so much sweetness and innocence in Weber, becomes in *Parsifal* the embodiment of demoniac sensuality', proclaiming in Kundry's scenes 'the dreadful and haunting voices of seduction'. However, the composer of Brander's ironic 'Histoire d'un rat' in the *Damnation de Faust* would have wholly endorsed Strauss's selection, in the chapter on the bassoon, of a passage in *Euryanthe*. One might almost be listening to Berlioz's own words: 'Weber draws from the bassoon heart-rending tones of suffering innocence—in the cavatina (Act III) of Euryanthe languishing alone in the forest'.*

The Strauss edition made a big impact on the French and Belgian musical worlds in the decade before the first World War. In his enthusiastic review of the work in the Brussels journal *Le Guide Musical*†
Ernest Closson draws attention to the fact that no examples of Russian music are given. Indeed, Strauss seems not to have been greatly drawn to the Russian school;‡ otherwise the volume, by drawing upon

* This cavatina, not quoted in the revision, opens with a *largo* recitative for unaccompanied bassoon extending over the entire range of the instrument.

† Nos 39–41, 1909.

‡ In 1907 Romain Rolland, discussing *Boris Godounov* with Strauss, insisted that this masterpiece of Moussorgsky was an opera of genius. Amazed at this verdict, Strauss was even reluctant to glance at the score. 'I don't know a Russian opera that has genius.' *Richard Strauss and Romain Rolland: Correspondence*, edited by Rollo Myers (London, 1968). Even the orchestra of the early Stravinsky left him indifferent. In the *Firebird* only

examples from the national school, and particularly Rimsky-Korsakov and Moussorgsky, both of whom regarded the *Treatise* as their bible, would have been even larger than it is. Nor are there illustrations, Closson notes, from the 'young French school', which, one imagines, does not include Charpentier, since there is a reference to the use of the celesta in an opera that was a particular favourite of Strauss, *Louise*. (The American publishers have substituted the fanfare for muted trumpets in *Fêtes* for Strauss's illustration from *Feuersnot*.) But the interesting affinity that we are now able to establish is between certain aspects of the orchestration of Berlioz and Debussy. The *Queen Mab* scherzo and the opening section of *Fêtes* are certainly the works where the two composers seem to have been inspired by the same lightness of texture. One sees here the same swift and elusive figurations; the same unexpected gleam of instrumental colour (the flashing flutes in *Fêtes*, the pastel shades of a pair of horns in the scherzo); the same vivacity and airiness; and the same concern with the timbres of cymbals, the metallic antique cymbals in the scherzo (earlier used by Debussy for a glinting effect in *L'après-midi d'un faune*) and the large cymbal, tingling in the air in an Impressionist fashion in *Fêtes*. I think it is right to say that in both cases the models for this type of orchestration must have been the three fairy choruses in Weber's *Oberon*, and particularly the *Presto agitato* in the chorus 'Spirits of Air and Earth and Sea' (Act II).* It is certain that Debussy regarded Weber's works as 'the best treatise on instrumentation', and he also held that Weber had hardly been surpassed in 'orchestral chemistry' even at the beginning of the twentieth century.† *Oberon*, profoundly admired by both Berlioz and Debussy, thus forms a link between these two great orchestrators.

Omissions of French and Russian music were observed by Closson, but not, apart from the works of Strauss himself, the omission of contemporary German and Austrian music. Mahler is mentioned only casually in the revision, in regard to his use in the symphonies of high clarinets and percussion instruments. Yet here again, with hindsight, we are able to perceive resemblances seldom imagined by earlier generations. We see now, for instance, that Mahler inherited Berlioz's sense of musical irony, which he enlarged and magnified, and that it was

Stravinsky's unusual writing for harmonics on the violins, at the opening of the ballet, aroused his interest.

　* Referring to the *Queen Mab* scherzo in *Portraits et souvenirs* (1900) Saint-Saëns writes: 'Auprès de telles délicatesses, de telles transparences . . . je ne vois que le chœur des génies d'*Obéron* qui puissent soutenir la comparaison.'

　† An account of Debussy's ideas on Weber's orchestra is given on page 17.

Mahler, in his *Symphony of a Thousand,* who realized the Berliozian ideal of a miniature army of performers. Orchestrally, Mahler nearly always leans in the direction of Berlioz rather than Wagner. As I have previously mentioned in my *Debussy: His Life and Mind,* Vol. II (London, 1965), a striking glimpse of the affinity between Mahler and Berlioz was given by a French critic, Amédée Boutarel, in his notice of a performance, which Mahler conducted in Paris in 1910, of his Second Symphony. Ten years earlier Mahler had conducted the *Fantastic Symphony* there. Is Mahler's enormous Second Symphony, expressing a complexity of ideas within too restricted a framework, 'not an enlarged, amplified and exaggerated Fantastic Symphony?' this critic asks. The Allegro of this symphony corresponds to *Rêveries et passions,* the minuet 'is the "Ball" movement removed to another setting and another period'. Berlioz in the 'Scène aux champs' shows us the artist in Nature; Mahler follows his wanderings in the Viennese Prater. Memories of the 'Marche au supplice' and the 'Dies Irae' are recalled in the heroic march and the funeral chorale of the finale, where, as in Berlioz, there is 'a certain admixture of irony and faith and an intermingling of despair and ecstasy'. Nor are comparisons restricted to these moral issues. M. Boutarel continues: 'There is the same obsession with colliding musical ideas, violent sonorities, lugubrious silences, drum effects, and there is even as in the Berlioz work, a flute warbling about in the middle of the finale. Everything about the work suggests the grandiose genius of Berlioz where contrasts are thrown sharply into relief.'*

Praising Strauss's Wagnerian sympathies, so abundantly illustrated in the revision, Closson observes that 'ce quelque chose de chaleureux et de passionné' in Strauss's orchestral style is not to be found among the French followers of the Wagnerian tradition. Oddly, he does not note that in the section on the horn there is no mention of the famous horn passages in Strauss's own works, nor does Strauss refer to the horn solo in the *Chasse royale,* which was written sixteen years after Berlioz published the *Treatise* and must surely have been known to him. A good half of the examples in the revision provided by Strauss, Closson notes, are taken from Wagner. They are the *Faust* overture, 1; *The Flying Dutchman* and *Siegfried Idyll,* 2; *Götterdämmerung* and *Parsifal,* 3;

* *Le Ménestrel,* 23 April 1910, p. 133. The same comparison between these works of Berlioz and Mahler was made by Richard Specht, *G. Mahler,* Berlin, 1925: 'Another form of the *Fantastique,* a symphonic diorama of the *Episodes de la vie d'un artiste.*'

Rheingold, 6; *Lohengrin*, 7; *Siegfried*, 8; *Tannhäuser*, 9; *Die Walküre*, 16; *Die Meistersinger*, 17; *Tristan*, 18.

Tristan crowns the list, one notes, but it was precisely in *Tristan* that some of Wagner's most characteristic melodic ideas were fertilized (as Gerald Abraham, Jacques Barzun and others have shown)★ by the earlier ideas of Berlioz in *Roméo et Juliette*. This must be the place to recall the terms of a well-known document in which Wagner himself indicates his indebtedness to the master of the early Romantic orchestra. He is writing in *Mein Leben* of a performance of *Roméo et Juliette* conducted by Berlioz in Paris in 1839–40:

> All this, to be sure, was quite a new world to me, and I was desirous of gaining some unprejudiced knowledge of it. At first the grandeur and masterly execution of the orchestral part almost overwhelmed me. It was beyond anything I could have conceived. The fantastic daring, the sharp precision with which the boldest combinations—almost tangible in their clearness—impressed me, drove back my own ideas of the poetry of music with brutal violence into the very depths of my soul. I was simply all ears for things of which till then I had never dreamt, and which I felt I must try to realise. True, I found a great deal that was empty and shallow in 'Roméo et Juliette', a work that lost much by its length and forms of combination; and this was the more painful to me seeing that, on the other hand, I felt overpowered by many really bewitching passages which quite overcame any objections on my part.

'A new world' by which Wagner was 'overwhelmed' and which drove back his own ideas to the depths of his soul—this was a generating force, an influence, a form of cross-fertilization between Berlioz and Wagner which has had the effect of keeping their work alive for us up to the present day.

★ See G. Abraham, 'The Influence of Berlioz on Wagner', *Music & Letters*, July 1924; and J. Barzun, *Berlioz and the Romantic Century*, ii (London 1951): 'A comparison of *Tristan* with certain parts of the *Romeo and Juliet* Symphony shows that Wagner was struck by Berlioz's idea of rendering a love call orchestrally by means of the gradual amplification of an initial "call" or unsatisfied musical start' (p. 184).

POUSSIN AND THE MODES

To see the manner in which Poussin's theories flourished in later periods we must investigate the records of Poussin's musical associations.

From Rome on 24 November 1647 Nicolas Poussin wrote at length to his friend and patron Paul Fréart de Chantelou on the matter of a number of orders he had received and on his methods of working and presenting the subjects of his pictures. 'I want to inform you of an important matter', he writes, 'regarding the manner in which subjects for painting are to be observed.'* Writing of the choice made by the Greeks to convey the character of one subject or another, he continues: 'I hope by the end of the year to have painted a subject in the Phrygian mode, that is to say a mode which is violent and furious, very severe and calculated to produce amazement.' Poussin also speaks of the character of the Lydian, Hypolydian, Dorian and Ionian modes.† The whole of this passage and particularly the section dealing with the modes in general‡ has long been well-known to art historians. This is partly due to the fact that Sir Anthony Blunt discovered that these extracts, though held to be by Poussin himself, were in fact copies by Poussin from a text by the Italian sixteenth-century musical theorist Gioseffo Zarlino; and also to the fact that the theory of the modes, in its application to painting, either in a definite or an indefinite manner, has given rise to lengthy discussions.

Let us first of all quote Sir Anthony Blunt's comments in his edition of Poussin's letters: 'The whole section of the letter in which Poussin

* Nicolas Poussin, *Lettres et propos sur l'art*, edited by A. Blunt (Paris, 1964), p. 121 *et seq.* See also *Correspondance de N. Poussin*, ed. C. Jouanny (Paris, 1911), p. 372 *et seq.*

† 'They [our noble ancient Greeks] intended that the Lydian mode should be adapted to woeful subjects since it has not the modesty of the Dorian mode nor the severity of the Phrygian mode. Inherent in the Hypolydian mode is a certain blandness or mildness which fills the souls of those who behold this mode with joy. It is the mode suited for the expression of divine subjects, glory and paradise. The ancients invented the Ionian mode for the presentation of dances, bacchanalia and festivities, in the nature of a mirthful mode.' This letter also states that the Greeks 'attributed to the Dorian mode qualities of stability, seriousness and severity and recommended its use for subjects of this kind reflecting wisdom'.

‡ The passage in question begins: 'Since the modes of the ancients were composed of many disparate elements, their variety produced different impressions and one became aware of their indefinite nature.'

speaks first of Greek music and later of the poetry of Virgil* was copied from the *Istituzione harmoniche* of Gioseffo Zarlino, published in Venice in 1558, one of the most celebrated treatises on music of the time . . . In regard to certain points Poussin incorrectly copied the text of Zarlino which explains the references to two different and even contradictory definitions of the Phrygian mode: Zarlino quotes two authors but Poussin copies the two definitions without indicating that they originate from different sources. The fact that this passage was copied from a treatise on music does not detract from the importance of this letter as an expression of Poussin's ideas. All the critics of Poussin, and Félibien chief among them, have noted that he definitely applied the theory of the modes in his work.'

The emotional character of a certain musical mode re-created in a picture was a novel approach. An example is the severe Lydian mode illustrated in the gravity of a picture of Poussin entitled *Lamentation over the Dead Christ*, in the National Gallery of Ireland, Dublin (see Plate 5). Here people are assembled around the tomb of Christ in sorrowful postures and are combined in a composition depicting grief. This represented a new approach to methods of painting.† Eighteenth-century art historians applauded these methods. 'Each picture should represent a mode in agreement with its character', declared Antoine Coypel. 'The heart can likewise be moved by the ear and the eyes. A mode must be chosen appropriate to the subject and its true character of joy, horror or sadness conveyed at a glance.'‡

Perhaps there is something analogous in this debate to the discussion at this same period on the priority in opera of music or poetry. We are almost in the world of Richard Strauss's *Capriccio*—*Prima la musica e poi le parole*—except that Poussin reveals a bond between painting and music. This established the function of descriptive music. This must have been the opinion of André Félibien, the author of the *Entretiens sur la vie et les œuvres de Poussin* (1685) who wittily observes: 'It would be dangerous if painting were allowed to arouse passions in the manner of music, though in fact our excellent painters are indeed equipped to create great confusion.' Speaking of the powerful emotions aroused by a certain piece of military music, he explains: 'In truth music of this

* Poussin, *Lettres et propos sur l'art*, p. 125.

† The parallel principles of music and the visual arts, particularly relating to the theories of architecture, during the Renaissance are investigated in the chapter 'Musical Consonances and the Visual Arts' in *Architectural Principles in the Age of Humanism* by R. Wittkower (London, 1952), p. 103 *et seq.*

‡ Antoine Coypel, *Sur l'esthétique du peintre* (Paris, 1721), pp. 240, 328 and 391.

kind is not entertaining and no pleasure would be offered by painters producing cruel effects of this kind.' It appears that in listening to this particular work a certain Danish King was compelled to draw his sword and run it through four members of his suite. 'I imagine that it was not the intention of Poussin', Félibien pointedly observes, 'to place those who behold his pictures in this mortal peril.'

At this point we must take into consideration a study by Paul Alfassa.★ 'I have always thought,' this author states, 'that one was wrong in attributing too great a value to the theories formulated by Poussin in his correspondence. . . . The letter on the modes, particularly, has never seemed to me clear or relevant . . . the "modes" to which [the pictures of Poussin] are said to refer—if indeed they are modes at all— are by no means clearly distinguished from each other.' Alfassa recognizes the importance of the discovery of Sir Anthony Blunt, particularly as Blunt demonstrates that Zarlino was not the only writer of this period whose texts were appropriated by Poussin, but he is compelled to note the strangeness of certain expressions of Poussin in his letter to Chantelou.†

It is by no means easy to evaluate the influence of the musical modes in a department of the imaginative mind which is not strictly musical; one can hardly expect a conclusive result. Moreover, as I am bound to repeat, Poussin's musical relationships have never been investigated by musicians. Music historians have long discussed the significance of the modes and no definite agreement has been reached on this subject— indeed most authorities are agreed on the variety of interpretations that have been put on the character of the modes.‡

Nevertheless the nature of a musical influence in the work of Poussin continues to preoccupy art historians, § and obviously for good reasons.

★ *L'origine de la lettre de Poussin sur les modes d'après un travail récent* (the recent work was the thesis on Poussin by Sir Anthony Blunt, followed by other important works) in *Bulletin de la Société de l'Histoire de l'Art français* (Paris, 1933), pp. 125–43. The texts of Poussin and of Zarlino are printed side by side (pp. 138–42).

† Alfassa suggests that Poussin's French translation of Zarlino's Italian text was either too literal or incorrect. He changed the expression 'rapid rhythms' (*numeri più veloci*) into 'minor modulations' and 'stringent harmonies' (*harmonia più acuta*) into 'a sharply focused view' for the reason, so we are told by Alfassa, that the terms rhythm and harmony did not seem to him suitable to painting.

‡ See D. P. Walker, *Musical Humanism in the 16th and 17th Century*, in *Music Review*, Cambridge, Vol. II, 1941, Nos 1–4 and Vol. III, 1942, No. 1 (pp. 220 *et seq.*); and Jacques Chailley, *L'Imbroglio des Modes* (Paris, 1961).

§ The history of the influence of the modes in the visual arts is comprehensively dealt with in the study *Das Modusproblem in den Bildenen Künsten*, by Jan Bialostocki in *Zeitschrift für Kunstgeschichte*, Munich, 1961, No. 2. Documents relating to Poussin and Zarlino

For whatever importance might have been attached to the theory of the interdependence of music and painting in the seventeenth century it is clear that today, after Debussy and Paul Klee, this theory has made a widespread impression. Not for nothing did Sir Anthony Blunt note the 'abstract methods' in the paintings of Poussin or the influence of Poussin on Delacroix, whose works contain the seeds of Impressionism. We may look back on this seventeenth-century controversy as an indication of a confusion of categories characteristic of a civilization approaching its height.

are examined by Denis Mahon in *Poussiniana: Afterthoughts arising from the Exhibition* in *Gazette des Beaux-Arts* (Paris, July–August 1962), p. 122 *et seq.*

THE MIND OF ALBAN BERG

The psychological inspiration in Berg's *Wozzeck* has frequently been discussed and so has Berg's allegiance to the twelve-note theories of Schoenberg. Is Berg therefore a remote disciple of Poussin? I think he is if we take into account the deeper musical and psychological explorations over a period of three hundred years. In *Wozzeck* Berg was clearly preoccupied with matters of moral and sexual abnormalities, though he distrusted the psycho-therapeutic methods of Freud whom however he had consulted in regard to his early attacks of asthma.

This is evident from the letters of Alban Berg to his wife Helene: 'Don't let the "Psyche" of that Dr Sch. affect you . . . You yourself ask whether all this is not "criminal". Of course it is, that's why I'm going to punish his crimes. I'm just waiting' (28 November, 1923). And the following day: 'Don't go to any more "sessions". Tell the doctor I've forbidden it, and say that if there had been any question of psycho-analytic treatment, we should have gone to Dr Freud or Dr Adler, both of whom we have known very well for many years. But we had no desire to do that at all. . . . In a week's time we shall be laughing about the crazy confidence trick of this "psycho-analysis", and all these explanations of unfulfilled desires, sexuality etc. . . . As he can use all the filthy aids of this beastly science, psycho-analysis, and you are alone and defenceless, you are bound to submit to the butchers.'*

'If I had the time I would devote a whole chapter to Lesbianism and homosexuality', Berg writes in an autobiographical document submitted to his future father-in-law, 'to those who are given to these practices as well as to those who are not and who take it upon themselves to proclaim people of these leanings as criminals.' There speaks the psychologist among the composers of our time, the full man but also the hypersensitive man and therefore the tolerant, compassionate man. Indeed, the composer of *Wozzeck* and *Lulu* was well equipped to explore the borderlands of normality that were being opened up in his time. At eighteen frustration had brought him to the brink of suicide. Thereafter, though happily married, he remained drawn to his Lesbian sister Smaragda, who had had a strong musical influence on him in his

* Alban Berg, *Letters to his Wife*. Trans. by Bernard Grun (London, 1971), pp. 334 and 335.

youth, and he also remained obsessed by the ideas of sexual emancipation in the works of Strindberg and Wedekind. Preoccupations of this kind are only remotely connected with the Poussin–Zarlino theories but they nevertheless belong to the same family of ideas even though in the course of three hundred years the classical ideals had been gravely undermined.

Berg was obsessed by the theories of these writers but he does not emulate the extravagances of their personal lives. This is not surprising. Composers, caught up in the complex machinery of the musical world, are compelled to lead conventional lives. 'In my universe disorder rules, and *that* is freedom', proclaimed Strindberg in anarchistic fashion. Wedekind, deploring the fact that artists, feeding on each other, were becoming alarmingly ingrown, commendably urged them to seek out 'men who have never read a book in their lives and whose actions are dictated by the simplest animal instincts'. He himself, drawn to the criminal world, became a disciple of a forger of pictures, many of whose counterfeits, we are told, hang in galleries still. No irregularities of this kind are to be discovered in the life of Alban Berg, though one may suspect that he hankered after a less conventional existence. A withdrawn intellectual, able only with difficulty to exteriorize his ideas, he resorts instead to self-analysis, a domain in which he showed powers almost as penetrating as those of Freud with whom, as we have seen, he was personally acquainted over many years.

These facts emerge from Berg's *Briefe an seine Frau* (Munich, 1965), a publication of over 600 closely-printed pages constituting the most substantial source yet made available for an investigation of Berg's inner life. The later English edition is a curtailed version. Indications in earlier publications of his acute sensibility—he once spent twenty minutes rehearsing a few bars of his violin concerto—his devastating sense of irony, his sudden veering from ecstasy to depression, and the pleasure which he confessed he found in physical pain—all these features of the over-refined intellectual are confirmed in these long, rambling letters. And they have a further value. They allow us to read in a more affecting manner an explosive tribute to the new spirit that was breaking through. Among the letters written at the age of twenty-two to Frida Semler Seabury* there is a passage which, as we now see, shows Wedekind to have been a central European counterpart of D. H. Lawrence:

* Information kindly supplied by Dr Mosco Carner. The letters appeared in *Memoirs of the International Berg Society*, New York, December 1969.

Wedekind—the really new direction—the emphasis on the sensual in modern works! . . . This trait is at work in all new art. And I believe it is a good thing. At last we have come to the realization that sensuality is not a weakness, that it does not mean a surrender to one's own will. Rather it is an immense strength that lies in us—the pivot of all being and thinking. (Yes, all thinking!) In this I am declaring firmly the great importance of sensuality for everything spiritual. Only through the understanding of sensuality, only through a fundamental insight into the 'depths of mankind' (shouldn't they rather be called the 'heights of mankind'?) can one arrive at a real idea of the human psyche. This achievement, mastered first by medicine and psychology, understandably enough, is now making its way into law, God be praised, and there it will produce the most wonderful fruits for humanity.

Once again, by contrast with the world of Poussin and his associates, the threshold of a new era seems to have been crossed. Berg's concern with the conquests of medicine and psychology brings music into the heart of the forward-looking ideas of his time. He had in fact been reading Cesare Lombroso, the principal figure in the new humane school of criminology, and Richard von Krafft-Ebing, whose *Psychopathia Sexualis* was the first large-scale investigation of sexual aberration undertaken on a scientific basis in the hope of introducing a more equitable form of justice.

The influence of the ideas of these writers on Berg's choice and treatment of *Wozzeck* was enormous. Though Lombroso believed that the criminal was a physical type, that he was a reversion, in fact, to a primitive type of human being—a naïve theory soon to be exploded—this far-seeing Italian physician was the first to perceive a connection between the abnormalities of the criminal and those of the artist. Both are of a larger-than-life order, both are likely to be motivated by a neurotic element. In an allied sphere Berg perceived similar connections, now widely endorsed, between insanity and genius. (Not for nothing did the early critics of *Wozzeck* simultaneously declare that it was the work of a destructive madman—the twelve-note system does in fact destroy the sense of tonality—and the work of a revolutionary genius.)

Berg was impressed by Lombroso's humane outlook—criminals were essentially to be pitied—and his heart must also have gone out to the victims of sexual aberrations described by Krafft-Ebing. Compassion for these victims was the overriding motive for the study by this psychiatrist ('By comparison other afflictions are as trifles', he states) and of course it is again compassion, underlying many different situations and interwoven at many levels throughout the plot, that is the

germinating theme of *Wozzeck*. Poussin and Berg join hands at last. As everyone is aware, without this compassionate spirit *Wozzeck* is merely a blood-curdling murder story. Several writers, encouraged by Berg's own statements, have interpreted *Wozzeck* according to the theories of psycho-analysis, and there are no doubt valid investigations to be carried out on these lines. But this seems not to be the historically accurate approach. Berg's masterpiece, as we now see, is more precisely a work reflecting the social and psychological theories not of Freud himself but of Freud's precursors.

WAGNER, JUDITH GAUTIER AND RENOIR

In 1869 an international exhibition of painting was held at Munich in the manner of many wide-ranging exhibitions regularly held in the capitals of Europe at that time. Critical articles on this exhibition were published by three French artists, fervent disciples of Wagner, Villiers de l'Isle Adam, Judith Gautier and her husband Catulle Mendès. They had undertaken the journey not only for professional reasons but from a sense of devotion to the Master who had invited this oddly assorted company, his 'Chère Trinité' as he called them, to his nearby villa on Lake Lucerne. Wagner's admirers were not noted for moderation. In the course of two months, in 1869, Judith Gautier heard twenty-two consecutive performances of *Rienzi*. Catulle Mendès was similarly one of the early upholders of the Wagnerian faith in Paris, while Villiers de l'Isle Adam, in a discussion on Shakespeare, Goethe and other giants of this order, maintained that Wagner surpassed them all. 'Il est cubique', he declared, anticipating a twentieth-century term in painting.

Contemporary impressions of this 1869 Munich Exhibition may seem somewhat arid as we read them today, but they are worth recalling since they show the style of painting to which these associates of Wagner were expected to respond. They did so only half-heartedly. One gathers that apart from the works of Courbet and Corot and the sadistic works of a German painter, Gabriel Max, most of the works exhibited at Munich were unadventurous and academic. Judith and Villiers were interested less in the exhibition than in the Munich museums. Not for nothing, therefore, was Judith Gautier among those who later encouraged Renoir to paint Wagner's portrait. This was at Palermo during the composition of *Parsifal*. Clearly, the opulent, sensuous style of Renoir was more harmoniously attuned to the Wagnerian ideals, even though Wagner himself was wholly unresponsive to painting.*

* On 30 September 1860 Wagner wrote to Mathilde Wesendonk in Rome: 'Ah how I see my child revelling in Raphael and painting! How beautiful, endearing and reposeful! But they will never move me. I am still the Vandal who throughout a whole year in Paris never managed to get to the Louvre. Doesn't that tell you everything?' Wagner wrote little about scenery and some of his ideas were in doubtful taste, notably the scenery and costumes he inspired Joukowsky to create for the Flower Maidens' Scene in *Parsifal*. Wagner was not greatly concerned with Joukowsky's shocking *Parsifal* scenery,

Wagner's personal relationship with Judith Gautier is important here. Divorced from Catulle Mendès, Judith Gautier remained attached to Wagner throughout his life, an unresolved father–daughter relationship. Most students of this period of Wagner's life are agreed that Judith, a mere girl of twenty-four, renowned for the perfection of her classical Greek features and her knowledge and erudition in Sanskrit and Oriental literature, was an inspiration to the ageing Wagner during the composition of *Parsifal*; and indeed Wagner's correspondence repeatedly emphasizes her overwhelming personal and physical appeal. There were of course many intellectual aspects of their amorous relationship. Wagner and above all Cosima were themselves drawn to oriental subjects. However, as we shall see, the pent-up passionate letters written in secret to Judith disclose, in the manner of the headier writings of Baudelaire, worlds where the appeals of the senses are constantly being equated or interrelated. Perfumes, sounds and colours, in the terms of the well-known Baudelairean formula, even more than oriental or religious aspirations, excited Wagner's creative imagination. This is the lesson we may learn today from the Wagner–Gautier correspondence. In many of Wagner's letters—those from Judith Gautier have been destroyed—one might be reading Baudelaire's theory of the *Correspondances*.

At the time of her visit to the Munich Exhibition in 1869 Cosima Wagner wrote to Judith: 'I am delighted to see that you are giving your support to Bavarian painting which I consider the best in Germany. I particularly recommend to you the portraits of Lenbach of which you have seen a portrait of Goethe at Triebschen and who is altogether superior.'

Franz von Lenbach (1846–1904) was an academic portrait painter whose subjects included Bismarck and Eleanora Duse as well as Liszt,

nor indeed with the unchallengeable glories of Raphael. In the visual arts he was, as he says, a Vandal. Yet does the nature of his music not blast a way to the abstract art of later times? As we remarked in the chapter on Turner (see p. 65) he told Ludwig II that having invented the invisible orchestra he wished now to complete his journey into the abstract world by inventing the invisible stage. Once again we approach, in Wagner, one of the final realizations of the Impressionist ideal. In the meantime his ironic remark about the invisible stage suggests a fascinating field of research, namely the development of scenic ideas in Wagnerian productions from the *art nouveau* style of his own time to the styles of the present day. This has been admirably undertaken by Geoffrey Skelton in *Wagner at Bayreuth* (London, 1965). Other authorities are Michael Petzet for the early productions, and the revolutionary works of Adolphe Appia, notably the catalogue for the exhibition *Appia and the new approach to Stage Design*, held at the Victoria and Albert Museum, October 1970.

Wagner and Cosima Wagner. Judith visited his studio in Munich and noted his admirable practice of copying masterpieces. Originality was not conspicuous in this Sargent of his time. Nor were the Bavarian paintings in the exhibition especially memorable despite Cosima's recommendations. In fact Judith's impressions were soon forgotten. She writes: 'The International Exhibition of Painting—the pretext of our journey—was, I believe, very remarkable; it brought distinction to the artists who organised it and showed the value of Bavarian painting. But I am bound to admit that despite some very conscientious reports which I wrote on the exhibition—I no longer remember in which papers*—I retain only confused memories. However, I remember the name of one painter, Gabriel Max, forgotten perhaps today, who had just come before the public and who was creating a great sensation. I remember the impression made upon me by his gracious girl martyr who, deadly white in colour, seemed to sleep so voluptuously on the cross.'†

Gabriel Max (1840–1915), a forward-looking figure, belonged to a school of Munich painters whose ideas were based on the theories of the English Pre-Raphaelites. Religious and mystical aspirations, motivated by powerful erotic images, are displayed in his work in a spirit suggesting undertones of *Parsifal*. Some of his works have conventional period titles such as *The Secret of Love* and *Longing*, but he was also emboldened to paint a terrifying picture of a lion devouring a woman entitled *The Lion's Bride*.‡ Wagner's Kundry is perhaps suggested in the criticism by Catulle Mendès of Max's *A Nun in the Cloister Garden*: 'This young nun suggests some kind of French refinement. She is relaxing after a wearisome journey and is seen weeping beneath a flowering tree surrounded by a springtime scene of birds and butterflies. Is M. Max sure that some perversity did not cross his mind while painting this all too beautiful sister of the church?' §

In view of the fact that Judith Gautier was later to publish no less than four different translations of *Parsifal* in a persistent pursuit of the ideal, and that Wagner was to find in his recollections of Judith the motivation of many of his musical ideas, I think it is worth quoting a remarkable description of the painting which she saw at Munich, *The Martyr on the Cross* (St Julia) written by Richard Muther:

* See M. Dita Camacho, *Judith Gautier, sa vie et son œuvre* (Paris, 1949), p. 86, for details of these forgotten articles.

† Judith Gautier, *Auprès de Richard Wagner* (Paris, 1943).

‡ They are reproduced in *Gabriel Max* by Nicolaus Mann (Leipzig, 1890).

§ *L'Artiste* (Paris, 1 September 1869).

Here stands a cross on which a girl martyr has ended her struggles. A young Roman is so thrilled by the heavenly peace in the expression on the unhappy girl's face that he lays a crown of roses at the foot of the cross, and becomes a convert to the faith for which she has suffered. The mysterious mortuary sentiment in the subject is strengthened by the almost ghostly pallor of the colouring. Everything was harmonized in white, except that one dark lock, falling across the pale forehead with great boldness, sounded like a shrill dissonance in the soft harmony, like a wild scream . . . It was even a fine variation . . . that the victim should have been a soft and sweet girl, made for love and never for the cross. And it was the more absorbing too, because it was impossible to say whether the young Roman was looking up to the beautiful woman with the desecrating sensuality of a *décadent* or with the fervid ecstasy of a convert.

Speaking of the musical aspirations of Max's work, Herr Muther states:

In their anaemic colour his pictures have the effect of a song of high, fine-drawn and tremulous violin tones, at once dulcet and painful. With their refinement and polish, their subtle taste and intimate emotion so wonderfully mingled, they reach the music of painting . . . Only the figures of the English Pre-Raphaelites have the same sad-looking, dove-like eyes, the same spiritual lips, tremulous as though from weeping.*

I have thought it worth while dwelling on the figure of Gabriel Max who alone, according to Judith Gautier, provided a harmonious echo of the Wagnerian entourage. Apart from this solitary figure Judith was moved by the architecture of Munich and its museums. 'What an amusing town is Munich with its architectural follies!' The Florentine and the Norman styles are reproduced in this Bavarian city, also the Greek and the Venetian styles. At the Pinakothek the Rubens collection represents 'the triumph of the artist's carnal glory'. In his work 'everything glows'. And how tastefully the canvases are hung, against a background of an appropriate colour and in the most favourable light. Judith is sensitive to historical contrasts. 'When one enters the Van Dyck room after having spent some time in the sunny regions of the Rubens collection, one has the impression of a mysterious, restful or gloomy tonality where gradually one becomes aware of the outlines of white masks.'

As a child Judith's sense of humour bordered on the grotesque. She refused to be intimidated. She was accused at her convent, for instance, of being unmusical. Nothing of the sort. She would lie on top of the

* R. Muther, *History of Modern Painting*, Vol. I, London, 1907.

grand piano and play the music upside down, that is to say the stave of the right hand with the left and the stave of the left hand with the right, to the hilarity of everyone present. Something of this challenging spirit persists in her account of the Munich museums. The catalogue tells us, she says, that 'a wolf devours a sheep while a fox runs into the picture', or 'a woman seated next to a braying donkey is suckling her child'. How off-putting are these prosaic self-evident comments! And our 24-year-old art critic laconically concludes her Munich report with the words: 'C'est bon de rire un peu!'

Wagner may have been unresponsive to the works of painters but not to their underlying spirit since, as we have seen, identical concepts often determine the style of painters and composers of similar periods or persuasions. There was a mysterious bond here between Wagner and Judith Gautier, but they also shared another source of inspiration. In her study of Judith Gautier, Dita Camacho points out that Wagner's interest in oriental civilization was established long before his meeting with Judith Gautier.* In the last years of his life his knowledge of the works of the Comte de Gobineau, his long attachment to Schopenhauer, his meditations on the ancient Vedas and the philosophy of Buddha, also his long-standing project for an opera on the subject of Buddha, a subject which later appealed to Debussy and for the same reasons, his fervent desire to flee to Egypt and India—prevented only by death—everything led him towards the magic of the Orient, its peace and wisdom. He had read the works inspired by the oriental ideals of Judith Gautier, notably her translations of Chinese literature published in *Le Livre de Jade*. In fact Judith Gautier led the French oriental revival illustrated later in the works of Gauguin and Van Gogh and in the music of Debussy and Ravel.

Many writers have attempted to surmise from Wagner's correspondence with Judith Gautier the nature of their more intimate relationship. For contemporary readers this is probably of secondary importance. Present-day biographers are more concerned to discover a kindred artistic outlook such as we find in the biography of Wagner by Guy de Pourtalès. After quoting the letters to Judith dealing with the perfumes he expected to receive from her and the colour and texture of materials she was to procure, he declares: 'Thus was *Parsifal* brought to life, amid flasks of Rimmel, Oriental silks and perfumed swaddling clothes. . . . We find him [Wagner] annotating the French version of the Bhagavit-Gita, the Gospels, St Paul and Renan's *Life of Jesus*. . . .

* M. Dita Camacho, *op. cit.*

Wagner had at one time thought of removing the scene of his play to India so as to bring in Buddha's disciple Ananda who was beloved of Savitri the fair "untouchable" and to win their twofold salvation by her chastity.'* Exquisite perfumes and oriental philosophy—it is not surprising that Judith Gautier, who saw herself as one of the Flower Maidens in *Parsifal*, felt some kind of identification with the hidden appeal of Wagner's final work.

Ultimately *Parsifal* becomes a work in the Baudelairean tradition. In 1876 Judith returned to Germany for the inauguration of the Bayreuth Festival Theatre, and over the following two years Wagner addressed to her a series of amorous letters, the realistic tone of which strikingly contrasts with the sublimated nature of his earlier letters. The realism is in the perfumes and colours evoked by memories of Judith's presence. The birthday of Cosima's daughter Daniela (by her first husband Hans von Bülow) is the pretext for the first of these letters. 'Cosima tells me that her daughter would be delighted if a pretty sachet were placed among her presents. Try and find a beautiful fine-smelling sachet in silk. Choose a perfume of your taste, really yours and send me half-a-dozen paper sachets at the same time which I will place in my linen in the morning so that I may remember you while composing the music of *Parsifal* at the piano.'

These perfumes were appreciated by Cosima, Wagner and Judith in a sort of aromatic trio: 'The sachets, the attar of roses and the cold cream have arrived', Cosima writes, 'so that we are well provided for. . . . The *Lait d'Iris* is to my liking but it is not powerful enough for my husband who now prefers the *Eau de Lubin*. I have suggested consistency as a means of increasing the power of perfumes. . . . Montaigne declared that he wore his fragrant waistcoat three days, one day for himself and two days for his friends, which was thoughtful of him.' In the domestic sphere Wagner showed a most fastidious sense of colour. 'I would like to have for my couch a most beautiful cover which I shall call "Judith". . . . A yellow satin background, as pale as possible, dotted with flowers. . . . If not yellow then a very light blue. All this for a good morning's work on *Parsifal*.' And the name Parsifal, Wagner informs Judith, quoting the passage in Act II where Kundry explains the meaning of this name, is of Arabian origin.†

* Guy de Pourtalès, *Richard Wagner* trans. by J. L. May (London, 1932).

† Léon Guichard, *Lettres à Richard Wagner par Richard et Cosima Wagner* (Paris, 1964), p. 254, discusses the etymological origin of the name 'Parsifal'. Judith Gautier was obviously ready to share Wagner's oriental inspiration as one gathers from her limpid translation, quoted by Guichard, of Kundry's text in Act II.

Turkish slippers and a Japanese gown were later requested from Judith, who was at this time working on a translation of *Parsifal* in collaboration with Cosima and at the same time receiving fragments of the music from Wagner. The colour of the satin she is required to send is now to be not yellow or blue but rose. Guy de Pourtalès is certainly right in surmising that Judith, in this work, inspired Wagner's supremely erotic imagination. 'I am mad about a certain colour which can no longer be found', Wagner tells her in a further letter, 'a buff or a flesh colour. (Ah! if it were only the colour of your own flesh I would then have the rose colour I was looking for.)'

As for the perfumes, these should be sent in vast quantities ('Excedez, je vous prie'.). Bath essence is required in 'abundant waves' and in bottles by the dozen. Cold creams and sponges are among other indispensable toilet articles to be dispatched; and there is much discussion on the superiority of Rimmel's *Rose de Bengale* as a bath essence, or Atkinson's *White Rose*. 'I am old enough to indulge in childishness', he tells his youthful voluptuary. 'You make me afraid with your attar of roses since it really lingers in my garments. But, as I have said, be lavish expecially with bath essence. My bathroom is above my studio and it is a joy for me to have it filled with perfume.'

An interesting commentary on these Baudelairean aspects of Wagner's character is provided by Guy de Maupassant. Shortly after Wagner's stay at Palermo Maupassant wished to see the suite of rooms which he had occupied at the Hôtel des Palmes. At first he saw merely a conventional hotel suite. On opening the wardrobe, however, 'a delicious perfume filled the air like a breeze wafting across a bed of roses. . . . "This is where Wagner stored his linen after it had been drenched in attar of roses", said my escort. "It is a perfume that will persist for ever." I inhaled this floral scent buried in his wardrobe, and it seemed to me that I had found here something of Wagner himself. Something of his soul arose from these secret but endearing practices, a key to the more intimate side of his nature.'*

The present-day preoccupation with the gratification of the senses, in music as in painting, is foreshadowed in Maupassant's observations, and it is reflected in a study by the German authority on colour, hearing and synaesthesia, Albert Wellek, published in the *Bayreuther Blätter* (Spring, 1929). Elements of synaesthesia are of course recognizable in the music of Wagner. Drawing a distinction between symbolical description (tone-painting) and 'musical second sight', a term which he borrows

* Guy de Maupassant, *La Vie errante* (Paris, 1890).

from Heine, Herr Wellek gives many examples from *Walküre* (the
fire-music as described by Strauss), *Tristan* ('Wie hör ich das Licht!')
and *Parsifal*, proving in these works an extension of the Baudelairean
principles.

The final episode in Wagner's association with the Impressionists is
equally illuminating.

In 1882 a number of Paris Wagnerians, among them the magistrate
Antoine Lascoux and Jules de Brayer, an early enthusiast of Moussorg-
sky, inspired it is believed by Judith Gautier, persuaded Renoir, then in
his fortieth year, to paint Wagner's portrait. Everyone who is acquain-
ted with the pictures of Wagner knows the portrait by Renoir in the
Bibliothèque de l'Opéra in Paris: a benign old gentleman, with an
almost baby face, as different from the famous portrait by Lenbach as is
Landseer's Queen Victoria from her statue in front of Buckingham
Palace. It is not a great Renoir, nor even perhaps a very good one, but
as a portrait of Wagner it is most valuable for its delicate touch of
satire. 'A picture of merciless psychological insight,' says the German
art critic Meier-Graefe. Yes indeed; like the portraits of Philip IV by
Velazquez, it shows respect but also a disquieting familiarity, affection
but also a certain sense of banter. Wagner, of course, saw none of the
less flattering qualities—nor, for that matter, did he appreciate the
others. He said it was like 'an embryo of an angel which an epicure had
swallowed, thinking it was an oyster'.

This portrait is barely referred to in the writings on Wagner, and
beyond the fact that it was done at Palermo in 1882 we have heard
little more than fiction. A writer in *La Revue musicale* (October 1923),
for instance, says that at the second sitting Wagner was so shocked by
what Renoir had done that he sent him away, convinced that he had
to do with either an ignoramus or a charlatan. This in no way tallied
with the few details that were available in the biography of Renoir by
Ambroise Vollard. A full account of the meeting between Renoir and
Wagner is to be had from a letter which Renoir wrote from Naples in
January 1882, to an unnamed friend and which first appeared in
L'Amateur d'Autographe (Paris, 1913).* Before quoting from Renoir's
letter it will be useful, in order to appreciate the tone of some of the

* Other facts relating to the Renoir–Wagner relationship are set out in my study 'The
Renoir Portraits of Wagner', *Music and Letters*, January 1937, from which the present
account is taken. The subject is developed in the booklet by Willi Schuh, *Renoir und
Wagner* (Zürich, 1959), and further information particularly on Paul von Joukowsky is
given in the same author's *Umgang mit Musik* (Zürich, 1970).

remarks, to glance at Wagner's relation to contemporary French movements in art and literature.

The French infatuation for Wagner dates back to before *Tannhäuser*, but it reached its height when Charles Lamoureux began his series of Wagner concerts in 1882. Speaking of this period, Romain Rolland says: 'Wagner acted directly or indirectly on the whole of artistic thought, even on the religious and intellectual thought of the most distinguished people in Paris.' In the monthly *Revue wagnérienne*, the Symbolist poets, Mallarmé, Verlaine and René Ghil, paid tribute to Wagner as a hedonist and as a deliverer from the scientific dogma of Auguste Comte, Taine, Renan and Émile Zola. Victor Wilder wrote on the ritual of the *Meistersinger*, Huysmans on the overture to *Tannhäusser* and Teodor de Wyzewa on Wagnerian painting. This was not, as might be imagined, painting for the scenery of Wagner's dramas, but painting such as that of Degas, Gustave Moreau, Odilon Redon, Fantin-Latour, supposedly inspired by the ideals of Bayreuth. 'In a word,' says Romain Rolland, 'the whole universe was seen through the eyes of Bayreuth.' The extent of this infatuation may at first seem unjustified, but it will not seem so strange when, as we have seen, it is realized that the Symbolist movement, and particularly the Impressionist movement, was essentially a musical movement.

There was nevertheless a deep-seated difference between the ideals of Wagner and of his French disciples. Mallarmé, who came most completely under his influence, eventually deplored a certain pomposity in Wagner's style; and it was not long before Henri de Régnier could write:

> Un petit roseau m'a suffi.

It was this pomposity that Renoir observed and slyly introduced in his Palermo portrait. We need take no notice of the fact that the editor of *La Revue wagnérienne*, Edouard Dujardin, once included Renoir in a list of 'Wagnerian painters'. Renoir has described his feelings for Wagner in these words: 'I had let myself be carried away by that kind of passionate fluidity that I found in his music. But one day, a friend took me to Bayreuth and I must tell you that I was most devilishly bored. The cries of the Valkyries are all right for a bit, but when they last six hours at a stretch they are enough to send you mad. I shall always remember the scandal I caused when, at the end of my tether, I struck a match before I left the hall.' [*] This is not to say that Renoir was without

[*] Ambroise Vollard, *La Vie et l'œuvre de Pierre-Auguste Renoir* (Paris, 1919).

respect for Wagner. Quite the contrary; but one cannot speak of him as a 'Wagnerian painter' as possibly one might of Gustave Moreau or Fantin-Latour. In fact it would not be surprising if Jules de Brayer, who, besides being an ardent Wagnerian, was also the great champion in France of Moussorgsky, had Renoir's sceptical attitude in mind when he suggested to him that he should paint Wagner's portrait and sent to Renoir at Naples a letter of introduction.

Renoir took a boat for Palermo, but left this letter in Naples. He had not read it, nor did he remember whom it came from, and on his arrival wondered whether he should not take the next boat back. No, he would write a letter of introduction himself and present it to Wagner at the Hôtel des Palmes.

A servant who took my letter [he writes] came back in a few moments, said in Italian, 'Non salue il maestro,' and turned his back on me. The next day I got my letter from Naples and saw the same servant who again accepted it most disdainfully. I waited by the entrance and concealed myself from everybody, for by now I didn't want to be received; in fact I had decided to pay this second visit only to tell the family that I hadn't come to beg a couple of francs. After some time a fair young man came along whom I took for an Englishman, but who is a Russian named Joukowsky.* He eventually found me in my corner and took me into a little room. He said he knew me well and that Frau Wagner was most sorry she could not receive me just then. He asked me if I wouldn't stay another day in Palermo, for Wagner was writing the last notes of *Parsifal*, was in a state of nervous disorder, wouldn't eat anything, etc.

I asked him to present my sincere apologies to Frau Wagner, for I had only one desire—to go away. We spent a fairly long time together and I told him why I had come. He smiled and I realized that my journey was a blunder. For he told me that he was himself a painter and wished likewise to do a portrait of the Master and that for two years he had followed him everywhere in the hope of satisfying his desire. However he begged me to stay. 'What he has refused me,' he said, 'he may grant you, and you cannot leave without seeing Wagner.' This Russian is charming. He took it upon himself to cheer me up and we made an appointment for the next day at two. When I met him at the Telegraph Office, he told me that yesterday, 13 January, Wagner finished his opera, that he was very tired, but that I should come at five o'clock and that he (the Russian) would be there so that I should not feel too embar-

* Paul von Joukowsky (1845–1912), painter and architect, born in Germany of Russian extraction, did a portrait of Wagner's family entitled *The Holy Family* (Daniela as the Virgin, Siegfried as the child Jesus and the sisters as angels). He also painted a portrait of Cosima Wagner in oriental costume and the scenery and costumes for *Parsifal*. See the work of W. Schuh mentioned in footnote on p. 160.

rassed. I agree and go off happily. On the stroke of five I am there and run into my servant who now greets me with a low bow and asks me to follow him. He shows me into a little conservatory, then into a little room, begs me to be seated in an immense armchair, and with a delightful smile asks me to wait a moment. I see Fräulein Wagner [i.e. Blandine, the 19-year-old daughter of Hans and Cosima von Bülow, later Cosima Wagner] and a short little fellow whom I take to be a little Wagner [the 12-year-old Siegfried]; but no Russian. Fräulein Wagner [i.e. Fräulein von Bülow] says that her mother is not there, but that her father will soon come; and then she runs away. I hear the sound of someone walking on a thick carpet. It is the Master in his velvet dressing-gown, with large, black silk-lined sleeves. He is very handsome and delightful, offers me his hand, begs me to be seated, and then starts the silliest conversation full of 'hi's' and 'oh's,' half French, half German with guttural endings.

'Je suis bien gontent. Ah! Oh!'—and then some guttural sound. 'You have come from Paris?' 'No, I have come from Naples'; and I tell him how I lost my letter, at which he laughs very heartily. We speak about everything imaginable. When I say 'we' you must understand that all I said was 'Dear Master,' 'Certainly, dear Master.' When I got up to go away, he took my hand and seated me again in my armchair. 'Addentez encore un beu, ma femme va fenir. Et ce bon Lascoux,* gomment va't'il?' I explain that I haven't seen him for I have been in Italy a long time and he doesn't know that I am here. 'Ah! Oh! You will not forget to go and see him· Ah! Ah!'—and then some German guttural sound. We speak about *Tannhäuser* at the Opéra—in short, our conversation lasts at least three-quarters of an hour, during which I wonder why the Russian hasn't come. At length he comes in with Frau Wagner, who asks me if I know Monsieur de Brayer well. I look up. 'Monsieur de Brayer? No indeed, dear Madam, not at all. Is he a musician?' 'But wasn't it he who gave you the letter?'

'Oh, de Brayé, yes, yes, I know him very well. Excuse me, we pronounce the name differently.' And I make a long speech to excuse myself. At the same time I was able to make good my *faux pas* about Lascoux. To show that I knew him well I imitated his way of speaking. Then she said that when I returned to Paris I should call on her friends, particularly Lascoux; and she reminded me about this when I left. We spoke about the Impressionists in music.† What a lot of absurd things I must have said! After some time I got all hot, completely giddy and red as a cock. When such a shy

* Antoine Lascoux, the Paris magistrate who was the founder of 'Le Petit Bayreuth,' a society of Wagner enthusiasts among whom were Chabrier, Adolphe Jullien, Camille Benoît, Vincent d'Indy and Amédée Pigeon. A picture of this group by Fantin-Latour, entitled 'Autour du Piano', is in the Louvre.

† A most significant statement but one wonders which 'Impressionist' composers Renoir could have known—possibly Chabrier, and he might also have included Bizet under this all-embracing term.

person as myself lets himself go there's no knowing where he will end. I think he liked me though I cannot say why. He abhors the German Jews, and among other Jews, Wolff.★ He asked me if, in France, people still liked *Les Diamants de la Couronne* [the opera of Auber]. I poured abuse on Meyer-beer. Well, I had enough time to say all the silly things one can think of. Then suddenly he said to Joukowsky: 'If, at about mid-day, I feel all right I can sit for you until lunch. You know that you must be patient; I'll do what I can and if I can't sit for very long it won't be my fault. M. Renoir, ask Joukowsky if he minds your doing my portrait as well, assuming, of course, that you will not disturb him.' 'But of course, dear Master,' says Joukowsky. 'I was about to ask him,' etc. etc. 'How do you wish to do it?' I say 'En face,' and he replies, 'Splendid. I'll stand with my back to you, and thus I shall have a perfect composition.' [Presumably by seeing them both in the mirror.] Whereupon Wagner: 'You will paint me with your back to France and M. Renoir will do me from the other side. Ah! Ah! Oh! . . .'

The next day I was there at mid-day. The rest you know. He was very jolly and I was sorry I was not Ingres. I believe I used the time well. Thirty-five minutes is not much, but if I had stopped before it would have been very beautiful, for at the end my model lost his good humour and became stiff, and I think I changed what I had done too much. Well, you'll see.

Afterwards Wagner wanted to see. He said, 'Ah! Ah! I look like a Pro-testant priest,' which was true. Anyhow I was very pleased the sitting wasn't too much of a farce. What I have done is a small reminder of this wonderful head.

<div align="right">

Friendly greetings,
Renoir.

</div>

Renoir told his biographer, Ambroise Vollard, that he did only two portraits of Wagner—a drawing from life and an oil-painting which he made from this later in Paris. There are, however, two other portraits, which he presumably made subsequently, and which had long re-mained unknown to writers on Wagner. One of them, a lithograph, appears in Ambroise Vollard's biography, *La Vie et l'œuvre de Renoir* (Paris, 1919); the other is a second oil-painting, formerly in the posses-sion of Alfred Cortot and now in the Louvre.† The best is unquestion-ably the original drawing. The second painting has not the freedom of the first, though it seems to be a copy of it. As for the lithograph, Wagner's remark about the embryo of an angel would not be mis-

★ The Paris journalist Albert Wolff who also criticized the Impressionists.

† Besides these there is a drawing by Renoir of Wagner made from a photograph of 1867 and reproduced in A. Jullien's *R. Wagner* (Paris, 1886), p. 157. The dates of Renoir's portraits of Wagner are discussed by W. Schuh in *Umgang mit Musik*.

applied. But they are all interesting, not only for the keen character drawing, but for the unfamiliar view they give of Wagner in the last year or so of his life. Not for nothing did a later biographer of Renoir, Michel Drucker, compare Renoir's conception of Wagner to Klingsor, surely the most Baudelairean of Wagner's *Parsifal* characters.

HUYSMANS, REDON AND DARWIN

Redon was obviously a dual personality: the dark, lugubrious, almost insane visions of an accomplished draughtsman; the first indications in nineteenth-century art of the surrealist chaos; and, on the other hand, the unexpectedly naïve flower-pieces, produced between 1890 and 1895, brilliantly illuminated in pastels and oils. Later there were the scenes of Venice of 1908. 'Travelling is a means of returning to hidden regions of one's earlier life', Redon notes, and on which Mlle Bacuu comments in *Odilon Redon*.* 'In these views of the lagoons with their indefinite demarcations of quays and with the luminous sight of yellow and red sails, poetry and reality are combined. They are works which remind one of Turner, but of a Turner who might have had a French mind and a French sense of taste.' Elsewhere it is suggested that Redon in his oils and pastels had affinities with Van Gogh or even Matisse. A dichotomy there certainly was in Redon, torn between his sombre lithographs and his brilliant flower-pieces, but the analogies with Van Gogh and Matisse and especially with Turner are likely to distort the nature of Redon's altogether original contribution.

A musical development supports my theory. A comparable mind in music is, I believe, that of Messiaen, not because of Messiaen's addiction to harmonic and orchestral colour, unbelievably extravagant by comparison with the discretion of Redon, but because he shared with Redon a view of the primitive, symbolic, pre-human world which was a reflection in the work of painters, writers, and later musicians, of the evolutionary theories of Darwin. Or so it would seem if we take the sceptical view of Darwin expressed by Huysmans at its face-value.

To follow this argument we must first examine the ideas of Redon expressed in his diary and supplement these by the analysis of Redon's work in the sardonic criticisms of Huysmans.

In Redon's Journal *A Soi-même* (1867–1915) we read:

Nature proclaims the manner in which gifts are to be obeyed. My inclinations are towards the dream world. Torments and surprises are concealed. But they are organized according to principles calculated to evoke the uncertainties of the mind's borderlands . . . I have done nothing, moreover, which had not been wholly foreseen by Albert Dürer in his *Melancholy*. This

* Roseline Bacou, *Odilon Redon. La vie et l'œuvre*, 2 vols. (Geneva, 1956).

may at first create an incoherent impression but which is false. Dürer's work is based on the significance of the line, animated in depth like a great fugue. By comparison we merely present a few short bars.

Art suggests a flooding of the mind towards the dream-state directed by thought. This is the process at the present day, regardless of any idea of decadence. On the contrary, we may be aware of an evolution, an expression. This art of suggestion springs entirely from the provocative function of music. But it is also a personal art built on a logic of its own. Early criticism failed to see that nothing in my work needed definition, nothing demanded an explanation, nor were limitations to be set, since the sincerity and simplicity of truth has a meaning in itself.

A title given to my drawings is sometimes a burden. A title is justified only by its vague indeterminate nature, suggesting a double meaning. My drawings inspire but they escape definition. Like music itself, they bring the viewer to an ambiguous indeterminate region.

This preoccupation with music ran through Redon's creative life, as we saw in his attachment to Schumann. In 1900 he wrote: 'Music, even more than an act of passion, promotes a highly acute form of sensibility even more acute than passion itself. It is a danger, but a blessing for those by whom it is absorbed . . . The sense of mystery consists of constantly being in an ambiguous state, that is to say on a double or triple level. In the mind of the viewer images arise from other images— all of which demands from the painter an infinite sense of tact and discretion.'

Redon, like his friend Gauguin, clearly belonged to the race of explorers. In 1908 he wrote:

A painter who has found his technique does not interest me. He calmly gets up every morning and quietly pursues the work in hand. I suspect a certain boredom common to the virtuous workman who continues his task without the unforeseen inspiration of the joyful moment. He has not the sacred torment of which the origin is in the unconscious and the unknown. From the predictable he expects nothing, I love that of which I know nothing.

The artist's work should constantly be accompanied by anxiety. Anxiety establishes an equation between reality and the dream. It promotes originality and it renews the creative faculty. Without anxiety there would be no errors and no inequality. It introduces an element of humanity. . . .

I received much correspondence about my drawings and lithographs expressing appreciation. They revealed to one correspondent a religious faith—though whether this can be so I cannot say. I thought again about my works created in moods of dejection, for dejection brings a fervour of its

own. The lithographs create this mood of dejection. The charcoals were on rose, yellow or blue paper and I was influenced by them in my pastels and oils.

But black is the essential colour. It comes to life from a certain well-being. The use of charcoal, I find, demands a certain physical power. Which is to say that charcoals belong to the middle periods of an artist's work. In later years the use of this medium is exhausting. One can always cover a surface with some black matter but it will be dull and lifeless. It will be nothing more than charcoal and not a charcoal drawing.

In his book *Certains* (page 561) containing sketches of Turner, Cézanne and Wagner,* Huysmans boldly defines the original work of Redon in a review which he calls *Le Monstre*. His grotesque thesis is that Reydon, a symbolical artist, revived an ancient tradition of some kind of alarming monster, belonging to the Middle Ages or beyond.

He imaginatively describes the fictitious character of these monsters who are no longer able to arouse in us the sensations of evil, crime and horror which was their original purpose.

An abbreviated form of Huysmans's florid style will suffice. The monsters of antiquity were enormous in structure though relatively simple in appearance. In Assyria they consisted of bulls, tiaras andro-cephala with eagles' wings, flying dragons, mammals with the snouts of wild beasts. Berosus, the third-century Chaldean priest, has set down descriptions of monsters which, according to Chaldean tradition, inhabited the earth: they were men with legs and goat horns, herm-aphrodites with horses' hoofs, dogs with four bodies and the tail of a fish, hippocentaurians, mares with the nose of a bull-dog bat, beasts having some resemblance to the sturgeon and reptiles. . . .

Even more terrifying were the unconscious fantasies of the most civilized European culture. In Greece most of the monsters were born from the copulation of Echidna, half-woman, half-serpent, with the giant Typhon, its body streaked with vipers hidden beneath a refuge of feathers, hurling stings from its mouth and devouring flames. They established a celebrated tradition. Orthros the double-headed dog, the Dragon of a hundred heads of the Hesperides, the Python with a

* The essay on Wagner includes a description of a picture entitled 'Wagner' by an anonymous painter and exhibited at the Tuileries in 1884. The picture, Huysmans says, probably with his tongue in his cheek, shows a section of a circus in which the shadow clowns appear in the form of ghosts. 'Could this really be true?' Huysmans asks. 'How can one explain the morbid elegance of this dream-like painting and the distressing and deli-cate suggestions of an art representing the spirit of Wagner, thus brought to life by a mere buffoon devoted to weight-lifting?' The pierrot music of the twentieth century suggests that Huysmans was nearer the truth than he had imagined.

hundred mouths, the Lernaean Hydra, the Chimaera and the Gorgon, and the Sphinx of which the animal and human structure is the most complicated of all. . . . Greek mythology builds its monsters from outsize serpents and dragons.

Redon and his followers, as we shall see, apparently reached back to a curious strata of animal evolution, not unknown to Wagner in *The Ring* and probably for the same reasons. In the Middle Ages the dragon persists, appearing in a form hardly modified since ancient times, in the sculptures of cathedrals, or the lives of the saints. It looks like a winged serpent bending its back marked with hooks, waving in its crocodile-like mouth the forked tongue of the python. It branches out into minor types such as the Tarasque, the amphibious monster of the Rhône, but which maintains despite all this the form of the reptile and the saurian.

Elsewhere we read that as opposed to the ferocity of the dragon, in this naïve view of the universe, the demoniac, also the luxurious, aspects of life are personified by the pig, the toad and the goat, associated with the hindquarters of a man. The monsters at Notre Dame in Paris make this clear. Christian symbolism has kept the secret of the imaginary language of these animals in stone. We know that the lion, the bull and the eagle are evangelical animals . . . that the cock symbolizes pluck and watchfulness, that the vulture, earlier considered by the Egyptians as an emblem of Maternity, signifies, in the Bible, the cruel rapacity of the demon itself. It is also stated that the pelican is none other than the Saviour which nourishes its young with its blood and that it is more-over, in the thirteenth century, the image of David meditating on the Passion of Christ. Animal symbolism takes a constantly changing form in Huysmans's medieval interpretations, including the fish as the sym-bol of Christ and the ram of God. Whether Redon or, at a later stage, Messiaen were closely acquainted with the monster symbolism of Notre Dame is doubtful. Huysmans, however, shows that it is in this cathedral that the panorama of demons and monsters is most clearly illustrated.

Jerome Bosch and the two Breughels (the elder and the younger, known also as 'Hell Breughel'), associating vegetables and kitchen utensils with the human body, portray beings in which the skull is a salt-cellar or a funnel and who walk on their feet which are in the form of bellows or grease-pans. In a picture of 'Hell Breughel' at Brussels overjoyed frogs open up their stomachs and lay eggs.

Following this tradition to modern times, Huysmans mentions Goya, whose well-known *Caprichos* make a scurrilous appeal such as the

macabre vision of a woman drawing the teeth of a hanging man. The Japanese, and Hokusai in particular, although they worked in a different medium, brought the monster tradition to an end.

Is all this grotesque fantasy? Is this another example of Huysmans's macabre caricature? Or is there somewhere a fractional continuity? In the works of a symbolist painter, Huysmans says, 'A new conception of the monster was established. This was the task undertaken by the only painter following the fantastic visions of our time, Odilon Redon. He does in fact echo the terrifying rumbles from the world of antiquity. In one of his albums he portrays the phrase of Flaubert in *La Tentation de Saint Antoine*: "And all kinds of terrifying beasts arise." Against a black sky, phosphorous beings, bladders and germ-carriers, capsules decorated with eyelashes, glands both watery and hairy, fly in the air, wingless, and become confused with the ribbons of tapeworms. It seems as if the whole fauna of worms and parasites were swarming in the night. Suddenly there appears an unfinished sketch of a human face. It emerges from these living whorls; or it may be buried in the gelatinous texture of the protoplasms.

'M. Redon must surely have derived some inspiration from the ideas of the ancients, he must have seen the face of man united to hideousness, or coiled up in caterpillars. Otherwise these monsters would not have been re-created. Wild-beast tamer, he must have interpreted certain phrases of the Dance of Luxury and Death in Flaubert's *Tentation:* "Here is a head of death surmounted by a crown of roses. It dominates the trunk of a pearly white woman, and below, a winding sheet studded with stars is seen in the form of a tail. And the whole body undulates in the form of a gigantic worm standing upright." The lithograph suggested by this quotation is one of the most extraordinary works ever undertaken by this artist.'

Elsewhere Huysmans tells us of a lithograph of Redon where, against the background of a black bat a monster stands out in white in the form of a large capital C. The head of death with an enlarged grin and filled with the tears of grief is overturned on a mummy, its hands crossed on its throat. From this head hangs an ornament in the form of an embroidered hennin. Here and there whitish cocoons are scattered about in the trembling shades.

In a second album similarly dedicated to Flaubert, and in a set entitled *The Origins*, the painter has again presented monsters: 'In one of them he spreads the news of the confinement of the world in the form of flying monads, the growth of tadpoles, amorphous beings, tiny

discs in which may be glimpsed the embryo of an eyelid and an ill-defined hole representing a mouth. In another bearing the title "a long red chrysalis", he rolls over in front of the square of a strange temple the body of a thin ghost with a woman's head taking the place of the capital. And this face, emaciated, livid, its mouth so painful in expression and thoughtful, seems vainly to await, like a victim on an executioner's block, the liberating fall of an invisible axe.

'Despite its wholly modern form, this figure returns, across the centuries, to the plaintive works of the Middle Ages. It shows the return of Redon to the fantastic book of beasts of the Renaissance, and beyond to the "Prophets of the Monster".'

However, Huysmans concludes, 'the great tradition of Religious Symbolism no longer exists. In the domain of the Dream, art is isolated, today particularly when the soul is appeased by the theories of Moritz Wagner and Darwin.'

Did Huysmans really mean this or was it all an ironic façade? The answer is that Huysmans was nearer the truth than he realized. Moritz Wagner was a German disciple of Darwin who wrote on the migration of organisms. The theories of Darwin himself, developed today by Julian Huxley and Sir Gavin de Beer, partly formed the basis of a history of music by Jules Combarieu, which is to say that evolutionary ideas at that time were a determining factor in art and music criticism. It may be that these beliefs were illustrated not only in the fantasies of Redon but in the comparable bird music of Messiaen.

DEBUSSY'S LIBRETTO FOR
'THE FALL OF THE HOUSE OF USHER'

The following translation of Poe's tale *The Fall of the House of Usher* is based on the publication of this tale in the form of an opera libretto in my booklet *Debussy et Edgar Poe* (Monaco, 1951). This study attempted to investigate the nature of Poe's sensibility. Debussy, who based his adaptation on the Baudelaire translation, saw Roderick Usher as a hypersensitive musician, but who was also an early abstract painter. Debussy's libretto matches neither the original text of Poe nor the translation by Baudelaire; it radically departs from these versions, partly to emphasize the role of the Doctor and also for reasons of technical operatic production. Lady Madeline, the sister of Roderick, has a dumb role. In the projected operas of Debussy's later years, *Usher, Le Diable dans le Beffroi* and *Orphée-Roi*, there are no less than three dumb roles of this kind.

Although the tale is an allegory on the decay of a civilization, an over-written subject, Poe approaches the subject afresh. He shows that Roderick Usher was suffering 'from an acute form of anxiety hysteria', the diagnosis of Freud's disciple Marie Bonaparte and published in her *Life and Works of Edgar Allan Poe: A Psycho-Analytic Interpretation* (London, 1949). Normally historians may find technical studies of this kind forbidding. But Madame Bonaparte's illuminating study, presented with a foreword by Freud, is wholly appropriate to certain of the ideas we have investigated. Freud's introduction might have been written by Baudelaire himself:

> In this book my friend and pupil, Marie Bonaparte, has shone the light of psychoanalysis on the life and work of a great writer with pathological trends.
>
> Thanks to her interpretive effort, we now realise how many of the characteristics of Poe's works were conditioned by his personality, and can see how that personality derived from intense emotional fixations and painful infantile experiences. Investigations such as this do not claim to explain creative genius, but they do reveal the factors which awaken it and the sort of subject matter it is destined to choose. Few tasks are as appealing as an enquiry into the laws that govern the psyche of exceptionally endowed individuals.

A discovery of 'the factors that awaken creative genius' is the aim of analysis and it was also the aim of Debussy's interpretation of Poe's allegory. Worried by the technical problems of turning this allegory into an opera, he told the director of the Metropolitan Opera in New York, Giulio Gatti-Casazza: 'It is a piece of bad business you are doing. I have some remorse in taking these few dollars. I do not believe I will ever finish my part of all this. I am writing for myself. Other people's impatience doesn't concern me.'

His letters tell a different tale. He brought himself in the end to finish the libretto, which I now reproduce in an English translation. But he seemed to have lived in a world of fantasy, since he frequently mentions the music he has written for this work, sometimes giving precise details. Beyond a few sketches, however, no traces of the music he claimed to have written have been found. We can only conclude that the work must have remained almost entirely in his imagination, like the fantasies of Poe himself.

THE FALL OF THE HOUSE OF USHER

Libretto in two scenes adapted by Debussy from
the translation of Poe's tale by Baudelaire

SCENE OF THE ACTION

The large room with a rounded vaulted ceiling of Roderick Usher. Long narrow windows rising at a certain distance from the oak floor. The walls are hung with tapestries in dark green. To the left a high fireplace in which a burning fire throws out red reflections. In a straight section of the wall, also to the left, is a large ebony panelled door.

Ornate, ancient furniture which, though genuine in style, is dilapidated and uncomfortable. Books and instruments of music are scattered about.

At the back of the stage three steps lead to a French window which opens on to a parkland at the extremity of which is a stagnant tarn.

It is the close of day. Dark, heavy clouds move past the black cypress trees thrown in relief against a leaden sky.

CHARACTERS

Roderick Usher is thirty-five. He has an anguished appearance, resembling Edgar Allan Poe. Though his clothes are neglected he is obviously fastidious. He wears a high dark-green cravat.

The Friend of Roderick Usher, older than Usher, a gentleman farmer [in English in the original] of simpler appearance. He is dressed in brown corduroy velvet and high boots.

The Doctor is a man of uncertain age. He has red hair with an occasional silver thread. He looks piercingly through large-sized glasses. He talks in a whisper and with anxiety. He constantly fears the presence of someone in black watching him from behind.

Lady Madeline is very young. She wears a long white dress.

The costumes belong to an early English romantic period.

SCENE I

At the rise of the curtain the room is empty. A lamp placed near a large divan lights up the stage. A remote, feeble voice is heard. It is the voice of Lady Madeline who presently crosses the stage and disappears to the left. At about the same time the Friend of Roderick Usher, preceded by a servant, enters through the garden window. The Doctor has entered furtively through a small door obscured by the tapestries.

THE VOICE OF LADY MADELINE
> In the greenest of our valleys
> By good angels tenanted,
> Once a fair and stately palace—
> Radiant palace—reared its head.
> In the Monarch Thought's domain
> It stood there;
> Never seraph spread a pinion
> Over fabric half so fair★

THE DOCTOR. Who are you? What do you want? Have you not been told that no one has the right to enter this room?

THE FRIEND. Roderick has written to me. His desperate letter allows no delay. I am his only friend. Listen to what I have to say.

THE DOCTOR. Yes I know. (*They greet each other formally.*) You see before you his devoted doctor. It was even my sad duty to remain with his mother during her last hours. What a wretched end!

THE FRIEND. He needs to see me instantly. He hopes to derive some pleasure from our meeting, some relief from his intolerable suffering. His imploring shrieks show him fighting against an unknown terror.

★ I revert here to the text of Poe.

THE DOCTOR. Alas! There is nothing more that we can do. This man is the last member of a proud but inbred race. Almost all were ill, maniacs addicted to strange practices. Madmen, my dear Sir, madmen!

THE FRIEND. I found in Roderick only a soul devoted to art and beauty.

THE DOCTOR. You may see him in that way if you wish. But in fact he pursues bizarre, distorted ideas. He couldn't have done otherwise. You will see him for yourself. Although still young, his disordered mind has wrecked his feeble body. Notice the shape of his forehead with broad temples displaying signs of insanity.

THE FRIEND. And his sister Lady Madeline? I know that they have never been separated and that they are wholly devoted to each other.

THE DOCTOR. Lady Madeline is not about much. What do you want from her?

THE FRIEND. What strange behaviour. I don't see the point you are making. Kindly answer my question.

THE DOCTOR. Listen carefully. Lady Madeline, weak and fragile, is the pale reflection of our dear friend. The evil associations of the stories of the House of Usher have determined her destiny. Gradually they settled the character of her smile and the remote look in her eyes. Lady Madeline will disappear as others have done before her, possibly more quickly. But it will be her fault. This is not the way one loves a sister.

THE FRIEND. What do you mean?

THE DOCTOR. I'll tell you. If you could hear her voice which seems to come from beyond her very self. Often he makes her sing music whose purpose can only be to torment the angels. This is beyond one's understanding; and it is dangerous. A woman is not just a lute. But he will listen to none of this. He doesn't realize that this is her very soul which will disappear with the songs she sings. Ah! Why doesn't she listen to me? I have done all I could to warn her. She is so beautiful.

THE FRIEND. What sort of despair possesses you? Take me to see Roderick.

THE DOCTOR. Quiet, here he is. Don't show yourself yet.

SCENE II

*Roderick enters, his clothes dishevelled. He looks steadfastly before him
and yet from the look in his eyes objects seem not to register. His
gestures are rough and jerky, his voice is harsh.*

RODERICK. Madeline, Madeline . . . A moment ago I was asleep. But
I heard it. Her voice; it was her voice, I am sure. There is none
other like it in the world. Ah, I have no will to go any further. No,
I can't see this any more. Feverishly going to sleep and awakening
in anguish. Endless torments. (*He goes to lean against a window.*)
Ancient death-like stones, what effect have you had on me? From
one day to the next I become more and more part of you. You are
aware of it, and each day I am more effectively crushed by your
embrace. I am part of you, I resemble you. Each hour devours me
as you are disintegrated by the winter rains. [*Alternative version:*
Why this strange punishment for faults which I have not com-
mitted? What have I done?] Evil stones, your cadaverous appear-
ance weighed upon me since my childhood. And yet from the
time when my mother died, I laughed—yes, I had the courage to
laugh. You were unable to share the joy of seeing her delivered
from our odious spell. Nor did you hear weeping. You have no
pity in your heart.

Your ghostly hands have ceaselessly woven this heavy greenish
cloak stifling me like a leper. I need to live and to seek light. If
sunlight enters, it is to hasten death. Let me leave, do not retain
me any more. No, no, say no more, I do not wish to hear your
complaints, your sorrowful complaints of those who have come to
die here, drawn here by these mournful stories. Remain here, die
here. Quiet, I will obey.

It is cold, the mist is rising. What is over there near the greyish
rushes. Some lost bird? He flies through the mist like a hand be-
longing to a dead body. Ah! I remember you. You were here
when my mother embraced me for the last time. What do you
wish today? What is the tribute to death which you are seeking? Is
it Madeline, my sister, whom I have loved excessively, my only
friend in life? Ah! her lips on my forehead are like some stimu-
lating perfume. Her lips which tempt me like an exotic fruit but
which I have never dared to touch. Do you not know, evil bird,
that if you take her from me, nothing more will remain? Are you

not aware that she is my only reason for not dying? Ancient walls, have you no pity?

Surround me! Enclose me as if you represented a tide, but made of stones. Protect me so that I no longer hear this sinister sound. Do not allow the wings of death to enter. Do you hear? Do you hear? They are flying towards me, these black wings. I have lost faith. I am afraid.

THE DOCTOR. (*The Friend, whom the doctor tries vainly to stop, rushes towards Roderick.*) Do not be afraid, I have often found him in this state. It would be dangerous to wake him at this moment. We can do nothing, I can assure you.

THE FRIEND. Away with you. (*The doctor has made an ironic gesture of commiseration and disappears through the garden window.*) Roderick, Roderick, my friend. (*Roderick opens his eyes, looks at the dark door, at his friend bending over him, and rises without apparent effort.*)

RODERICK. You—it's you (*they throw themselves into each other's arms.*) I was so anxious to see you. (*Roderick automatically assumes a friendly expression for he is able to alternate rapidly between liveliness and indolence.*) Welcome to the ancient House of Usher. Forgive me, I should have gone to meet you, the roads are bad and little known, and you would have found no one to show you the way. People are afraid of this house. Torches! Let us light the torches! I can hardly see you!

THE FRIEND. Dear Roderick! I needed no one. Thank goodness! And now let me leave our old devoted friendship in your hands. Do you remember?

RODERICK. Yes, indeed, we have played and worked together. You were able to understand and love a child who was given merely to dreaming. You were able to forgive the sudden flights of fancy of a wavering, fantastic nature.

THE FRIEND. Roderick, what are you saying?

RODERICK. Seeing you again makes me think of the events which have shaped my life. How often in a dejected mood did I helplessly look upon the ruination of my home and myself. A home which no one dared to disturb and which was left without happiness and tradition. (*He nervously adjusts his clothes.*)

THE FRIEND. What's the matter?

RODERICK. This evening I was overcome by the mist rising from the pond. The peasants say it is deadly. They may be right. (*To the*

friend who has closed the window) Thank you, that's better. Forgive me for asking you to see me on this sad occasion. You are my friend—my only friend, and I haven't forgotten. Nothing is forgotten here. Look at me—look at what these early recollections have done to me. I look like an old man.

THE FRIEND. Now listen, Roderick, you are young. You can still escape from your surroundings. Leave! New landscapes can inspire new ideas. Joy, having left your home, has not wholly disappeared. It can be recaptured, in every corner of the world, like a mother deprived of its child. Leave!

RODERICK. Do you think that I have never tried? I was alone, tired of suffering and of patiently waiting for death. A fever drove me on. Livid like a thief, I was obsessed with fear. I fled. No sooner had I crossed the threshold than an unconquerable force compelled me to return. The ancient stones of the house, aware of my flight, began to sparkle, as if each of them assumed the role of a reproach. I heard their tyrannical command, 'Remain, remain! Nowhere else will you find your last peaceful sleep. Remain till your death!' Never again have I wished to depart.

THE FRIEND. A feverish state brought on these fantasies. Once the bonds had been broken they would have been forgotten.

RODERICK. Quiet now, if you believe in me. Surely you understand that it was not for nothing that my ancestors suffered and loved in this home. Through them the stones acquired a domination which through the centuries has directed our destinies and which I, the last of the race, am compelled to obey.

One was possessed by a constantly heightened terror, one was subjected to distress and bitterness which affected stronger minds than my own. Observe this hardly perceptible rent running along the walls losing itself eventually in the stagnant waters of the tarn. The course of this rent is obstinate and determined. It represents for me a secret wound eating into my heart which will warp my mind and devour my life.

THE FRIEND. Roderick! Roderick!

RODERICK. This again opens the way to Fear. Make sure that you are out of sight of this livid ghost, haunting one during sleepless nights. No other torture of this kind exists. Hands grasp you by the nape of the neck and drag you to the unknown. A terrifying struggle silently pursued in the gloom leaves one in a state of collapse. I shall be unprotected even by my sister, my sorrowful

Madeline! These traditions, these struggles, these wounds will mark the end. (*He weeps desperately.*)

THE FRIEND. Come now, forget these ideas that derive from earlier theories.

RODERICK. My ancestors knew however that the tradition would reach its end. (*He leaves like a madman through the little door.*)

THE FRIEND. Roderick, where are you going? You mustn't . . .

THE DOCTOR (*arriving at the garden window and remaining on the threshold*). Don't pursue him. The worst has happened, as I feared.

THE FRIEND. What! You don't mean . . .

THE DOCTOR. Yes, she is dead.

THE FRIEND. Lady Madeline?

THE DOCTOR. Yes.

THE FRIEND. Where is she?

THE DOCTOR. Underneath there. (*He points to the middle of the floor.*) She was found, on her return from her normal walk, stretched out on the staircase leading to her room. She was dead. We took her to the vault under the floor of this room.

THE FRIEND. Why so much haste?

THE DOCTOR. Swiftness was imperative. Roderick's madness would not have withstood the sight of her dead body.

THE FRIEND. Is this your manner of respecting death? What right have you to act in this way?

THE DOCTOR. This is no concern of yours. Creaking noises from a copper-lined corridor and a heavy iron door leading to the vault could have attracted Roderick's attention.

THE FRIEND. But Roderick was bound to know?

THE DOCTOR. Certainly. But now do as I say. Your devotion to Roderick is obviously futile. Leave this disastrous house before in fact this terrifying maniac claims another victim.

THE FRIEND. Leaving him, with the wholly inexplicable death of his sister, lonelier than ever?

THE DOCTOR. This is where I come in, including (*aside*) the collecting of my fees.

THE FRIEND. I think I can hear him, one moment.

THE DOCTOR. All right, but say not a word for that will finish him and the end, therefore, of the Ushers. (*He goes out. Roderick enters, holding a book in his hands. In a low voice he sings the song that Lady Madeline sang at the beginning of the act.*)

RODERICK

> In the greenest of our valleys
> By good angels tenanted.*

That is what she sang. Her voice is within me. Ah, there you are. Did you not meet Lady Madeline coming here? Although very weak, she often walked in this park and I forbade her to walk near the tarn, a mirror of calm water mysteriously drawing reflections.

THE FRIEND. Your doctor is coming along.

RODERICK. The devoted doctor of the Usher family. Ha, ha! He fancies I know nothing at all, and believes me to be completely mad. What he wants is my death and watches over me like a greedy raven. Waiting, that's his motto, waiting.

THE FRIEND. Now what is in your mind?

RODERICK. I believe that he actually loved Madeline—the old grave-digger. Are you sure you didn't meet her? Perhaps you found her chronically ill and feared to tell me the truth. I know how frail she is, that she no longer wishes to see anyone. And I also know that for her own peace of mind she should remain aloof, which was her personal wish. In my heart I shall hear her eternally. In her singing darkness lifts, a scent more beautiful than that of flowers descends and the silent angels of death retire. Surely you must have seen her.

THE FRIEND. Then why shouldn't I have told you?

RODERICK. True enough. You could not have known about all this. Listen! Do you not hear?

THE FRIEND. No.

RODERICK. Look here, I have found this curious book of ancient myths. It is about African satyrs and Aegipans. For hours I imagined the music which might have accompanied these strange ceremonies. Read this. Can't you hear some funereal passionate dance? (*As they read, the music imagined by Roderick Usher is heard in a vague fashion. But soon Roderick drops the book and looks steadfastly ahead in his usual devastating fashion. He makes towards the window.*) I must know. I can no longer bear it.

THE FRIEND. Roderick, you are not to go out. A storm is approaching, the clouds are heavy and low in the sky, pursuing each other like frightened beasts.

RODERICK (*After a pause followed by a glance at his friend*). This you have

* I revert here to the text of Poe.

never seen. One moment. (*He opens the window.*) Look at this unexpected clarity—a luminous shroud covering the pool. And the accursed bird, the bird of horror—there he is. He will fly no more. Do you not see him?

THE FRIEND. Abandon all these images—they are fantasies. The storm is reality, and that we see before us. It is icy and dangerous in the open. (*Aside*) What can one do? (*To Roderick whom he has finally managed to bring back to the divan.*) Here is our favourite novel. I will read you this splendid legend—the Knight and the Hermit.

RODERICK. No, leave me alone. Go and rest. Tonight is no more dangerous than any other night.

THE FRIEND. Tonight is terrible and we shall spend it together. Listen to me. 'Sire Ulrich, a brave stronghearted man, by the magic virtue of a herbal wine which he had drunk, waited no longer to discuss matters with the Hermit who was by nature malicious and stubborn. He feared a tempest and he therefore lifted high his bludgeon and rapidly opened a passage across the door boards so that the dry wood, sounding hollow, carried an alarm from one end of the forest to the other.' (*During this reading Roderick who remains seated leans his head on his chest and gently sways from one side to the other.*) Roderick, you aren't listening.

RODERICK. Oh yes I am, and most eagerly.

THE FRIEND. 'Ulrich going through the door was most furious and amazed to perceive no trace of the malicious Hermit, but in his place there was a marvellous dragon with a tongue of fire. He was to be seen in front of a golden palace of which the floor was in silver and on the walls of which was a brilliant bronze shield.'

RODERICK (*under his breath*). How the shield shines!

THE FRIEND. 'Then Ulrich lifted his bludgeon and struck the dragon on the head who fell before him giving a foul gasp together with a frightful roar.'

RODERICK (*who has still been regularly swaying and who has been glancing towards the ebony door*). The shield is shining. She will soon be in possession of it.

THE FRIEND. 'And now that the magic spell was broken he proceeded along the silver pavement towards the place where the shield was hanging which in fact did not wait for his arrival but fell at his feet.'

(*At this very moment, as if a bronze shield had fallen on a silver*

floor, a distinct echo was heard, metallic but muffled. Roderick throws himself to the floor, one ear to the ground, a wicked smile trembling on his lips. He speaks very softly while his friend leans right over him.)

RODERICK. You don't hear. I can, I have been listening for some minutes. I have been listening, but I didn't dare. Oh, have pity on me, unfortunate wretch that I am. I didn't dare say what I thought. He guessed what was in my mind and took his revenge, the old raven. He placed her alive in the vault, he had already tried to do this, I know, I am sure. Only just now I heard her feeble movements from the bottom of the vault. Ha, ha! Sire Ulrich, the death rattle of the dragon, the sound of the shield, and then, the sound of the door—the iron door. (*He rises on his two hands but his speech is cut by a demented laugh.*) Do you see her? She is in the copper-lined corridor. You see her poor hands are bleeding. Her dress is covered in blood. Ha, ha, Roderick! She whom you loved so much, she whom you should not have loved—you were not able to protect her. Oh how she will reproach me. She is walking up the staircase, I hear her steps, I hear the beating of her heart. And her eyes—her eyes weeping with blood. (*He now boldly stands upright and roars out these last words as if he were breathing his last.*) Madman, Madman! I tell you that she is now behind the door!

(*Whilst Roderick shrieks the words 'Madman, Madman' and since his voice has acquired the power of a magic spell, the enormous ebony panels slowly open up. At the same time a violent gust of wind bursts open the garden window. Lady Madeline is seen on the threshold of the ebony door where, for an instant, she remains trembling and unsteady. Then with a deep and doleful scream she falls clumsily before her, on to her brother who has come towards her offering his arm, and in her final agony she drags him to the ground. The friend has fled. The storm is raging.*

At the very moment when Lady Madeline and Roderick fall to the ground, the disc of the full moon in blood red shines forth. The walls collapse in two. All that remains to be seen is the deep stagnant tarn silently enclosing the ruins of the House of Usher.)

CHABRIER, WAGNER AND THE
PAINTERS OF THEIR TIME

Shortly after 26 April 1890 Cosima Wagner wrote on the performance of an opera of Chabrier to Felix Mottl, the composer's friend and promoter:

> On Saturday I saw in Dresden *Le Roi malgré lui*. It is just a lot of trash from beginning to end. Neither God nor Minstrel [i.e. Mottl himself] could do anything with it. Good heavens! What vulgarity and how utterly devoid of ideas. It consists of Offenbach, Meyerbeer and Gounod artfully orchestrated in the manner of Berlioz. As for Chabrier's visit to Bayreuth, this remains a complete mystery. On leaving, Countess Wolkenstein and I remarked that at any rate this work assured us that we should never again listen to a note of Chabrier. If *Gwendoline* was bad, this is monstrous. He doesn't even know how to write a decent dance. The first act was horrifying, the second infuriated me, and the third left me so depressed that I wondered what the deuce I was doing here. . . . No performance could possibly hide, even for a moment, these beastly café-concert trivialities [*Sie dringt zu einem in bestialischer Weise*]. Back at home I had Chopin's mazurkas played to me throughout the evening in order to be reassured that, apart from the divine geniuses, there was still in music delicacy, sensibility, imagination and charm. Why are these clownish musicians allowed to make music? If only it were just vulgarity. But there is something more, a whole world that makes you shudder. . . .*

There were perhaps good grounds for Cosima's disturbed state of mind, for the intruder Chabrier pursued not the deeper Wagnerian philosophies but their practical application. Cosima Wagner's premonition should be borne in mind. 'There is something more, something that makes you shudder.' Was she looking ahead to *Petrouchka*? We know that Chabrier was inspired, like his friends Renoir and Manet,

* 'Correspondance inédite entre Chabrier et Mottl', *La Revue de Musicologie* (July 1963), p. 97.

It is amusing to note that shortly before this letter, on 6 March 1890, Felix Mottl, one of the greatest Wagnerian conductors of his day and united with Chabrier in an unbounded passion for Wagner, wrote from Karlsruhe to Cosima Wagner, presumably on the subject of this same opera: 'Chabrier was there and sent us head over heels in laughter with his gaiety and playfulness which, however, is not superficial. This is an opera that gains greatly by crossing the footlights . . . we may be sure of one thing! By comparison with our wretched German note-smearers, he is a very great man.' (p. 95)

by 'an obsession with pleasure gardens' (*l'obsession de la guinguette*).
Though he was an unfulfilled artist—the tertiary stages of syphilis had
brought his career to a premature end—Chabrier introduces into music
a child-like enthusiasm calculated to deflate the rhetoric of earlier com-
posers and to present, in a sophisticated form, the spirit of bandstand
music and the deliberately coarse humour of the music hall. It is refresh-
ing to see how Chabrier writes with zest, on the one hand, of the price
and quality of strawberries and cherries at a country market; and, on
the other, of the overpowering emotional impact of anticipations and
suspensions in the Prelude to *Tristan*. Elsewhere he responds in the
most human fashion to the sights of blown-up skirts on a windy pro-
menade at a Dutch seaside resort; and with the same enthusiasm to the
Rembrandts, the Hobbemas and the Ruysdaels at a nearby museum.
Letters of painters and poets often disclose sources of inspiration of this
kind. Descriptive letters of musicians regale us less often.

Literary as well as pictorial comparisons were aroused in Chabrier's
mind. In a description he gives to his wife of the changing multi-
coloured expanse of the Normandy seascape we may see a source of
inspiration common to many of the maritime artists of the nineteenth
century, from Turner onwards:

> The immensity of the seascape arouses in my mind thousands of associations.
> The sunrise scenes and the sunsets with golden and violet tones, the little
> fishing boats far in the distance, the majestic steam-boats suggesting the
> melancholy manner of Sully Prud'homme, sailing from Le Havre and
> heading either for Southampton or the North Sea—this vision of the sea
> embracing the whole range of tones on the painter's palette, displaying
> wonderful reflections and diaphanous effects, with these emerald greens of
> the most enviable nature, vague tones of blue calculated to send Lamartine
> into a state of despair, visions of foam which can only be reflected in Hugo's
> interminable verses, with shudders and sighs choking even Musset himself,
> and with all this, needle points, mysterious recesses, phosphorescent colour-
> ings and glinting reflections designed to send Monet into a fainting fit.★

In Chabrier's correspondence musical and pictorial elements were
happily united. The *Valses romantiques* of Chabrier and his *Marche
joyeuse* are perfectly attuned to Manet's *Un Bar aux Folies-Bergère*
which, during the last years of Chabrier's life, hung over his piano at
his home in the Avenue Trudaine.

In his analysis of the style and technique of this picture (exhibited at

★ 'Chabrier et ses amis impressionistes' by Roger Delage. *L'Œil* (Paris, December
1963).

the Salon in 1882, bought by Chabrier after Manet's death and now at the Courtauld Collection in London),* Raymond Mortimer draws attention to Manet's preoccupation with the commonplace. Everyday *choses vues*, or *choses entendues*, prompted the imaginations of both Manet and Chabrier. The barmaid, a sulky prostitute, is the central figure of this music-hall scene, painted however in a manner recalling Velazquez or Chardin. Applied to this painting, the term 'realism', Mr Mortimer suggests, has a doubtful meaning since 'a prostitute or a washerwoman is no more real than an ambassadress'. The description of Manet's methods applies equally to the musical methods of Chabrier: '[The doctrine of realism] ordained a detailed observation of contemporary life in its more squalid aspects, and a transmutation of the resulting material into works of art through beauty, refinement or forcefulness of style.'

Many musicians believe that Chabrier was at heart an amateur composer. He had been to no academy or conservatoire, he had won no prizes or awards and to the more narrow-minded musical practitioners, their eyes glued to notes on the printed staves, it did seem that Chabrier's unorthodox and intuitive methods, and indeed his bold exploratory outlook, were merely by-products of the established professional world.† In his study of Chabrier's Impressionist relationships‡ Roger Delage suggests that he acquired his education in the manner of students of painting, that is to say not so much by imitating academic models as by copying the admired methods of the masters. His copy of

* E. Manet, *Un Bar aux Folies-Bergère* (London, 1944).

† These intuitive methods, particularly his method of orchestration, are memorably described in a letter of 15 January 1908 from Henri Duparc to René Martineau, published in the catalogue of the Exposition Chabrier, Paris, 1914: 'What is biographically interesting is that Chabrier had some kind of sudden revelation of orchestral colour. How did this revelation came about? Had he read something? Or heard something? This sense of the orchestra—this gift which cannot be acquired—seemed to be lacking. Some time before *España* . . . he orchestrated some of the delightful piano pieces which he had just written and showed these orchestrations to friends, including myself: the orchestration was frankly poor—the orchestration of a pianist (conceived at the piano), heavy, clumsy and colourless —and I left his home disheartened. I was deeply attached to Chabrier and felt that the dear fellow would probably never bring any original ideas to orchestral colour. . . . Thereupon we each went our own way: I left for the country and Chabrier went to Spain. He came back with the dazzling *España*, a masterpiece of orchestration. Since then his orchestration has never left that level. Perhaps it has become perfected in that it more adequately conveys the spirit of his music. *España* creates the impression of a work marvellously orchestrated. The later works seem to have been *thought out orchestrally*. I am not even aware of the orchestration which is united to the underlying idea of the music and not superimposed on it.'

‡ 'Chabrier et ses amis Impressionistes' in *L'Œil* (Paris, December 1963).

the Overture to *Tannhäuser* bears the inscription: 'Musique de *Tannhäuser* copiée par moi pour apprendre l'orchestre.' Frequently in his letters one catches glimpses of his working methods revealing the influence of his friends Manet and Renoir: 'I am working on studies (or sketches) in the manner of painters who hang up some job they have been at in the corner of the studio with the thought, "that will be a fine picture for later on".'

To reconstitute the worlds of painting with which Chabrier was associated may be impossible, despite the variety of details in his voluminous letters. It is nevertheless clear that visits to museums often provided a powerful source of inspiration. 'The Hague has a museum the size of a pocket handkerchief but what riches! The *Oxen* of Paul Potter, *The Anatomy Lesson* of Rembrandt, and numerous pictures of Van der Elst, Ruysdael, Van Ostade and Hobbema and two delightful Van Dykes.' Museums were certainly visited in Spain, though unfortunately we do not have Chabrier's impressions of Goya and Velazquez.* He writes in 1888 to the conductor Felix Mottl, his benefactor in Germany, 'I would have been so glad to show you the activities, still quite a few, in which we have something to offer, to take you through our admirable museums and our exhibitions. . . . I should like to have introduced you to our young musicians (we have some who are not too bad), to our painters and sculptors (we have some who are first class).'

The catalogue of Chabrier's collection of Impressionist paintings sold by auction in 1896 has frequently been reproduced† and indeed the thirty-eight oils, water-colours, engravings and drawings represented the finest of the early Impressionist collections. In addition to the *Bar aux Folies-Bergère* and *Le Skating*, Manet was represented in this collection by four further oils and a sketch, *Au Café*, representing George Moore seated alone at a café table. Chabrier also possessed three other Manets, the *Femme se promenant dans le jardin* (1881) in the collection of the Barnes Foundation, and two portraits of the composer at Harvard and Copenhagen. The three Renoirs in the sale included *La Sortie du Conservatoire*. Two Sisleys formed part of his historical collec-

* He brought back from Spain a series of engravings of bull-fights by Goya, not included in the sale of Chabrier's pictures in 1896, which, however, included Manet's etching *Seigneurs espagnols*, after Velazquez.

† The prices reached by each of the thirty-eight items were published in the biography of Chabrier (Paris, 1961) by Francis Poulenc. In addition to this collection another 'hardly important' collection, according to Joseph Desaymard, *Chabrier d'après ses lettres* (1934), of a personal nature was withheld. It included portraits of Chabrier, by Manet and Renoir, Manet's *Polichinelle* inscribed to Chabrier, and the Goya engravings.

tion, as well as Cézanne's *Les Moissonneurs* and six Monets, among them *La Maison de campagne* now in the Louvre. The collection of Chabrier if ever it could be reassembled would be rivalled, among collections of other composers, only by that of Chausson (see p. 89), which consisted largely of pictures by Delacroix.

Ruskin and Wölfflin saw a lack of clarity as the visual ideal but this was not the opinion of Chabrier. 'Ce qui n'est pas clair n'est pas français', declared the eighteenth-century philosopher Antoine Rivarol. Towards the end of the nineteenth century painters and musicians were similarly possessed by this transparent ideal of precision and clarity. '*It's very clear*, this kind of music,' Chabrier writes, 'make no mistake about it and it can be paid for in ready money. It's certainly the music of today or tomorrow *but not of yesterday*. . . . What we do not want is any kind of *sick* music.' Manet, likewise concerned with eliminating unessentials, wrote to Antonin Proust, 'Who will bring us back to our concepts of simplicity and clarity? Who will deliver us from the over-elaborate style?'

In 1865, seventeen years before Chabrier made a memorable tour of Spain, Manet, whose work shows a superficial Spanish influence, spent a period of three weeks in Spain. He went to Burgos, Madrid, attended the bull-fights and saw the paintings of El Greco, Velazquez and Goya. Manet had long been acquainted with the work of Velazquez in Paris, though in Spain he became more acutely aware of Velazquez's influence on his style and technique ('he is the painter of painters'). It is doubtful, however, whether the spirit of Velazquez is perpetuated in the numerous works of Spanish association of Manet, namely *Le Guitarrero*, *L'Enfant à l'épée*, *Lola de Valence* or the *Jeune Femme travestie en torrero*; only *Un bar aux Folies-Bergère* displays a deeper sensuality associated with the subtle mergings and contrasts of Velazquez's pinks and greys. Chabrier and Manet meet in their attraction to Spain. Yet any comparison between Chabrier's *España* and the works of Manet inspired by Spanish dancers and bull-fighters discloses the gulf between them. Parisian influences are evident in Chabrier's score—echoes of music-hall tunes and a grotesque trombone solo. A robust work, *España* has an almost impertinent humour. Manet's Spanish canvases, on the other hand, have disturbing sentimental associations, particularly the portrait of a young woman dressed as a bull-fighter.

Spain and France—France and Germany, through everyone's musical world there flows a River Rhine, said Busoni, and this is true of the scene we have been discussing. The worlds of Manet and Chabrier were

certainly remote from the Wagnerian ecstasies; and without knowing the many lanes and by-ways issuing from Chabrier's café-concert music, Cosima Wagner was perhaps not altogether unjustified in looking askance at this earthy music destined to succeed though not, as she imagined, to corrode the monuments of the Bayreuth master.

Index

Icon Editions

Antal, F./Classicism and Romanticism $5.95 IN-18
Ashton, D./A Reading of Modern Art $2.95 IN-5
Avery, C./Florentine Renaissance Sculpture $5.95 IN(t)-38
Breton, A./Surrealism and Painting $7.95 IN-24
Chastel, A./Italian Art $5.95 IN-7
Freedberg, S. J./Painting of the High Renaissance in Rome & Florence
 Vol. I $6.95 IN-13; Vol. II $7.95 IN-14
Gilbert. C./Renaissance Art $4.95 IN-33
Golding, J./Cubism $5.95 IN-8
Haskell, F./Patrons and Painters $5.95 IN-9
Kouwenhoven, J. A./The Columbia Historical Portrait of New York $6.95 IN-30
Lee, S. E./Chinese Landscape Painting $3.95 IN-10
Lee, S. E./Japanese Decorative Style $3.95 IN-17
Lindsay, J./Turner: His Life and Work $3.95 IN-4
Lindsay, J./Cezanne: His Life and Art $5.95 IN-23
Male, E./The Gothic Image $3.95 IN-32
Mathew, G./Byzantine Aesthetics $2.95 IN-6
Meiss, M./Painting in Florence and Siena $3.95 IN(t)-37
Panofsky, E./Early Netherlandish Painting
 Vol. I $5.95 IN-2; Vol. II $5.95 IN-3
Panofsky, E./Studies in Iconology $3.95 IN-25
Panofsky, E./Renaissance & Renascences in Western Art $3.95 IN-26
Peckham, M./Art and Pornography $3.95 IN-12
Penrose, R./Picasso: His Life and Work $5.95 IN-16
Poggioli, R./The Theory of the Avant-Garde $2.95 IN-1
Rosenau, H./The Ideal City $6.95 IN-15
Rosenberg, J./Great Draughtsmen from Pisanello to Picasso $7.95 IN-29
Salvadori, A./101 Buildings to See in Venice $2.50 IN-21
Salvadori, R./101 Buildings to See in London $2.50 IN-20
Salvadori, R./101 Buildings to See in Paris $2.95 IN-31
Stoddard, W. A./Art and Architecture in Medieval France $6.95 IN-22
Stokes, A./The Image in Form $4.95 IN-28
White, J./The Birth and Rebirth of Pictorial Space $4.95 IN(t)-27

73 74 75 12 11 10 9 8 7 6 5 4 3 2 1